AFRICAN AMERICAN ARTISTS AND
THE NEW DEAL ART PROJECTS

African American Artists and the New Deal Art Projects

Opportunity, Access, and Community

MARY ANN CALO

Epilogue by Jacqueline Francis

The Pennsylvania State University Press
University Park, Pennsylvania

Library of Congress Cataloging-in-Publication Data

Names: Calo, Mary Ann, 1949– author.
Title: African American artists and the New Deal art programs :
 opportunity, access, and community / Mary Ann Calo ; epilogue by
 Jacqueline Francis.
Description: University Park, Pennsylvania : The Pennsylvania State
 University Press, [2023] | Includes bibliographical references and index.
Summary: "Examines the involvement of African Americans in the New
 Deal art programs, shifting emphasis from individual artists toward
 broader issues informed by the uniqueness of Black experience"—
 Provided by publisher.
Identifiers: LCCN 2022046732 | ISBN 9780271094939 (hardback)
Subjects: LCSH: African American artists—History—20th century. |
 African American art—20th century. | New Deal art. | Federal aid to the
 arts—United States—History—20th century. | Art and race.
Classification: LCC N6538.B53 C35 2023 | DDC 700.89/96073—dc23/
 eng/20221021
LC record available at https://lccn.loc.gov/2022046732

The Pennsylvania State University Press is a member of the Association of
University Presses.

It is the policy of The Pennsylvania State University Press to use acid-free
paper. Publications on uncoated stock satisfy the minimum requirements
of American National Standard for Information Sciences—Permanence of
Paper for Printed Library Material, ANSI Z39.48–1992.

For Ciccio, Jude, Raffi, and Romy

CONTENTS

This book examines the involvement of African Americans in the federally funded visual art programs of the 1930s. The narrative presented here responds to the current state of the field: existing literature on the New Deal art projects neither adequately maps the scope of minority participation nor critically examines its complex implications. Conclusions about African American engagement with these projects are historically dependent on a narrow and incomplete documentary record. Because the archival underpinnings of this topic have remained relatively stagnant, a handful of sources with varying degrees of reliability have been circulated with great regularity and without much revision. I seek to modify and enrich this discussion by shifting emphasis away from individual artists' participation in the projects, the mainstay of standard histories, toward broader questions that arise from the particularities of Black experience. I argue that the revolutionary vision of the federal art projects must be understood in the context of larger goals realized, and those compromised, by the reality of racial segregation and enduring constructs of racial identity.

Chapter 1, "Historiography," provides a detailed analysis of extant historical narratives on the New Deal art projects with respect to their consideration of race. This story begins with the pioneering work of Francis V. O'Connor and examines subsequent generations of scholars who address many of the issues that O'Connor identified as important areas for future research. I consider a range of secondary literature, including standard histories of the New Deal art projects and general histories of African American art. This discussion concludes with an analysis of recent interdisciplinary scholarship on the New Deal art projects in which a new set of priorities has the potential to shape a deeper and more complex understanding of African Americans' relationship to the projects and their aims.

The primary emphasis of chapter 2, "Participation," is on the Federal Art Project (FAP) of the Works Progress Administration (WPA). Evidence of Black artists' successful engagement with these new opportunities is considered in the context of challenges they faced within them. The notion of broad citizen participation was seminal to the FAP's philosophy, resonating

in discussions of both the production and consumption of art. But the FAP was an organizational behemoth governed by a set of rules and assumptions that played out across diverse populations and geographies. I examine the skill and relief requirements for the various projects within the FAP and their impact on choices open to Black artists. In a departure from standard histories that focus primarily on representation in the creative divisions of the project, I shift analytical focus to participation in educational projects like WPA-supported community art centers. These organizations, some of which were established in strictly segregated populations, combined technical instruction and exhibition opportunities with a social service mentality. While organizations such as the Harlem Community Art Center enjoyed public visibility and distinction, I expand the discussion to include an account of lesser-known centers in the South, noting the vast differences between specific locales. This is consistent with the development of a new frontier of research on the FAP that emphasizes its populism and strong commitment to cultural democracy as the signature aspects of its philosophy and legacy.

Chapter 3, "Advocacy," examines the preoccupation during the 1930s with organizing and activism as it plays out within the African American community. The Harlem Artists Guild, founded in 1935 by a group of New York–based Black artists, was a significant force in the cultural politics of the decade. While the importance of its advocacy on behalf of these artists is undisputed, very little is known about the inner workings of the organization. I chart the activities of the Harlem Artists Guild in the context of the activist climate of the 1930s, including its relationship to the National Negro Congress and the Artists' Union, and examine the internal dynamics in 1938–39, effectively its final years of existence as a collective body. In some ways, the Harlem Artists Guild was a prototypical Popular Front organization, not unlike other such initiatives that emerged against the backdrop of the Depression. At the same time, it was undeniably shaped by earlier issues and models of Black artistic advocacy that set it apart from other activist groups of the 1930s.

Chapter 4, "Visibility," considers exhibition opportunities for African American artists during the project years, including but not limited to shows associated with the federal art programs. I identify the various categories and venues in which project art was displayed and the representation of Black artists within them. Visibility in this context is understood

as a complex phenomenon that, like advocacy, cannot be explained in isolation from conditions African American artists faced before the 1930s. By way of comparison, I chart concurrent exhibitions of so-called Negro art assembled and hosted with the cooperation of organizations such as the Harmon Foundation, which had dominated earlier promotional efforts and the influence of which was mediated by the existence of federal arts initiatives.

I conclude in chapter 5, "Aftermath," with a discussion of the 1940s, which saw the winding down and eventual end of these government-funded initiatives. Past historians of American art tended to think of this decade as a transitional moment characterized by the unraveling of social art and the ascendance of a different set of aesthetic priorities. Challenges to this narrative, of which there have been many in the past few decades, do not necessarily bring us closer to understanding the landscape for the majority of African American artists. The 1940s saw continued efforts to promote their work in the form of several key "Negro art" exhibitions now regarded as historic milestones, but the direct impact of the federal art projects on these initiatives is by no means clear. Finally, I return to the intersection of art, race, and community by examining the rise and fall of the People's Art Center in St. Louis.

ACKNOWLEDGMENTS

The impetus to write this book came from my involvement in an earlier project on critical discourse and African American artists in the interwar decades. Although I was able to track responses to the work of Black artists during the Depression, I was frustrated by the lack of primary research on the substance and scope of their engagement with the New Deal art projects. My book *Distinction and Denial: Race, Nation, and the Critical Construction of the African American Artist, 1920–40,* mapped the institutional contexts in which Black artists worked and exhibited in the 1920s and early 1930s. But it became increasingly clear that changes resulting from the implementation of the art projects in Black communities warranted further study.

On the most fundamental level, this book is a work of archival scholarship. It would not have been possible without the army of professionals who organize, maintain, and make accessible the documents from which history is written. I am in awe of their knowledge and skill, and immensely grateful to them. The Archives of American Art occupies a special place in this narrative. Without its extraordinary staff and the research services they provide, we could not tell the story of American culture. Their early investment in the process of documenting the New Deal government art projects made possible an archival foundation that continues to support and generate work on this vast and complex phenomenon.

Research for this book was completed against the backdrop of the global COVID-19 pandemic. I want to recognize the support I received from archivists who responded to my requests with great generosity, providing me with digital copies of documents I was not able to view because of travel and other restrictions. I am especially grateful to several institutions with holdings on the People Art's Center (PAC) in St. Louis and their remarkable staff: Zachary Palitzsch at the State Historical Society of Missouri; Renee Jones at the St. Louis Public Library; and Dennis Northcott at the Missouri History Museum Archives. I also want to thank Amy Tolbert and Clare Kobasa of the Saint Louis Art Museum, who apprised me of their ongoing research on the PAC and brought an important set of documentary photographs to my attention. Special thanks also to Lisa Moore of the Amistad

Research Center in New Orleans, who dug through the Louise Jefferson Papers on my behalf and came up with an important set of documents related to the Harlem Artists Guild.

During the course of my research, I had numerous conversations with individuals at historical societies, museums, and libraries in North Carolina and Florida; they shared research strategies, documents, and the names of local historians from whom I learned a great deal. In particular, I want to thank Meg White and Ju'Coby Pittman of the Clara White Mission, and Adonnica Toler of the Ritz Theatre and Museum for making themselves available during a series of visits to Jacksonville.

Among my professional colleagues, I am grateful especially for Jacqueline Francis's interest and involvement in this project. Our many conversations, and the hours spent in the archives together, were both enjoyable and consequential. This is a better book because of Jacqueline's wisdom and input. I am honored that she agreed to write the epilogue. Her contribution expands outward from the historiographic and documentary approach at the heart of this study, signaling the emergence of a new frontier in future research.

After twenty-five years of teaching and administration, I stepped down from the faculty of Colgate University in 2016. I could not have found myself in a better environment and still feel lucky to have spent so many years with the wonderful students and stimulating colleagues I encountered there. Colgate continued to provide financial support for the completion of this book after I moved to emerita status, for which I am grateful.

Finally, in my personal life, the most significant change since I began this project has come in the form of four wonderful grandchildren: Francesco and Raffaella Lindia, and Jude and Ramona Brownell Calo. These children are amazing in every way and give me hope that my life will remain full of joy and that the world can become a better place. This book is dedicated to them.

In short, integration of the Negro into the art program of the Works Progress Administration was apparently insincerely attempted, paradoxical as it may seem to say so; and never achieved the fullness of its possibilities.

—JAMES PORTER, 1939

You have to have a wall before you can get a mural.

—CHARLES ALSTON, 1965

CHAPTER 1

Historiography

Like all research specialties, New Deal art-historical scholarship emerged in a particular context and pursued a specific set of questions. Early inquiries into the government-supported art projects of the 1930s were rooted in the political, cultural, and intellectual climate of the 1960s. Pioneering scholar Francis V. O'Connor was first prompted to explore New Deal art projects because of his interest in Jackson Pollock and his desire to track the painter's experiences in the 1930s. Thus the initial aim, at least in part, was to understand the impact of the projects on a cohort of high-profile contemporary artists who had emerged in New York City after the war. O'Connor's work also developed against the backdrop of advocacy; he studied the New Deal projects as a potential model for the establishment of a permanent government funding structure that would support the creative arts.[1]

As this early research evolved, O'Connor and his collaborators shifted their emphasis from the art projects in New York toward documentation of the art projects as a whole. They sought to articulate the chronology of, and differences among, various New Deal art programs, and to identify their respective ideologies, administrative practices, and funding streams. This approach ran counter to what Audrey McMahon, regional director of art projects for New York and New Jersey, had earlier predicted: "Nothing is to be gained by the separate consideration of these various programs.

It is safe, I believe, to prophesy that retrospectively they will be envisaged by art historians as one and the same thing."[2] Their relevance, she suggested, was to be found in general impact, not specific details. This was not borne out as the field of New Deal art history took shape, but when it came to the assessment of these programs in relation to African American artists, McMahon's assumption proved largely true. Historians have tended to think of the projects overall as initiatives that redressed chronic disadvantages faced by Black artists, with a generally positive effect on their subsequent professional development. The result is a kind of consensus view of their collective historical relevance that is often vague or scarce in terms of details and complacent in terms of analysis.

Perhaps the biggest problem facing scholars interested in African American artists and the federal art projects has been getting reliable basic information on participants. The largest New Deal art project, what was known as "Federal Project Number One," administered by the Works Progress Administration (WPA), encompassed government-supported programs to provide work relief not only for artists but also for writers and creative practitioners in theater and music. Black visual artists were largely associated with the Federal Art Project (FAP), a branch of Federal One. But, unlike the other branches, there was no dedicated "Negro" unit within the FAP, as there were, for example, in theater and writing. The personal record section of the FAP questionnaire asks about gender but not race. By design, the various divisions of the FAP were intended to be "race blind," at least in principle. In some ways, the well-intentioned strategy of the FAP, to eliminate race as a separate category, has made it difficult to examine the differences between promises and practice within it.

Finally, when considering the general topic of African Americans and the federal art projects, an important distinction must be maintained between institutional issues related to administration and participation, and thematic concerns as they played out in New Deal art. O'Connor's primary concern, at least initially, was the former, even as he noted the differences between various projects and their general policies with respect to matters of artistic freedom and choice of subjects. But in the wake of his groundbreaking research, an art-historical subspecialty emerged that focused on the analysis of style, subject matter, and themes in visual art produced under government-sponsored programs. In this area of research, African Americans have been more visible, especially when it is concerned

with artworks made in specific locales where Black communities figure prominently in local history and mythology. Although contemporary approaches to race and representation have increased interest in such material, it does not figure prominently in the present study.

DOCUMENTING THE NEW DEAL ART PROJECTS

There is no systematic or exhaustive study of African American experience in the visual art projects, but there are numerous places to look for information and insight. Sources fall into several general categories, all of which evolved out of O'Connor's initial research. Archives were at the center of this early work and remain essential to New Deal scholarship. Of particular import are the papers of Holger Cahill, national director of the FAP, and those of O'Connor himself. Both contain key documents culled from the vast records of the WPA housed in the National Archives.[3] These documents formed the core of O'Connor's 1968 groundbreaking report to the National Endowment for the Arts on government support for the arts, published the following year by the New York Graphic Society.[4]

A half century later, this research remains unparalleled in its scope and ambition. In addition to mining official documents, O'Connor sent letters to artists and art teachers as well as to former supervisors and administrators who were employed on various New York City and New York State projects between 1933 and 1943. He wrote to historical societies, art magazine editors, art dealers, and galleries that might represent artists who had been on the projects. Effectively, his goal was to establish contact with anyone who had been associated with the FAP, the Public Works of Art Project (PWAP), the Treasury Department Section of Fine Arts (Section), or the Treasury Relief Art Project (TRAP). In a form letter designed to solicit information, he underscored that the historical aspect of the project would be used to shape future policy, and that recovery and evaluations of artworks were research priorities.[5]

O'Connor's initial research included outreach to the Schomburg Center, from which he requested the catalog for a 1967 exhibition at City College titled *The Evolution of Afro-American Artists, 1800–1950*.[6] He explained that he was seeking documents relating to the participation of Black artists in the projects and material on the Harlem Community Art Center (HCAC). A small number of Black Americans consistently appear on working lists

of artists in the O'Connor Papers. As the mission expanded, the research team made a responsible effort to uncover and record details about African American participants. New names were added to the archive and O'Connor sought information from the General Services Administration about their employment, a process that continued after he submitted his report in October 1968. These records were by no means exhaustive, but they made it possible, for the first time, to track the work history of a significant number of African American artists on the projects.[7]

Soon after the publication of O'Connor's research, it became clear that focus on the creative divisions of the New York projects had led to an incomplete if not biased understanding of New Deal art programs overall. In the years that followed, O'Connor and the scholars he brought together systematically identified aspects of the New Deal art projects in need of more research. Through conferences and symposia, as well as in the pages of *Federal Art Patronage Notes* (1974–83), a quarterly newsletter that shared information about ongoing research and the status of current government-sponsored initiatives, parameters emerged for a new scholarly field expected to expand over time. As stated in the inaugural issue of *Federal Art Patronage Notes*, the newsletter was to function as a resource for those interested in the history and matters of public policy related to government support for the arts. It promised to report on newly completed scholarship and work in progress and on forthcoming exhibitions and academic conferences dealing with this topic. "In short," O'Connor wrote, "these pages are intended to serve as a clearing house for ideas and information from those actively engaged in writing, research or administration in the field of federal art support."[8]

The first issue of the newsletter called for the organization of an academic conference on New Deal cultural programs. Research had been ongoing since the late 1960s and it was time for scholars to share findings and exchange ideas. The conference objectives were ambitious:

1) to assess the present state of research and plan long-term goals, 2) to exchange information directly and to encourage students to work in the field, 3) to stimulate regional shows of New Deal art and activities, 4) to explore the compiling and publishing of a basic textbook on the New Deal art, music, theatre, writers and historical records programs to which experts in each area would contribute,

5) to assess the effectiveness of federal art preservation efforts and to organize a strong voice to encourage these efforts—and to protest if necessary, 6) and finally, to organize a similar strong—and historically informed—voice in the drafting of legislation affecting the visual arts and the individual artist.[9]

O'Connor felt that energies and resources needed to be directed at more than academic scholarship; he spoke as an advocate for research, for the preservation of New Deal art, and for ongoing federal support of contemporary art.

The following year, a conference called "Fine Arts and the People" was held at Glassboro State College, organized by O'Connor, Gerald Monroe, and Jane De Hart Mathews and funded by the National Endowment for the Humanities. Key figures in the first generation of New Deal art historians participated, including Greta Berman, Belisario Contreras, Garnett McCoy, and Karal Ann Marling. Warren Susman chaired a session called "The Projects Seen in the Light of Cultural Trends in the 1930s," and Arthur Schlesinger Jr. was invited to act as a commentator and synthesizer.[10] The content of the Glassboro conference shaped future scholarship on New Deal art and the government projects. The session O'Connor presided over, devoted to general issues on art and the Depression, raised a series of questions that would guide research for the next fifty years.

Participants were urged to consider the federal art projects as agents of artistic change, democracy in the arts, and cultural populism. They called for better understanding of the ideological positioning of the projects, asking not only how they affected artists but also whether they created new audiences, markets, and a stronger sense of community. Questions were raised about the role of censorship and the projects' collective impact on art education. O'Connor asked specifically about the role and influence of the community art centers (CACs) and what kind of data and analysis would be helpful. He addressed the need for comparative frames that would weigh the national against the local, and federal support for the arts in the United States in relation to other nations. Finally, participants identified the need to broaden inquiry by asking, "What was the role of Blacks, women, and the various ethnic groups on the Projects? To what extent did Project art reflect minority views and depict ethnic heritage as related to the strength and destiny of America?"[11]

Susman's session provided strong support for inquiry into these larger questions. He called for expanding perspectives on the projects in ways that related them to broad cultural patterns of the interwar decades, such as the documentary impulse, the visibility of culture in popular mass media publications like *Life* magazine, definitions of high, middle, and lowbrow culture and their impact, and ideals espoused by proponents of the so-called American Renaissance and by philosopher John Dewey. Susman also stressed the need to develop appropriate methodologies for approaching these questions that would allow historians to think about the artist as both a creator and a worker, and about the relationship between art and society in America. His remarks were underscored by Schlesinger, who noted the need for better understanding of the personal tastes of those who sponsored and ran the programs, and of their nationalistic and patriotic impulses.

In the ensuing years, *Federal Art Patronage Notes* continued to encourage and share research on the New Deal federal art projects in the interest both of expanding understanding and of providing historically informed guidance on the drafting of contemporary federal art policy. It published periodic bibliographies of New Deal arts scholarship and reported on various public initiatives. By the summer of 1983, O'Connor seems to have become discouraged about the slow progress of research. His remarks that year were in part occasioned by events marking the fiftieth anniversary of the inaugural New Deal art project. Referencing the earlier conference, he noted that an ambitious research agenda had been laid out but that not enough had been accomplished. In his view, there had been a decline in the scope and originality of New Deal patronage studies, and he expressed hope that commemorations of the anniversary would stimulate new work. Once again, he singled out the importance of conducting regional and state studies, and he prioritized increased understanding of the art education initiatives: "More than any other institution, it was the New Deal art projects in general, and the Federal Art Project's Community Art Centers in particular, that first brought the personal experience of creativity to the American people. Yet the history of this vast educational endeavor has been neglected, as has the role played by project artists in creating the various schools of the arts which now flourish in so many universities."[12]

A follow-up conference, "New Deal and American Culture in the Thirties," was held at Columbia University in April 1985, timed to coincide with the fiftieth anniversary of the legislation that created Federal Project

Number One. The purpose of the conference was to assess the state of inter-disciplinary New Deal scholarship a decade after Glassboro, with emphasis on addressing each of the Federal One projects independently and on trying to understand the relationships among them. O'Connor, speaking on the "Visual Arts" panel, noted that after twenty years of dedicated scholarship there had been "a certain unwillingness to go beyond what is convenient in the archives."[13] Participants concerned with problems in regional stud-ies pointed out that traditional documentary sources do not capture the nuances of diverse programs and audiences. CACs across the country again took on special importance in this discussion, each one understood as spe-cific to its location and environment. In discussing future directions for New Deal scholarship, the historian Jannelle Warren-Findley observed that "the mapping of state and regional programs is absolutely crucial before we can even say for certain what was done by these government programs, because state and regional programs were simply too diverse to be able to generalize about them."[14]

Even as he prioritized regional and cross-disciplinary approaches to New Deal cultural projects and their diverse constituents, O'Connor remained concerned about issues of quality that had emerged early on in his research, focused as it was, at least initially, on project participation among celebrated artists of the post–World War II generation: "Those of us in the field of the visual arts have to consider just how far we can go with works of art as documentation before we have to decide between the good and the bad.... Do we seek the 'significant best' or the 'best significant'? ... Are we to assume that one should apply universal criteria of quality or only historically relative criteria? ... Do we select out of the product of an entire generation of American artists the best to illustrate our points about the culture from which they came?"[15] In raising these questions, O'Connor recalled the anxiety of FAP administrators such as Holger Cahill, who sim-ilarly worried about criticism of New Deal art as driven by social objectives rather than aesthetic values. But, in the end, these questions were about the story New Deal historians wanted to tell and how they were going to tell it.

EARLY NARRATIVE HISTORIES OF THE PROJECTS

The first wave of narrative histories of the federal art projects appeared in the years immediately following O'Connor's early publications and built

extensively upon them.[16] In addition to official documents, oral history played a prominent role in shaping the content of these subsequent narratives. Personal testimony provided important details about individual experiences and the bureaucratic functioning of the projects, as well as interpretation of the ideological flashpoints. While in the main they were celebratory, participants also raised larger questions about the implications of government support for the arts and its impact on outcomes and the future development of American art.[17]

In assessing the pivotal role of oral testimony in New Deal cultural history, Roy Rosenzweig and Barbara Melosh offered a critical examination of the strength and inherent limitations of excessive reliance on such sources.[18] They identified biases attributable both to limited sampling and various contextual issues that could be brought to bear on these accounts. For example, they noted that despite the impressive number of such interviews (by their count well over one thousand), a disproportionate emphasis was placed on speaking to creative visual artists and high-level project administrators, with little insight from support staff who managed the projects on the ground. The sample is also unbalanced geographically, with the metropolitan New York area heavily represented, followed by California and a select number of mostly urban areas spread across the country. The South is vastly underrepresented, with only Florida achieving at least some visibility.

Rosenzweig and Melosh also identified various forms of bias that emerged from the identities and personal circumstances of the subjects and from the historical moment in which they were interviewed. Among the small number of women who were consulted, little emphasis was placed on the uniqueness of female experience, perhaps reflecting prefeminist wariness of dwelling on gender differences. The authors ascribed age-related bias to a large swath of the oral accounts, given that many were individuals well past middle age recalling the experiences of their youth. In addition to being tinged with nostalgia for youth and romantic ideas about comradery under shared circumstances of deprivation, the projects tended to be seen through the lens of subsequent success. As the authors said of the sample overall, "generally the bias is toward people who continued to work in the arts and who were thus likely to agree that government sponsorship helped artists."[19] Subjects were inclined to think of how their personal goals and creativity were supported, rather than the implications of the projects' larger social goals.

African American oral history subjects did reflect on issues of race in the challenges and opportunities they faced, but their conclusions about the value of the projects were equally embedded in a set of assumptions about art and creativity that were widely shared among their peers. In scholarship about Black artists and the art projects, an interview conducted with Charles Alston for the Archives of American Art enjoys particular prominence among historians. While generally positive about the projects, like many artists of the postwar era, Alston expressed reservations about the dominance of social issues in the art of the 1930s. As Rosenzweig and Melosh explained, "when Harlan Phillips interviewed the painter Charles Alston in 1965, their conversation revealed the doubts of both the interviewer and interviewee about the aesthetic efforts of the socially conscious art of the 1930s. Both men shared the tacit assumption of formalist art criticism, the notion of art as separate from society and therefore inevitably compromised or debased when in the service of politics. Asked by Phillips how the project affected his work, Alston was ambivalent."[20] Writing in 1990, these authors concluded that the evolving priorities of New Deal cultural historians, and their increased interest in the broader social patterns implicated in the art projects, necessarily involved a shift away from individual recollections to sources less mediated by highly personalized and, in many ways, contingent assessments of value.

Whatever the shortcomings or limitations of their work, these early historians provided a very clear picture of the scope and aims of the New Deal art initiatives. In addition to furnishing empirical data on logistics, financing, and levels of participation, they charted important distinctions between the projects managed by the Treasury Department and those associated with the WPA. They sought to explain the impact on these divisions of the philosophical and personal differences between Edward Bruce and Holger Cahill, their respective directors. These discussions turn on a few key points: an emphasis on need versus competency; on relief versus competitive commissions; and on volume of production versus the production of a few good works. Although the differences were real, we are cautioned against absolute binaries here. Richard McKinzie, for example, pointed out that Cahill, who ran a program based on need and relief, worried privately about issues of quality because he wanted to ensure an elevated and ideally permanent status for his programs. Cahill addressed the issue of

competency by creating different divisions based on skill levels, but he also recruited accomplished artists to the projects.[21]

William McDonald suggested that the FAP understood that it could and should potentially play an important role in improving race relations.[22] This was to be accomplished through ensuring access to the benefits of the projects rather than challenging existing norms regarding legal segregation. Cahill believed that the achievements of Black artists such as Samuel Brown and Charles Alston added to the positive image of the projects; the two were frequently cited in official literature because they had been chosen for inclusion in *New Horizons in American Art*, an early showcase of project art held at the Museum of Modern Art. But historians sometimes exaggerate the extent to which the projects made the development of African American art possible, perhaps taking too literally the claims of key administrators. Black artists recognized that the projects gave them opportunity, but to overstate this is to ignore the fact that Alain Locke had been writing about Negro art for a decade, and that familiarity with the works of these artists had been growing through the Harmon Foundation (HF) and other exhibitions.[23]

All of these authors were required to mediate between recognition of opportunity and nondiscrimination as reflected in project official literature, and the reality of low participation numbers. McDonald stressed the growth in the number of Black artists in the WPA in the first year, thanks in part to successful advocacy by organizations such as the Harlem Artists Guild (HAG). Bruce Bustard, by contrast, points out the failure on the part of Section administrators in particular to be proactive in securing commissions for Black artists.[24] Most writers agree that while the employment of African American artists was mixed, there was definite progress in terms of expanding opportunities for art education and appreciation in Black communities.[25] They consistently note that the projects did not challenge legal segregation, and some examine the general implications, especially in the South. According to McDonald, local administrators in southern states worked with the national office to achieve equality of opportunity to the extent that this was possible given conditions on the ground. These historians also argue that the projects stimulated interest in African American culture, both by employing Black artists and by encouraging the depiction of local history and African American life. This did sometimes involve stereotypes, but it could also lead to new levels of understanding and cultural sensitivity.

What do these early sources tell us about African American artists and their actual experiences? With various degrees of attention and detail, the authors note the participation of specific artists and the projects they worked on. Drawing on similar primary sources, they tend to tell the same stories. Detailed discussions of African American experience in this literature are focused largely on a few high-profile initiatives that were well documented as sites of controversy, or on individuals who directly intersected with the agents of cultural change that define the era, such as the Artists' Union (AU), the American Artists' Congress (AAC), and the magazine *Art Front*. The Harlem Hospital mural project, for example, involved biracial activism in which the AU and the HAG joined forces to combat the unsympathetic and intrusive actions of a local WPA administrator. Not much attention is given to the HAG as a specific organization beyond published statements in *Art Front*, but the overall contributions of Aaron Douglas and Gwendolyn Bennett, who were active in the HAG and also involved in the AAC, are recognized. The many accounts of the HCAC and its founding director, the artist-educator Augusta Savage, emphasize its status as a flagship of artistic outreach to local communities and as a training ground for a generation of Black artists.

It would be inaccurate to state that these early authors simply ignored African American experience, but one does not get a consistent sense from this literature of how aware project administrators were of race issues beyond a very general sense that positive things could be achieved. And while historians spent a lot of time discussing the programs' varied philosophies and requirements, they did not always demonstrate a critical awareness of how such things related to the larger issues facing African American artists. Most note the lack of Black supervisors on the FAP as a problem and the efforts of activist groups to exert pressure on authorities to expand these numbers. But distinctions between association with the creative versus the educational divisions, or between the Treasury- and WPA-funded projects, were not routinely examined in terms of their implications for African Americans artists except to account for their numbers.

AFRICAN AMERICAN ART HISTORY

Historians of African American art have understandably paid greater attention to this topic but have relied on the same resources: oral histories,

archival records, and New Deal cultural histories.[26] They also benefited from the growing number of specialized studies in African American art, particularly monographs on individual artists. Participation in the projects of notable figures such as Aaron Douglas, Archibald Motley, Jacob Lawrence, Charles Alston, William H. Johnson, Richmond Barthé, Augusta Savage, and Sargent Johnson, to name a few, has been consistently noted in the historical literature, providing important insights into the impact of that experience on their work. Monographs have also added much-needed primary source material to the record and expanded our understanding of the local context in which these various opportunities were offered.

Collectively, these historians have raised questions and identified issues that had specific bearing on the participation of African American artists in the projects. They were, for example, attuned to the complications of qualifying Black artists for the art projects. Individuals were asked to provide information on their training as artists and their exhibition history, a challenge for Black artists who lacked the opportunity to attend art school or regularly show their work. Augusta Savage, who had been teaching Harlem art workshops for many years prior to the establishment of the FAP, was a key figure in assisting many of her former students who sought employment by the projects. The HF was also involved in this process despite its troubled relationship with the Harlem artistic community in the 1930s.

On the issue of artistic training, there is strong consensus among historians of African American art that the projects provided Black artists with time to work and unprecedented access to materials and instruction. In this sense, there is consistency with official project literature and the secondary sources on New Deal art history. These historians recognize and celebrate the contributions of FAP-supported initiatives in urban locales, such as the South Side Community Art Center in Chicago and the HCAC, to the education of Black artists. Printmaking and mural painting have special prominence in this literature, the former for the democratic impulse the medium embodied and the latter for the obvious public profile mural projects enjoyed. In addition, printmaking required technologies difficult to access for artists not formally enrolled in art schools, and mural painting involved a specialized pedagogy and mastery of technique not easily obtained outside public commissions.[27]

One very significant difference between mainstream general histories and those that focus specifically on African American art is the attention

given to the role of the HAG in the cultural politics of the 1930s. Mainstream sources tend to focus on the AU and AAC, but historians of African American art have recognized the importance of the guild as an advocate for everything from increasing the number of Black supervisors, to fighting cutbacks that disproportionately affected Black artists, to rallying public support for the establishment of the HCAC. The role of the HAG was also crucial in addressing a problem that many historians note: the obvious imbalance in terms of access to FAP-sponsored exhibitions. Denial of adequate opportunities to show their work had been a persistent challenge for generations of Black artists, and the HAG worked collectively to organize and promote exhibitions of its members as an alternative.

With respect to documenting actual participation, these general texts vary widely in both scope and accuracy. Inconsistencies in the literature can be explained in part by an early investment in biographical and archival scholarship on a topic for which the primary record is itself uneven. The many references to who-worked-on-what-project-and-when can give the impression of randomness, of the impulse to convey information on hand without much concern for discursive force or relevance. There is some differentiation between artists who were understood to be in a privileged position owing to their association with nonrelief initiatives such as the Section or the very exclusive PWAP. But mainly we learn about identifiable works of specific artists done with government support, not unimportant by any means, especially given the general problem of recovery in New Deal art history.

Approaches to this period that emphasize the facts of participation provided infrastructure for a parallel effort to establish what access to these programs effectively *meant* to this generation of Black artists and to the development of African American art. At their best, these analytical accounts transcend standard histories and seek to capture the larger relevance of the projects as mechanisms whereby African American artists could successfully enter the mainstream of American cultural life. Such observations are most persuasive when the frame is comparative—that is, when they weigh what appears to have been a paternalistic and exotic interest in so-called Negro life driving the Harlem Renaissance of the 1920s against an era of openness to Black experience that seemed connected less to the reification of racial difference than to the broad search for a complex notion of American identity. These arguments are ultimately about

redefining the position of race in the national story and the relationship of Black America to the majority culture.

Jeff Donaldson's groundbreaking study of "Generation 306" made this case, characterizing the interwar decades as "germinal." During this period, we witness the abstractions of the Harlem Renaissance give way to the practical politics of the New Deal; the associations between race and primitivism, so appealing to white viewers, recede. Black artists were "invited" to participate in the projects, their status and fate more closely linked with white American artists than at any other time in history.[28] Donaldson constructed the 1920s as a period that encouraged individualism among artists competing for limited resources. Conversely, the Depression ushered in an era of shared aesthetic ideals and investment in collective strength. More recently, Stacy Morgan has argued that even if such comparisons are rooted in timeworn contrasts between the preoccupation with Black exotica in the 1920s and the manifest social justice concerns of the 1930s, there is truth to the claim that Depression conditions reoriented artists' thinking in terms of their ideological and structural relationship to American culture.[29]

David Driskell presents a very different scenario in his essay for the landmark exhibition *Two Centuries of Black American Art*. While recognizing the legacies of the Harlem Renaissance as quite specific (nationalism, primitivism, atavism, and what he called "Tannerism," by which he meant overcoming the system), he understood it as extending into the 1930s, albeit mediated by changing economic, social, and cultural conditions. Driskell invoked W. E. B. DuBois's concept of double consciousness as a way of understanding the complex relationship between these two decades. Despite forging an independent identity in the 1920s, Black artists continued to see themselves through the eyes of others, part of the sociocultural system yet apart from it. Driskell also revisited Locke's argument that the American Scene movement was helpful to Black artists insofar as it led to the "discovery" of African American subjects and established their importance to the country's story. He felt that Locke at times exaggerated the transformative implications of 1930s realism, pointing out, correctly, that this had been ongoing since the majority culture "discovered" Black subject matter during the Jazz Age.[30]

Driskell noted that many Black critics and artists enthusiastically embraced the ethos of the 1930s in part because it enacted a shift away from racial protest to overall social protest sanctioned by the mainstream.

Black artists were drawn to socially minded realism both because it was a dominant idea and because it genuinely met the needs of a generation of artists who wanted to express their fundamentally American identity and also to accelerate social change. But even though this confluence of ideas was a good fit for Black artists in the 1930s, they were ultimately not able to get out from under what was a fundamentally narrow perspective on art. As these social platforms collapsed and government support dried up, the problems faced by Black artists were compounded by multiple factors that, in Driskell's view, slowed their growth: lack of a coherent aesthetic ideology, sustained informed criticism, and diverse forms of patronage.[31]

Recognizing that the government policy of nondiscrimination in the federal art projects had a significant positive impact on African American artists and allowed them to survive, Driskell also suggested that the projects created false hopes among artists about the possibility of lasting change. And he argued that the commitment to socially conscious realist art may have hamstrung Black artists, especially in the postwar period. This point is underscored by the thinking of American critics such as Sam Hunter and Barbara Rose, who looked down on the 1930s as conservative and reactionary. When Driskell argued that Black artists embraced the period ethos to their eventual detriment, as abstraction and formalism ascended in postwar art, he seemed at some distance from the feelings of social solidarity and common agency that infuse Donaldson's account, written as it was in the context of the Black Arts Movement and its commitment to community and activism.

Among the authors of survey texts, Sharon Patton has been the most interested in detailing the social and institutional aspects of the period that influenced the circumstances and development of African American art. She covers basic information in a way that balances the larger picture with details that are specific to Black experience. In addition to a clear time line and summaries of the respective projects, her book *African-American Art* includes an informative discussion of the CACs nationwide and their role in employing Black artists and providing art instruction for those who could not afford it. With respect to Harlem, Patton charts the HCAC's relationship to prior workshop activity in the 1920s and identifies key players who facilitated these kinds of initiatives in Harlem and elsewhere. Patton's treatment of the projects is framed by nuanced discussions of the patronage and critical issues surrounding African American art in the 1920s and their

extension and modification during the 1930s. She positions the New Negro thinking of Alain Locke in relation to both the ideology of the New Deal and counterarguments embodied in the alternative critical paradigm of James Porter, all of which are examined for their implications in the post–New Deal art world of the 1940s.[32]

Patton provides a fulsome account of the HAG, characterizing it as an alternative to, and not just an appendage of, the AU. She notes its importance as a political organization but also points out that it was created to animate discussion on how best to foster the visual arts in the Black community. In effect, she confirms that the HAG was a cultural as well as an activist organization. This insight was advanced earlier in Romare Bearden and Harry Henderson's *A History of African-American Artists*, whose treatment of the 1930s deserves special recognition as the most comprehensive discussion of African Americans and the New Deal art projects in the general literature.

Bearden and Henderson were particularly interested in providing a complete and accurate account of the Depression era and what it meant to African American artists. They conducted numerous personal interviews and reviewed available archival documents as well as the secondary literature. They consider several projects at length and provide an impressive level of detail on the participation of many individual Black artists. Bearden and Henderson promised prospective publishers an inside look at the HAG, as a way of accentuating the book's originality. Their extensive account of the HAG drew heavily on typescripts of previously unpublished minutes from meetings held in 1938–39, and on other supporting documents such as membership lists and internal correspondence. While this material was abbreviated in the published book, their basic argument about the rise and fall of the HAG, and its connection to earlier efforts to advance the interests of Black artists, fundamentally altered simplistic narratives that characterized the organization as an advocacy group embedded primarily in the cultural politics of the moment. Like Driskell before them and Patton after, Bearden and Henderson stress continuity modified by an altered sociocultural landscape.[33]

NEW DEAL SCHOLARSHIP AT THE TURN OF THE MILLENNIUM

In the past three decades, a new generation of scholars interested in the cultural landscape of the 1930s has shifted the conversation about the art

projects, moving it closer to O'Connor's vision for future research. Recent New Deal scholarship builds on earlier conceptual formations while raising different kinds of questions, and in the process a more nuanced account of Black experience is emerging.[34] While scholars have long recognized the impact of American philosopher and educational reformer John Dewey on the functional ideology of the New Deal art projects, there has been increased scrutiny of the specific role it played in FAP national director Holger Cahill's drive to supplant elitism with grassroots engagement in the arts. This line of inquiry has given privileged status to the CACs and the Index of American Design as embodiments of the FAP's purest investment in democratic and populist ideals. The CAC movement has proved fertile ground for scholars interested in New Deal cultural initiatives as anti-elitist and inclusive in principle and implicitly educational and social in purpose.[35]

Broader inquiries into social context and lasting impacts have resulted in a more complex understanding of African Americans' relationship to the projects and their aims. For example, while most historians engaged official FAP rhetoric on art and democracy to affirm the nationalistic aspirations of the WPA, interest has grown of late in the projects as mechanisms of social and political engineering undertaken to restore cultural coherence during the Depression. Definitions of "citizenship" as a condition reliant on common ideals shared by diverse segments of the population lend themselves to consideration of African Americans as key constituents in the project of achieving national identity and unity. The New Deal art projects are also increasingly viewed as agents of education that had a significant impact on the development of citizen-consumers operating in an emerging market for accessible populist art. To varying degrees, like the projects themselves, recent authors have moved away from traditional understandings of professionalism in the arts toward an emphasis on amateurism, shared values, and the cultivation of grassroots interest in the arts, all of which resonate with the development and circulation of African American art.

Jonathan Harris's 1995 study *Federal Art and National Culture* marked a turning point in the literature. Harris described the instrumental construction under the New Deal of a coherent American public able to acknowledge difference without inciting antagonism. In the rhetoric of the New Deal, he argued, citizenship elided the particularities of class, race, gender, and occupation. Society writ large maintains ideological consensus through shared organizations and structures directed at common goals.

Harris understood the FAP as a fundamentally hegemonic project, directed at creating and sustaining a unifying vision of America during a period of crisis. Through programs such as the Index of American Design, which aimed to document the regional histories of American material culture, the FAP sought to excavate lost cultural memory and in so doing revitalize American art and the nation itself. CACs promoted aesthetic populism and democratized notions of artistic production and experience. Art that belonged to the people and embodied popular values could combat the destructive associations with individualism and elitism that had caused cultural disaffection and eroded fundamentally American values, as the FAP understood them.[36]

This understanding of the FAP as a universalizing discourse perpetuating national unity in the interest of restoring cultural health to a badly damaged nation has been challenged by scholars who see a much more complex ideological landscape informed by multiple goals and evolving definitions of culture.[37] From the standpoint of African American experience, it is an abstraction largely disconnected from the reality of people's lives. Harris, like other scholars, acknowledged that the FAP did not challenge legal segregation. But, he claimed, it rhetorically advanced the equivalence of artist/Negro/citizen to neutralize conflict and admit this otherwise marginalized group into an inclusive notion of national identity. In practical terms, of course, this did not happen, especially in places where the overall number of artists was small and racial segregation was strictly enforced. Black artists remained isolated no matter how seductive the paradigm; there was a functional inconsistency between promise and practice that rhetoric could not resolve.

Lauren Sklaroff, like Harris, discusses the approach to race in the rhetoric and strategies of the government art projects as a way of addressing concerns of African American citizens without attempting actual structural change to segregation. These programs promoted the idea of a more inclusive America in part to secure support within the Black community for Roosevelt's agenda, a point that Harris also makes. But Sklaroff, in her book *Black Culture and the New Deal*, maps the conditions on the ground as Black leaders engaged in constant negotiation on issues that mattered to them, such as discriminatory practices and the right to control representation of African Americans in project art. She examines in detail the extent to which Black artists and intellectuals associated with the Federal

Writers' and Federal Theatre Projects were invited into the process. The result was sustained conversation about administrative prerogatives and the interpretation of Black life and culture. In the context of these cultural debates, Sklaroff argues, African Americans achieved a measure of agency. In her view, the projects were a form of civil rights policy that went far beyond their nominal objectives of providing relief for financially distressed artists.[38]

Although there is some overlap between the FAP and the other divisions of Federal One in terms of approaches to race, it is important to note how they differ. In general, the progressive administrators behind these programs believed that art could be a weapon of social reform and a democratizing force, and they were invested in the notion that improved race relations might be a potential outcome of the projects. But because both the Theatre Project and the Writers' Project had administrative structures dedicated to Negro affairs, where race issues were front and center, they had greater potential to advance thinking about Black cultural experience and achievement. There are examples of African Americans who pushed back on isolated representations of race in mural and public sculpture projects, but this was more closely scrutinized in the Federal Writers' Project, where officially appointed advisors such as the well-known poet and literary critic Sterling Brown monitored literary production. As Sklaroff points out, the Writers' Project developed complex mechanisms for addressing race concerns that involved consideration of both historical circumstances and present-day demands. The FAP, with a few notable exceptions, was in large part focused on the logistics of extending benefits to Black communities in a segregated society; it was primarily concerned with access.[39]

Historian Joan Saab has identified education as a key operative principle in the cultural landscape of the New Deal. In *For the Millions: American Art and Culture Between the Wars*, a thoughtful analysis of the so-called populism of the era, she weighs the educational mission of the FAP against that of the Museum of Modern Art (MoMA), pointing to their concurrent efforts to influence the national discussion through what she calls the pedagogy of production and the pedagogy of consumption. The former associated making art with the development of a healthy citizenry and improved spiritual existence, while the latter encouraged thoughtful engagement with utilitarian objects. Both contributed to a sense of the nation as enriched by a commitment to art grounded in everyday experience; people feel better

because they express themselves through art production, and the quality of their lives is improved by recognizing and acquiring good (as in folk or modernist) design.

Saab's study charts the contentious relationship between art and democracy that characterized the interwar decades and the mechanisms of accommodation, both ideological and practical, that evolved to resolve emerging contradictions. Her treatment of African American experience breaks new analytical ground, particularly in her discussion of the Harlem Hospital mural project. This initiative resulted in a well-documented controversy that invoked major themes of race discrimination and activism in the WPA projects; it frequently serves as a trope signaling racial awareness in New Deal art history. From the push to appoint a Black supervisor (Charles Alston) to protests against interference from unsympathetic local WPA administrators, the Harlem Hospital mural project has come to signify successful resistance to racism and bureaucratic injustice. Acknowledging this, Saab also enlists this project as an exemplar of the tension likely to emerge when notions of aesthetically and socially relevant art come into conflict with mutable constructs of the so-called public. In mural painting, aesthetic values are brought into conversation with social utility, a situation that is complicated by the intent to widen access to include diverse audiences. The value of Saab's discussion lies in the way she uses the Harlem Hospital murals not simply as a racial cipher but as a way to illuminate a larger thesis about navigating inherent tensions in public art. Black experience in the projects emerges as both specific and conceptually broad.[40]

In *Democratic Art: The New Deal's Influence on American Culture* (2015), Sharon Musher points out that New Deal art historians like Harris have gone beyond what she describes as the celebratory recovery stage, examining FAP contributions both to the cultural agenda of the Left and to the solidification of bourgeois values. Like earlier historians, she identifies the diverse ideologies underlying the art programs that led to varying approaches united by similar aims: to democratize and Americanize the arts and expand public consciousness about the value of cultural experience. Her discussion of the CACs in Cahill's vision of democratic access to the arts is an excellent account of how these centers worked and their guiding philosophy. Musher foregrounds the importance of engagement with artistic process in this division of the projects, which emphasized education, broad participation, and the integration of the arts into everyday life rather

than the creation of singular works of art. She also points to the genuine popularity of the CACs as measured by the levels of attendance and the enthusiasm shown in communities that pursued the opportunity to establish them.[41]

Musher's approach to the centrality of the CACs within the FAP supports an extensive consideration of the impact this program had in Black communities. She looks carefully at the implications of race in the planning and realization of the CACs, weighing official project rhetoric against actual operating conditions. While many communities celebrated the civic and social implications of the CACs, African American leaders, she notes, saw equal access to these programs as a civil rights issue. Musher is also attuned to pitfalls in official project rhetoric with respect to race. The CACs placed a great deal of emphasis on the education programs' capacity to tap into the naïve artistic impulses of children, which was seen as a way of restoring what had been lost to the inhibitions of adulthood and the damage of industrialization. But, as Musher points out, when speaking about encouraging creativity in Negro children, FAP officials reinforced primitivist stereotypes by advancing ideas about instinctive creativity and paid insufficient attention to structural and societal issues that impeded the development of professional Black artists.

There were bound to be challenges with an organizational structure that hoped to support artists without discriminating but had to operate in communities that took segregation for granted. While previous historians have identified this problem, Musher gives it a nuanced analysis. The CACs "attempted to expand creative opportunities for racial and ethnic minorities," she notes, "while simultaneously reinforcing race-based distinctions and hierarchies in the art world."[42] Musher is aware of the unique conditions that Black artists and communities confronted in the FAP, but she is also careful not to overstate the implications of separatism. In a fulsome account of the HCAC, the best known of the Negro-identified CACs, Musher acknowledges its unique origins but does not detach it from centers established in nonminority communities. She presents the HCAC, located at the heart of an urban Black community, as the successful realization of project goals overall; it was an achievement that existed not in isolation but as the very embodiment of the project's goals and values throughout the nation.

Saab concludes *For the Millions* with a discussion of the transition at the end of the decade from experiencing art to acquiring it. Democratization

creates new markets, she argues, and learning about art becomes learning about what to buy. The role of the FAP in the promotion of consumption to an expanded audience for art has become an important theme in recent New Deal cultural histories. In *The Federal Art Project and the Creation of Middlebrow Culture*, Victoria Grieve explores this theme, focusing on FAP contributions to the consolidation of middlebrow culture in the 1930s. Cahill's project of providing ordinary citizens with wider access to the arts did not require the outright rejection of highbrow culture but rather its transformation into something more inherently populist. Both the CACs and the Index of American Design became key elements in the ascendance of middlebrow culture by connecting the creation, access, and appreciation of art to the so-called common man through nonelite and widely available education.[43]

Grieve asserts that the creation of middlebrow consumers was intrinsic to the FAP's agenda from the start. Cahill believed that expanded participation in the arts would have great social and cultural value. But he also expected that this would ideally lead to the impulse to purchase among people otherwise alienated from the notion of owning art. The cultivation of middlebrow audiences through the CACs was crucial to the process whereby ordinary Americans, having been encouraged to participate in and value the arts, would ultimately replace the federal government as the primary patron of American artists. There is not much discussion of race in her study, but Grieve's emphasis on the commercial aspirations of the projects has important implications for the African American community and its artists. This is especially relevant given the significance she assigns in her conclusion to the disrespect shown to middlebrow culture in the 1940s, as the FAP succumbed both to political pressure and aesthetic contempt.

By focusing on expanded education and appreciation as mechanisms that fueled an emerging market for accessible art, these scholars collectively suggest that perhaps the most transformative aspect of New Deal cultural programming was the creation of a new audience. Isadora Helfgott argues that this impulse to bring art to the people served multiple agendas and was not the exclusive province of the federal art projects. In *Framing the Audience: Art and the Politics of Culture in the United States, 1929–1945*, she argues that New Deal historians have tended to understand the rise and fall of the projects primarily as a case study in the politics of government support for the arts. As a result, they have become isolated from other interested groups

with similar strategies for raising the profile of the arts and employing them as agents of change.[44]

There were many stakeholders, both progressive and conservative, in this movement to democratize art by changing its relationship to audiences and patronage systems; some embraced populism in the service of social change and others as a way to maintain the status quo. Traveling art exhibitions figure prominently in Helfgott's study as agents that expanded exposure to the arts across class and geographic lines. Specifically, she discusses the programs of the American Federation of Arts (AFA), College Art Association (CAA), MoMA, and the HF, examining them in terms of the cultural and political agendas they served. The objectives of these various traveling exhibitions ranged from the desire to encourage a new consumer base for the purchase of American art (AFA and CAA) to popular acceptance of modernist aesthetics (MoMA). Helfgott understands the objectives of the HF, an organization dedicated to the promotion of Black artists, as implicitly political. Its goal, she maintains, was to improve race relations and, like left-leaning artists, it enlisted art in the service of a social ideal.

The inclusion of the Harmon Foundation in Helfgott's analysis provides an opportunity to rethink the impact of an organization that over time has endured close and not always favorable scrutiny of its legacy.[45] The HF as an entity is rarely considered outside the scope of African American art history, but Helfgott includes it as part of an overall trend to erode elitism in the art world and encourage the development of wider audiences for art. This is an interesting argument, which, like Saab's, Musher's, and to a certain extent Harris's, advances the idea that what was happening in the African American community was not an isolated phenomenon but rather emblematic of larger cultural and ideological forces.

Helfgott reasonably concludes that these efforts to expand audiences, whatever their intent or origins, were in the main viewed by artists as being of limited or mixed value. This was especially true after the projects ended and the art world once again fell back on the traditional agents who circulated art and prompted its consumption: galleries, museums, and elite patrons. Be that as it may, in the decade after Harris moved the concept of social utility, and the creation of CACs, to the center in accounting for FAP ideology and its goals, historians expanded this discussion in ways that made it possible to argue that the community-based educational mission

was perhaps the FAP's most enduring legacy. This position stands in sharp contrast to the work of earlier generations, irrespective of race, for whom participation in the New Deal art projects, and its impact on the career development of professional artists, was central to perceptions of their import and success.

Participation

In 1972, Francis O'Connor published *The New Deal Art Projects: An Anthology of Memoirs*, a collection of commissioned essays that were meant to provide background material for the 1968 report he had prepared summarizing his initial research on federal support of the visual arts. He intended these essays to assist in reconciling the memories of individuals connected to the New York City projects with the documents and data he was uncovering.[1] The authors wrote about specific roles they had played, and they participated in a panel convened to discuss them. This initiative became the first serious attempt to give the projects meaning beyond their simple relief function. We learn from this anthology how artists navigated the complex network of personnel and regulations associated with each project, about activism and its impact on the era, about administrative oversight and the management of resources, about the collective spirit that made participation such a unique experience, and about the attention brought to the artists' achievements by exhibitions. But we learn almost nothing about African American artists and their engagement with these things, beyond a few references to individuals who participated in high-profile events such as the American Artists' Congress.

O'Connor recognized that lack of insight into the Black community within the emerging narrative about the New Deal art projects was glaringly

obvious and he understood it as a problem. This was a matter of both neglect and lack of coherent data. The FAP was a relentless bureaucratic machine, routinely soliciting information, issuing public statements, and generating a steady barrage of administrative reports. It aggressively pursued documentation from state and regional directors regarding project development and participation, including monthly accounts of class attendance at CACs and gallery exhibitions. Holger Cahill and his staff were intent on rapid implementation and expansion; they sought to demonstrate the merits of their ideas through a kind of obsessive attention to numbers that reflected organizational success. But internal FAP planning documents suggest that there was often tension between the official proclamations of the FAP and the very real logistical challenges it faced in living up to its ideals. Outreach to the African American community was sporadic, and, like all aspects of the FAP, participation and program records are dispersed and not easily aggregated for purposes of analysis.

Because Black artists were largely overlooked as standard histories of the programs were being written, the task of tracking and sorting relevant data on their participation has been an ongoing challenge. The O'Connor Papers include various categories of data and some General Services Administration employment records that identify project assignments and dates. This material has been widely used to document the activities of a core group of approximately thirty Black artists whose involvement in the projects was well known. Early histories that relied heavily on O'Connor's original research were skewed to the New York metropolitan area, where the ratio of Black participation was higher than the national average. But the record has since grown through other kinds of documents, including the archives of individuals like Alain Locke, who interacted frequently with project administrators, and of organizations such as the HF and the HAG. This expanded body of evidence suggests a level of national participation significantly higher than original estimates.

CLASSIFICATION AND PARTICIPATION

Economic relief for unemployed arts professionals during the Depression took various forms, from financing art made to adorn public spaces to direct support of artists who worked in their studios or taught in educational programs. African American artists were represented in all the New Deal art

projects, albeit in varying degrees. They received limited support from the Public Works of Art Project, which ran as a kind of pilot national program from December 1933 to May 1934. Their overall participation was also very low in the Treasury Department's Section of Fine Arts, which became known as the Section and which started in October 1934 in the wake of the PWAP and continued into the early 1940s. Both the PWAP and the Section were competitive programs run by the Treasury Department that did not necessarily draw artists from the relief rolls. Treasury also ran a program called TRAP in which some Black artists found employment. Like the Section, TRAP was a program designed to create murals and sculpture for public buildings, but it was subject to different rules in that a percentage of the artists employed had to be certified for relief.

Although nominally a relief program, the PWAP sought out artists who already had a reputation and compensated them accordingly. The program was organized geographically, with direction provided by people involved enough in the local art scenes to know area artists. Regional committees were formed to identify sites that would receive PWAP works. The PWAP in New York was administered by Juliana Force, director of the newly established Whitney Museum, who had a strained relationship with the artists in need of relief. In keeping with the overall philosophy of the program, she and her advisors were strict on the issue of qualifications. Numerous New Deal historians have noted that the level of selectivity became a concern for artists who were in dire financial need but unable to participate; they especially objected to the fact that the PWAP hired fewer artists than the funding allocation would have supported.[2]

While the overall numbers were low, more African American artists benefited from the PWAP than has been previously recognized. Of the roughly thirty-five hundred artists employed by the PWAP, approximately twenty were African American. The greatest concentration was from the New York metropolitan area, which included New Jersey and metro Connecticut (six), followed by Illinois (four), the District of Columbia (two), and California (two). Six states had a single participant.[3] The Philadelphia artist Samuel Brown enjoyed special status within this group and was frequently mentioned by government officials eager to promote the idea that Black artists might achieve genuine success with federal support. His work drew the attention of Eleanor Roosevelt, and he was one of the few Black artists included in several national exhibitions organized to promote this

project. Fiske Kimball, the director of the Philadelphia Museum of Art, who headed up the PWAP in that district, communicated to the HF that Brown had been chosen solely on the basis of his work, noting that his racial identity and past involvement with the organization were unknown to those who had made the selection.[4]

Of the New Deal art programs, the highest level of African American participation can be found in the FAP of the WPA, launched in the late summer of 1935 and operating until 1943, with several administrative changes along the way. There are multiple reasons why Black applicants who might have been overlooked by the PWAP fared better in the FAP, not least of which is that the latter was a relief-driven rather than a professional status–driven project. The WPA required that 90 percent of its participants qualify for relief. Initially, 75 percent of FAP employees were designated "relief" and 25 percent "nonrelief." This exemption for the employment of artists in the latter category allowed the FAP to keep promising artists on the projects when they ceased to qualify for relief. It was also used in the South, where there were fewer artists eligible to run the programs.

Individuals assigned to the FAP had to first qualify for relief, which involved completing forms, broadly applicable within the WPA, that provided information about their personal circumstances. For consideration as participants in the FAP creative projects specifically, they were asked for details about their professional credentials, such as evidence of relevant education, past employment, exhibition histories, formal reviews, and gallery representation.[5] Historians have consistently noted that the FAP was structured to accommodate as many artists and arts professionals as possible within a wide range of qualifications and expertise. Guidelines stated that ability and skill classification should be determined both by the information applicants provided and by the quality of work submitted. Major consideration was also given to the presumed ability of the individual to perform the work assigned.[6]

Applicants were assigned one of four designations: professional and technical, skilled, intermediate, and unskilled. Supervisors, and those entrusted with the training of others, were chosen from the professional classification; these were experienced artists who could be expected to work independently and produce at the highest level of excellence. This category also included accomplished teachers, lecturers, and those involved in research on the arts. Skilled artists denoted a lower level of achievement but still of recognized

merit. They were qualified to work in all FAP divisions under supervision, and in certain conditions might be able to work on their own projects. The intermediate classification applied to craftsmen and apprentices who required direct supervision and guidance. An individual in the unskilled category could be assigned supporting roles, such as gallery assistant and office personnel, that did not involve the production of artworks.

These skill ratings were used to create employment in the basic categories that made up the bulk of the projects: fine arts (what became known as the creative projects), practical and applied arts, educational services, and technical or supervisory personnel. Within this overall structure, artists could be assigned to easel painting (including graphic arts), mural painting, sculpture, applied arts (including posters and signs), arts and crafts, photography, lectures, criticism and research, circulating exhibitions, art teaching, and other miscellaneous art services. Efforts to better understand the arts and establish their value in the daily life of citizens were approached through programs rooted in education, community service, and research. Signature programs that emerged from this overall structure, such as the Index of American Design and the CACs, developed their own identities as vehicles strongly linked with the populist and democratic ideals underlying the program overall.

Cahill sought to create a system in which recognized ability came to the top and others less accomplished could be employed in socially constructive ways. The elite creative projects, such as easel painting, mural painting, and sculpture, required professional credentials; that is, individuals assigned to these projects had to prove that they were already artists. Skill classification was about demonstrated achievement and the capacity for future work, and the latter seems to have been predicated on the former. In theory, the FAP did not discriminate on the basis of race. But in practice, because Black artists had historically been denied access to the mechanisms that conferred professional status, they were at a significant disadvantage within this process, especially on the creative projects. Organizations like the HF worked to combat this by collecting and making available relevant information about artists who had participated in its annual shows, which traveled all over the country. But Bearden and Henderson pointed out that government administrators' relative ignorance regarding African American art, combined with the artists' lack of formal credentials, threatened to drastically undercut the participation levels even in the relief-driven FAP.

The top classifications of professional and skilled could also lead to the applicants' employment as art educators, where the credentialing process was less restrictive. Audrey McMahon, who ran the New York City FAP, claimed that it was often a challenge to get artists to accept teaching positions because they were perceived as demanding assignments. The creative projects allowed artists simply to work in their studios, but those who took positions as teachers struggled to do their own work on the side. Teachers were recruited from unemployed artists who had relevant experience and from practicing artists who could not "make" the creative bracket. While McMahon personally valued the contributions of teachers, she noted that because the FAP seemed to favor workers in the creative projects, it was considered a promotion to transfer there from the educational programs.[7]

Some individuals were identified as being an especially good fit for teaching roles because of their personalities or long-standing commitment to the educational mission. As director of the CAA, McMahon had been involved early on in administering relief programs for artists. Before coming to the FAP, she had worked with organizations focused on African American art, such as the HF and various educational arts initiatives in Harlem. Thus many Black artist-teachers were known to her already when the FAP got under way. In her view, the teaching programs were the natural heir to earlier workshop activity sponsored by the CAA in collaboration with settlement houses and adult education programs, the goal of which was not to create artists but to foster creative expression and the appreciation of art. By the end of the decade, African American participation numbers in New York City were closely tied to the HCAC, which had become the hub of artistic activity in the Black community.

The disproportionate emphasis on the primacy of educational rather than creative work in the Black community is mirrored in O'Connor's retrospective compilation *Art for the Millions: Essays from the 1930s by Artists and Administrators of the WPA Federal Art Project*. The anthology contains four contributions by African Americans, one in the section on art teaching and three on the CACs, leaving the impression that Black artists were important largely in the context of these community-based projects, three of which were in the South. In his introduction, O'Connor notes that Black artists were heavily disadvantaged during the Depression, and he applauds the efforts of artist-educators who attempted to "spread cultural democracy

to even the least regarded citizens," providing them with equality "insofar as the social conventions of the 1930s permitted."[8]

FAP STATEMENTS ON RACE

A few key documents have been used consistently in the literature to establish the FAP approach to race and its understanding of the impact it was having in the African American community. Of these, the transcript of a talk given by FAP administrator Thomas Parker at Tuskegee Institute in July 1938 has particular significance. While it cannot be said to reflect a philosophy of race per se, Parker's speech is an important framing document that provides insight into how project administrators understood their relationship to the potential development of African American art. His Tuskegee observations overlap sufficiently with other scattered statements about African Americans and the projects to confirm its status as a kind of official statement on race. Parker delivered these remarks at the invitation of the American Teachers Association, an organization of Black educators founded at Tuskegee.[9] The context was a meeting in which Negro youth examined various occupations in America. Parker was recommended to the program organizers by W. N. Buckner, the chair of the Art Department at North Carolina College for Negroes, and called his talk "The Negro in the Arts."[10]

Scholars of the New Deal art programs make frequent reference to this talk, which, they note, includes statements that in retrospect may strike readers as misleading, naïve, and at times stereotypical. Parker leads, for example, with the familiar characterization of "the Negro" as "instinctively an artist" whose cultural production "has always been attuned to the rhythmic expression of a people deeply sensitive to the poetic values of life." In comparison to Black writers and individuals involved with music, the Negro visual artist has "lost the naturalness and direct appeal characteristic of his expressions in the other arts." African art is much admired today for its powerful form and expression, but the "vitality of this native tradition was lost in America." The writings of Alain Locke clearly inform these statements, in particular Locke's assertions that African art was characterized by originality that manifested itself in disciplined, powerful form, and that Black artists paid a price for seeking to master academic conventions rather than exploiting their own racial artistic heritage.

The introduction is followed by a lengthy discussion of Black partic-
ipation in the various divisions of Federal One, namely, music, theater,
and writing. Parker made a point of noting the range of genres in which
Black composers and performers had been engaged; they had not been
restricted to racially specific forms of expression or racial content but were
also involved in classical opera and theater. While he was clearly more
enthusiastic about initiatives that seemed to have some direct connection
with race, such as folk songs, spirituals, and the much-celebrated theatrical
productions focused on racial dramas, Parker insisted that they were in no
way required. Regarding the Federal Writers' Project, he noted the contri-
butions of Black authors, especially in the South, to the American Guide
Series, a collection of state guides commissioned by the FAP, and described
Sterling A. Brown's important role as the Writers' Project editor for Negro
affairs. Prominent Black writers employed by the projects were mentioned
by name, including Richard Wright and Claude McKay in New York and
Zora Neale Hurston in Florida. These participants, Parker claimed, were
laying the groundwork for future historical studies of African American life.

Turning to the Federal Art Project, Parker identified efforts on behalf
of Black Americans as twofold: support for community-based educational
programs and support for creative work by visual artists. The FAP had
given African Americans new opportunities to reverse negative trends and
in so doing to "realize their vital role" in the fabric of the nation's culture.
Through classes and exposure to exhibitions, a foundation was being laid
for the development of future talent and new audiences were being created.
He mentioned Negro galleries and centers in North Carolina, Florida, and
Virginia and plans for a similar enterprise in Tennessee. This work was coor-
dinated with numerous art teaching centers, and its basic philosophy was
consistent with that of programs established across the country—namely,
to relate art "to the everyday life of the people." Having positioned these
educational initiatives as part of a larger national platform, Parker addressed
details specific to the Negro centers, such as local supporters and affili-
ations, leadership, and attendance figures, giving special emphasis to the
HCAC as one of the best-equipped centers in New York, with a large and
distinguished staff of artists and teachers.

To underscore achievements in supporting the creative work of visual
artists, Parker described the participation of talented Black easel and mural
painters in the creative projects, noting milestones such as Charles Alston's

Harlem Hospital design, the first mural ever exhibited by an African American artist at MoMA.[11] Other artists mentioned by name were Samuel Brown, Allan Crite, Charles Sebree, Charles Sallée Jr., the late Earle Richardson, Dox Thrash, Palmer Hayden, Sarah Murrell, and John Lutz. A line or two about their specific works or notable achievements accompany some of these references, but in the main it is a roll call. Parker concluded the Tuskegee address by speaking about hope for the future, referring to "great possibilities for the development and stimulation of hitherto insufficiently recognized abilities which promise significant value in our national culture." This statement reflects the commonly held view that the FAP had created both opportunity for Black artists and a place for them in the narrative of American culture.

Parker's approach in the Tuskegee talk to promoting African American participation in the FAP is consistent with other public addresses and internal documents on this issue. The list of artists on the projects was adjusted according to context; specialized reports, for example, might focus on participation by medium or region. But FAP administrators tended to run these initiatives together in the interest of projecting an image of collective and sustained support for the arts within Black communities. The goal was to create a narrative of progress through expanding numbers; data on the employment of artists merged with African American community participation, although these things represented very different kinds of individual engagement. The FAP ascribed to itself a central role in creating a supportive environment in which these artists could thrive, the result being a portrait of great strides being made in the development of Negro art. FAP administrators' eagerness to promote the opportunities they offered Black artists sometimes resulted in exaggerated claims. Among the talents who they alleged had "come forward" in this context, for example, were numerous artists whose names would have been recognizable to anyone who had followed the Harmon Foundation Negro art shows since the 1920s. But these official statements also emphasized that African American artists now had, for possibly the first time, an opportunity to realize their vital role in "seeking to integrate the fabric of our national culture pattern."

Parker spoke often about the CAC program and its place in the broad vision of the FAP, and the Tuskegee talk is best understood in this context. His comments on the impact of the educational program are wholly consistent with director Holger Cahill's vision of the crucial role assigned to the

development of CACs in realizing the mission of the FAP. In a talk delivered to the People's Art Center Association in St. Louis in May 1941, Cahill noted that the challenges faced by Black artists were more difficult in scale but tracked closely with the problems all artists faced in America. They suffered from lack of support and the declining role of the arts in community life. Creating opportunities for self-expression, therefore, must take place in the context of encouraging interest in art within previously underserved communities. Like all artists, Cahill said, "the Negro artist cannot express the soul of his people in isolation from it. The Negro people cannot produce artists unless it is given opportunities to share in a democratic way in the experience of art."[12] The CACs were expected to play a vital role in nurturing future talent and creating an audience; for Cahill, these functions were inextricable.

COMMUNITY ART CENTERS

There is wide agreement among historians regarding the importance of community art centers in Cahill's vision of a more democratic approach to the creation and consumption of art in America. The CACs were to become major agents of change that could simultaneously tap into the native creativity latent in ordinary citizens and expand interest in the arts through widening access. In so doing, they would revitalize culture by instilling pride in local and regional traditions lost to industrialization, modernity, and the values of the elitist art world. In addition to restoring cultural health and fostering a positive environment for the future development of American art, CACs were expected to fulfill practical functions, such as providing youth with productive activities and emotional outlets in the interest of stemming delinquency and civil unrest. Unemployed artist-teachers who worked in these centers were allowed to remain active in their professions and to acquire new skills. Artists who had never taught learned to employ their talents in the interest of the social good, thus lessening the distance between themselves and the communities that might support them.[13]

A great deal was expected of these centers; they were called upon to contribute in multiple ways to a complex national agenda. In public and internal reports, the FAP made ambitious claims about growing interest in the arts as measured by the extent of local support and interest in the centers. Their educational function was easily assessed by tracking the number

of classes offered and attendance statistics. But given the burden of larger expectations and the varied conditions under which CACs operated, metrics of success necessarily remained ambiguous and fluid. McKinzie observed that despite the bureaucracy and unified rhetoric that character-ized many of the FAP divisions, the CACs did not have much in common. The job of their directors was not to impose uniform standards but rather to adapt to the communities they served. Grieve has similarly noted that there was a certain amount of decentralization in the CACs; local interests and energy were meant to take precedence over prescriptive directions from the national office. The CACs were nationally defined but locally determined, or, as Lisanne Gibson argues, they were negotiated sites whose potential role in the participatory cultural democracy the FAP envisioned was inev-itably tied to specific circumstances and operational logic.[14]

Any assessment of the impact of these community-based art programs on the African American population must account for the distinction between what were called "Negro extension galleries" and independent CACs in large urban areas developed to serve Black residents. The Harlem CAC achieved the highest profile within the landscape of FAP initiatives focused specifically on creating opportunities for African Americans. Although the HCAC technically came into being as an educational project whose mission aligned with similar initiatives nationwide, historians have acknowledged that it became an important training ground for a generation of Black creative artists with professional aspirations. This arrangement begs the question of how effectively the organizational structure of the FAP could respond to the differing needs and conditions of specific communities. The HCAC functioned simultaneously as a laboratory for emerging artists and an instrument of art education for the public. This complex identity required constant negotiation between emphasis on community participa-tion and emphasis on developing artists, a balancing act that threatened to undermine the importance of amateur engagement, which was a hallmark of CAC programming.

Before the opening of the HCAC in December 1937, significant efforts had been made to extend the benefits of the FAP to Black communities in the South. As specified in an operating manual for CACs, "In cities where there are large community groups which find it difficult to avail them-selves of the opportunities offered by the main art center, branch art centers designed to meet the special needs of these groups may be set up,

provided adequate quarters can be obtained without additional expense to the Federal government."[15] Extension or branch galleries were established for various population groups under this provision; they were sometimes opened simply to accommodate smaller communities in the general geographic area. In the case of Negro extensions, they were created to provide opportunities for members of Black communities, large and small, that lived under strictly enforced conditions of segregation. This is very different from the HCAC, the South Side CAC in Chicago, and the People's Art Center of St. Louis, all of which were established as autonomous organizations that, while serving large minority populations, were technically not defined solely by race separation. Many Negro extension galleries and centers partnered with local educational or social welfare organizations, including historically black colleges and universities (HBCUs), Black high schools, the YMCA, housing developments, and community centers that ministered to the poor.

Study of the initiatives within the FAP formed to serve southern Blacks presents a specific set of challenges. A fair amount of confusion was created simply by the FAP's changing terminology. For example, in the early months, program administrators referred to experimental art galleries, demonstration galleries, federal art galleries, and community art centers. Although these were nominally separate concerns with varied purposes, reports and correspondence often used them interchangeably. Facilities with overlapping functions developed for Black populations in the South were called alternately "Federal Art Galleries (Negro Unit)," "Federal Negro Art Galleries," and "Negro extension galleries." Internal reports diverge widely in their accounts of basic information and evolving governance. What is consistently true across documents and locations, however, is that efforts on behalf of the southern Black population were regarded as "extensions" of centers operating for the majority population.[16]

The initial focus on the South in the CAC initiative reflected the FAP administrative position that this part of the country was a cultural wasteland.[17] The FAP reasoned that because very few artists in the South were able to avail themselves of the creative divisions, most would be better suited to other sorts of educational work involving closer supervision. Arts activity, such as it was, often consisted of small, independent organizations driven by private enthusiasms. Parker reported to Cahill in November 1935 that rapid progress could not be expected in the South. FAP administrators

found it difficult to work with organizations that were sometimes resentful of outside efforts to coordinate energy and support for the arts through government sponsorship. "The strong provincialism which prevails throughout the entire South," Parker wrote, "must be broken down before any art program of a statewide nature will meet with any success."[18]

The FAP also struggled to address the challenges of working with communities that were both culturally backward and strictly segregated. Early in 1936, Parker noted the problem of reaching Black communities, writing, "Because of the race question I have suggested ... that extension divisions or galleries be set up to take care of this population. There is a definite need and real demand for these units."[19] The CAC program was launched with the establishment of a facility in Raleigh, North Carolina, in December 1935; by May 1936, a Negro extension gallery was operating at nearby HBCU Shaw University. In Florida, programs were launched in Jacksonville, Miami, and St. Petersburg only a few short months before the first Negro unit was opened in Jacksonville, with others to follow. Between 1936 and 1941, CACs were also set up in Virginia, Tennessee, Oklahoma, and South Carolina, and related educational programming was offered in Georgia, Alabama, and Louisiana. In most of these locations, the rule of segregation was accommodated by making alternative opportunities available for the Black population.

Numerous historians have noted the well-documented tensions that resulted from efforts to make Black artists associated with the urban CACs available as instructors in southern Negro extension galleries through what was called the "artist loan program," designed to provide staffing for CACs in areas where a critical shortage of professional artists slowed progress.[20] As Musher explains, CACs were encouraged to avoid controversy, but this was especially challenging when loan artists became hostile to the circumstances in which they found themselves. This included the West as well as the rural South and could take the form of distaste in conservative areas for certain artistic practices, from modernism to the use of nude models, or of racial and ethnic discrimination. Jewish applicants were sometimes rejected out of hand by communities in the West that expressed discomfort with what they viewed as left-wing and bohemian behavior in the urban artists assigned to work there. African American artists who went to work in the South, coming from urban centers where they had established mechanisms for advocating on their own behalf, could be put off by the kind of negative

racial stereotypes that were commonplace in rural areas. In some cases, they were also unsympathetic to the behavior of local Black residents and reluctant to become part of their community.

Such difficulties emerged in part because of the impulse to view African Americans in monolithic terms. Reminiscences of Black artists associated with these initiatives underscore the differences between them. In *Art for the Millions*, four Black artists employed by FAP educational programs offered observations about their respective experiences. Lawrence Jones, who had studied at the Art Institute of Chicago and worked briefly for Dillard University, was hired as an art teacher in the New Orleans FAP. This seems to have been strictly an art education project without a formal extension gallery program. Jones conveyed in very positive terms how this experience awakened in him a sense of social responsibility as an artist. "Believing as I do that the appreciation of art cultivates in man a sincere regard for the contributions of his fellow men, regardless of race or creed," he wrote, "I am trying through my own painting and art teaching to create a more democratic America."[21] Speaking as a Black artist and citizen, Jones praised the FAP in New Orleans for its positive impact on the community and on the development of artists, and expressed great satisfaction in knowing that his work was making an essential contribution to the cultural advancement of the Negro.

Vertis Hayes became the director of a CAC established in collaboration with LeMoyne College, an HBCU in Memphis; he described the center as a "strategic outpost" serving neighboring Black populations, not only in Tennessee but also in Arkansas and Mississippi. Hayes went to Memphis after launching his career as an artist in New York City, where he had worked on the controversial Harlem Hospital mural project. His remarks were prefaced by a brief account of the expansion of arts activity in Harlem, including a special nod to the HCAC, which he described as meeting a long-neglected need for arts experience in the community. Like Jones, Hayes saw the FAP as a positive force in the development of African American artists, citing its impact on younger artists who were moving away from the sentimental approaches to Black subjects that had characterized past art. Not surprisingly, he quoted Alain Locke, whose writings in the late 1930s consistently linked FAP support to the emergent vitality and confidence among African American artists. Hayes also discussed the institutional challenges Black artists faced, noting that they were routinely denied the opportunity to

exhibit despite the existence of numerous commercial galleries in the large metropolitan areas where they lived. They confronted both poor understanding in their own communities and limited opportunities to participate in the progressive art movements of their time. Hayes praised FAP efforts to increase opportunities for Black citizens to learn about art, an experience denied them even in cities where museums were supported by their tax dollars.[22]

In her essay in the *Art for the Millions* anthology, New York–based artist Gwendolyn Bennett explained how the HCAC came about, making it clear that the center was the outgrowth of initiatives that predated the FAP. Art workshop instruction and all-Negro exhibitions had been happening in Harlem for a while; Black citizens and activist groups lobbied the FAP for their support to ensure continuity and expansion. In effect, the HCAC came into being because classes were *already* organized in various places in Harlem and operating at capacity, obviating the need for a place where artists could continue to study free of charge and where instruction might also be made available to the larger public. Bennett became the center's second director, after Augusta Savage received a commission to do a piece for the 1939 World's Fair in Queens, New York. Like Savage, she was also an active member of the HAG, serving as an officer in the late 1930s. Bennett described the scope of the center's programing, stressing attendance and participation statistics as well as its many distinguished visitors, who included Paul Robeson, Albert Einstein, and Eleanor Roosevelt.[23]

A very different landscape is described by Harry Sutton, who directed the so-called Negro unit in Florida. While Bennett reported with pride on the collective excitement, well-attended programs, and legions of international visitors, Sutton emphasized the challenges of establishing a CAC in a poverty-stricken community with a dearth of visual artists and little prior exposure to art. The Jacksonville Negro Federal Gallery predated the HCAC by more than a year, and Sutton regarded it as a pioneering venture. Like Bennett, he was proud of its programs and enthusiastic about its future; unlike her, he emphasized the center's connection to a social welfare organization located in a high-crime neighborhood serving a largely underprivileged population. Accounts of the HCAC, especially from those associated with it, tended to stress its relationship to the well-organized efforts of extant civic and artistic advocacy groups. Sutton poignantly described the remarkable receptiveness to the center of this unsophisticated

community that now looked to it for leadership and depended on its guidance.[24] These differences capture not only the demographic realties of Jacksonville and Harlem but also the varied identities associated with a fully independent CAC established in an urban area already associated with Black artistic achievement, and one that operated as an extension program attached to a center designed to benefit the majority population.

The establishment of Negro extension programs became a source of pride for the FAP; they were promoted through speeches like Parker's Tuskegee address and press releases intended to familiarize the public with their initiatives. The latter were sometimes picked up by the national Black press, which conveyed basic information about these activities to a wide readership. A WPA release of 31 December 1937, titled "Art Project Opens Negro Extension Galleries," described several art centers in the South and also referred to work being done by notable Black artists employed by the FAP. As in Parker's address, community-based initiatives were merged with accounts of participation in the creative projects.[25] In January 1938, several African American newspapers reported on the content of this release, including attendance figures at programs operating in specific locations. The highest level of detail was provided about extension centers in North Carolina and Florida, which at the time the FAP regarded as signature achievements.[26]

North Carolina

North Carolina served as a testing ground for the community outreach model being developed by the FAP. As the North Carolina state director, Daniel Defenbacher established the first experimental art galleries; he went on to become regional director for the Southeast and eventually assistant to the national director responsible for community art centers. The fact that North Carolina had a sizeable African American population ensured that race would become a significant issue if the success of these programs was to be measured in terms of broad accessibility. Unlike the creative projects, which were at least nominally race-blind, regional CACs had to develop strategies for accommodating populations that could be denied participation as a matter of design. This was a fundamental assumption in the South, recognized early on by FAP administrators, who did not question that these lines would be drawn but rather sought ways to redress the resulting imbalances. By December 1935, experimental art galleries and art centers

were operating in Raleigh and Asheville, and a third was being planned for Winston-Salem. Shortly thereafter, Parker began to reference the need to reach the Black populations in these areas by establishing extension centers.

The Raleigh Art Center, opened in December 1935, was the first FAP-supported community art center in the country. An extension gallery established for the Black community in Raleigh opened the following May, also the first of its kind. In support of the extension gallery, administrators noted that Raleigh had a large Black population and two Black colleges without art departments. Shaw University provided the initial space in the reading room of its library and also contributed a classroom. The extension center was open to the general public and had its own staff, supplemented and supervised by the Raleigh Art Center. Reports emphasized that the extension gallery would host the same exhibitions that were seen in the main gallery, with the addition of specialized shows on Negro art.[27] In January 1937 the center relocated to St. Augustine's College, the other HBCU in Raleigh. Two additional Raleigh extension centers were subsequently opened, one at Washington High School and the other at Crosby-Garfield School (fig. 1).[28]

A similar pattern was followed in Greensboro, where a federal art gallery was established in July 1936, followed by a Negro extension in late September. The latter was undertaken in partnership with Bennett College, a higher-educational institution for women in Greensboro. The basement of the Carnegie Library at Bennett became a studio space, and exhibitions were displayed in the Carrie Barge Chapel. In anticipation of the center's opening, Defenbacher reached out to Edith Halpert, then exhibition director for the FAP, in the hope of securing a show of Negro art. A response came directly from Cahill, who claimed that, owing to the small number of African American artists in the projects, it would be impossible to put together an adequate exhibition on short notice. Some of the best examples were included in the *New Horizons* exhibition, he noted, but these would not immediately be available as the show was touring the country. Cahill offered to reach out to states that might be able to furnish works by the same artists and others, but because this would take time, he suggested delaying the show for a few months.[29]

The Greensboro and Raleigh extension galleries have been well documented in the literature as test cases for the FAP's "loan program." Specifically, scholars note the circumstances in Raleigh, where Ernest Crichlow

and Sarah Murrell were assigned to teach in the fall of 1938. Murrell, charac-
terized by one administrator as personable, was put off by the local attitudes
toward race she encountered and somewhat uncomfortable with the Black
community itself. Crichlow, who came highly recommended, seems to have
fared better. In correspondence with the North Carolina FAP state admin-
istration, he was described as one of the most competent teachers in the
New York City projects, and it was noted that the administrators hoped to
make him director of an art center at some point.[30]

Although the loan program was meant primarily to supplement staffing
at art centers in Greensboro, administrators also hoped that it might help
ease tensions around the Negro extension gallery that had been brewing
since its inception and had undermined its success. The opening of the
gallery, attended by two hundred people in the community, was noted with
enthusiasm in the local and national press.[31] But despite high hopes for
the partnership with Bennett College, the relationship deteriorated in the
winter of 1936–37. Problems centered initially around observations made
by Bennett president David D. Jones about the poor quality of the exten-
sion program. Bennett had agreed to renovate the basement of the library
for use as a studio art center. An arrangement had been reached wherein
Ben Looney, then director of the Greensboro Art Center, would do regu-
lar critiques with students in both the adult and children's program, and
would lecture once a week.[32] But in a December 1936 letter to Looney, Jones
expressed his opinion that the classes were being neglected and the exhibi-
tions were generally inferior to what was shown in the downtown facility.
Jones indicated that Bennett had upheld its end of agreement and hoped
that the new year would bring a fresh start in terms of strengthening the
vitality of this project.[33]

Looney immediately conveyed Jones's complaints to the state director's
office and assumed a defensive posture that reflected his personal antipathy
for Jones. He claimed to be working on solutions that might satisfy Ben-
nett and insisted that he was doing his best to make the program succeed,
including adding personnel to "teach the classes to these uncouth, dirty,
noisy children." Looney found the whole situation so unpleasant that he
asked to be relieved of further responsibility for the extension gallery lest
he be forced to take action that would reflect badly on the main Greensboro
center, explaining, "I am a Southern born white man and can go just so far
with a Negro of Jones' type."[34] Looney, a native of Louisiana who had spent

time studying and teaching in the Northeast, was no stranger to the African American artists in the community. In a review for the *Greensboro Record* of a Greensboro Art Center exhibition featuring local artists, he noted the participation of two local Black artists, Clinton Taylor and Preston Haygood, in whom he saw great promise.[35] This was a juried show held one month before the Bennett extension opened.

The situation was defused by the assistant state director, Gene Erwin, who told Looney that his full attention would be needed on matters of concern to the main center and that he should remain in his supervisory role at the Bennett extension but cease teaching there. Erwin also wrote to David Jones, expressing his regret that the situation did not meet his satisfaction. Because Looney could no longer spare the time to contribute to the extension gallery, Erwin hoped that classes would carry on with instructors guided by an art teacher from Bennett who was already involved. If this did not resolve the problems, Erwin suggested, it might be necessary to suspend the education program and concentrate on the gallery. He pointed out the success of the extension programs in Raleigh but affirmed that these initiatives had to satisfy both the FAP and the local sponsor. In his summary explanation for Defenbacher, Erwin stressed the importance of keeping Looney away from Bennett and his hope that future criticism of the extension program would be more specific and thus more efficiently resolved.[36]

Later that year, an additional Greensboro extension unit seems to have been established in conjunction with a local African American technical college.[37] Shortly thereafter, Looney left his position at the Greensboro Art Center and was appointed as assistant to Erwin, charged with aiding in the supervision of FAP art centers throughout the state. He was replaced in October 1937 by Frederick Whiteman, an abstract artist and teacher with prior experience working for the FAP in New York City.[38] Under Whiteman, plans were made to expand the staff of the Greensboro Art Center, including adding a Black instructor for the Bennett extension. In September 1938 Whiteman was reported to be interviewing prospective candidates in New York City.[39] Bennett was finally able to host an exhibition of contemporary Negro art, organized by the FAP, in early October 1938, which was noted favorably in the local press.[40]

But things again took a negative turn in the late fall when Erwin fielded further criticisms about the Bennett Negro extension gallery. This time, they originated with a prominent African American who had undertaken a

survey of galleries and art centers in the state and expressed concerns to the regional FAP director regarding the gallery's location at Bennett. The investigator argued that it was inaccessible to the general population, especially because the college did very little outreach and staff were poorly trained, the supervisor unfit, and the exhibitions not properly presented. This so-called "informant" genuinely believed that there must be skilled personnel in the area who could do a better job. He felt that the center would provide far better service to the community if it was informed of the problems so that the FAP could make the necessary adjustments.[41]

Erwin replied that he and his colleagues had felt for some time that the Greensboro extension center was not living up to its potential, lacking both adequate sponsorship and supervision. Things had improved under the new director of the main Greensboro gallery, but the personnel problem remained. Erwin claimed that the staff consisted of the best available, indicating that there might be well-trained African Americans suitable for this work but they did not have relief status. In cases like this, requests were often made to hire nonrelief personnel in supervisory roles, but because the number of supervisors was strictly limited, and because they were needed in the main art centers, it was not possible for him to employ noncertified Black workers. He expressed his hope that the artists recently acquired from New York City through the loan program might improve things.[42]

Rex Goreleigh and Norman Lewis had arrived in Greensboro several days earlier; Lewis was to teach painting and Goreleigh to both teach and assume directorial responsibilities. Despite Erwin's hopes, the center officially closed in December 1938. Erwin informed Parker that Goreleigh's loan arrangement had been canceled and Lewis had already left of his own accord. Plans were also being made to transfer the three local staff members to another project. In his official report to Parker, Defenbacher stated simply that the Negro extension did not meet FAP approval as an activity associated with the Greensboro Art Center. Cahill seems to have blamed Erwin, who, he claimed, did not have things under control, noting that the situation in Greensboro was close to being a public scandal.[43]

Florida

Florida saw the most ambitious community arts programming in the South, although Parker does not seem to have spent much time there during his fall 1935 field trip to scope out possibilities for FAP initiatives. In November

1935, Eve Alsman Fuller was appointed head of the FAP in Florida, and by February there were so-called demonstration galleries operating in Jacksonville and St. Petersburg. Although details vary, available information confirms the eventual existence of FAP centers in seven regions across the state: St. Petersburg, Jacksonville, Miami, Ocala, Pensacola, Key West, and Tampa. In addition, there were at least eight extension galleries run out of these hubs: two from St. Petersburg, four from Jacksonville, and one each from Tampa and Pensacola.[44] Among these were four designated as extensions serving Black regional residents: the Jacksonville Negro Art Gallery, Pensacola Negro Art Gallery, Jordan Park Negro Exhibition Center (St. Petersburg), and West Tampa Negro Art Gallery. Evidence suggests that some form of segregated arts programming also took place in St. Augustine, Ocala, and Key West. Negro children's classes were being conducted in the Methodist Town neighborhood of St. Petersburg several years before the establishment of the Jordan Park center. There are references to "negro [sic] Saturdays" at the Daytona Beach center and collaboration with faculty from Bethune-Cookman College who guided Black visitors through the college's exhibitions.[45]

Multiple documents refer to initiatives serving Miami's Black community, but they do not present consistent evidence of an extant single extension center. In September 1936 Fuller sent a list of photographs to Parker that included two from what she referred to as the Negro unit in Miami, one a "Negro Life Group" from Miami Federal Art Galleries and the other a "Negro Art Class" at the Negro Welfare Federation in Miami. An update on the Florida projects from about the same time refers to a Negro extension gallery in Miami but does not give a location. A personnel list dated June 1939 mentions a professional teacher in Miami who had done good work with the Negro housing group in Liberty City. In the expanded version of Harry Sutton's contribution to Art for the Millions, he notes that while there were no Negro art centers in Miami, a lecturer was provided for the Black community by the Miami Federal Art Galleries and a federal housing project provided space. And a 1942 retrospective report on the FAP in Florida indicates that some extension work was done with the Negro settlement in the Miami suburb of Lemon City, but no formal center unit developed there.[46]

The Jacksonville Negro extension center opened in June 1936, and one month later the state director communicated to the FAP national office that

the program was so successful it needed additional personnel. The Chicago newspaper *Metropolitan News* reported in November on a symposium attended by citizens of both races from Florida and beyond who agreed that the WPA had achieved the impossible in Jacksonville: the establishment of an all-Negro art gallery in the South.[47] As its statewide prominence grew, the Jacksonville program was touted as a singular and potentially significant achievement: "The development of the Negro unit is one of the basic art ideas in Florida. If it can be handled and supervised for a sufficiently long period under government auspices, it can become, not only an all-Florida unit, but can undoubtedly assert its influence over this section of the South."[48] While hope that the project might eventually serve as a pilot for other states dealing with similarly segregated conditions seems to have been premature, the fact remains that Florida was the only southern state to have what approximated a Negro unit, as opposed to simply extension programming for Negroes. A 1938 report sent to Alain Locke noted that in a two-year time span, the Jacksonville extension gallery achieved widespread community influence, reaching more than 45,000 people, including those who attended classes (10,813), gallery exhibitions (8,057), and other activities.[49]

Jacksonville's success was attributed largely to the abilities of its chief organizer, Harry H. Sutton Jr., who not only ran the Jacksonville extension project but also consulted with people in other areas of the state who were considering initiatives for Black residents. A February 1936 report noted that a small FAP project had been set up for the decoration of the Agricultural and Mechanical College for Negroes in Tallahassee by a young Negro artist. This may have been a reference to Sutton, who studied art there before being employed in 1935 on the WPA general adult education project in Jacksonville. Sutton was reassigned to the FAP in 1936 and became director of the Negro Art Gallery in June. In the fall of 1936, a personnel report on the Florida FAP listed Sutton as a "male artist (colored)" with a "P" classification, which placed him in a professional leadership category (fig. 2).[50]

Looking back on the achievements of the Florida FAP, an official stated that "the abilities of this supervisor—more than any other factor—made for the Negro art experiment in Florida an exceptional record."[51] Eve Fuller regularly reported to the national office on Sutton's activities, praising his enthusiasm and administrative skills. By the end of 1937, Sutton

was overseeing a children's program divided into three distinct groups, adult education classes, and a special workshop that had been requested by African American teachers in the area to better prepare them for arts instruction. In his capacity as director of the Negro unit, he ran the gallery and delivered public lectures on the history of African American art at the center and at Black high schools and colleges in the area.[52] Sutton was much admired by FAP officials, who described him as the "highest type of young, educated, southern Negro ... who has deep feeling and sympathy for his people; for their trials and shortcomings, as well as their talents" (figs. 3 and 4).[53]

Sutton's ambitions for the extension programs were evident from the start and were encouraged, to some extent, by Fuller. Exchanges between Fuller and Thomas Parker suggest that some consideration was being given to establishing the Negro unit as an independent entity, rather than an extension of Jacksonville's FAP gallery. Parker wondered if the best results might be obtained if they functioned autonomously: "would it not be the best procedure to establish this unit as an independent gallery set-up? I believe the Negro population will take a great deal of pride in knowing that this project is definitely their own."[54] Fuller apparently sought clarification on this suggestion, as Parker wrote her several weeks later stating that he was not necessarily recommending this but was seeking her input. It is not clear from this exchange whether Fuller objected to this idea in principle or simply thought it premature. Parker ultimately reassured her that he would follow her lead and trusted that she would confer with the national office when she felt that the gallery was sufficiently organized to operate on its own.[55]

Harry Sutton's brief essay in *Art for the Millions* describes the challenges he faced in seeking to establish an art gallery "for persons who were never exposed to art in any form" in a "Mission building located in the heart of a vice-infested Negro section of Jacksonville" flanked by poolrooms, bars, and cheap hotels on one side and a public high school on the other.[56] The Jacksonville Negro extension gallery was located in the Clara White Mission, a well-known social welfare organization with strong community outreach and support. Clara White was a former slave who for years undertook mission work primarily from her home in Jacksonville. The scope of the mission was greatly expanded under the leadership of her daughter, the celebrated humanitarian Eartha White. In 1932, to accommodate this

growth, Eartha White acquired the property that eventually housed the gallery and became the center for various programs in the African American community supported by the WPA during the Depression, including the Florida Negro unit of the Federal Writers' Project. Space for the gallery was created by repurposing and renovating three rooms of the settlement house that had previously been used to care for transients. White was also the chairman of the Citizens' Sponsoring Committee for the FAP gallery and its primary financial sponsor, covering rent and utilities.[57]

After considerable outreach, Sutton was able to organize a show for the opening of the gallery that featured regional African American artists.[58] It is clear from Sutton's writings that he wanted to position the Jacksonville gallery in a larger context that included Negro art initiatives throughout the country. He sometimes sought to capture the significance and personality of these various projects in evocative language. Plans to open a center in New Orleans, for example, placed this initiative at the origin of historical Negro art: "Here slaves fresh from their homes in Africa, untutored, unbleached, labored in iron, stone and wood. The grills [sic], fences, hitching posts, doorways—depict a valuable example of African art; art that now lay dead. Art for these Negroes to revive. Art buried with the bones and broken bodies of their ancestors. . . . Negro Art has an opportunity to come forth fresh in this new generation, to come forth in art students to live again. Like Negro spirituals of the deep south."[59] Sutton characterized the HCAC, a significant community art center in New York, as an addition to the "hot, rhythmical, hilarious" atmosphere of this city within a city, where artistic culture was celebrated in "the heart of swing and jitterbug."

Sutton also wrote about his philosophy and approach to teaching a population that had little exposure to art and was easily discouraged. His remarks are consistent with those of FAP art educators in general and recall views of teaching art to Black children that emerged in accounts of workshop activity in places such as Harlem prior to the Depression. Like these earlier initiatives, Sutton's words sometimes reflect commonly held stereotypes about innate Black creativity. Teachers, he believed, should not force pupils to imitate them but rather draw on their individual strengths and experiences. When offered such an opportunity, what can be expected is "an art from the depths of their heredity. The art which had been first developed hundreds of years ago by their forefathers lay dormant in their souls only to come forth now at the least encouragement in the triangular

composition in their drawings, in their color combinations of reds, blues and yellows. African fundamental. Negroid heredity. Racial talent" (fig. 5).[60]

Conventional notions of why Black children make art differently from other children were augmented by the more interesting conclusion Sutton reached that what these students created was directly affected by factors in their immediate environment. He noted, for example, that the work produced in the center varied based on the time of day. Morning classes generated images characterized by long lines and strokes that rose gradually, and by colors that got progressively lighter as they moved toward the center of the composition. Afternoon students, in contrast, produced pictures with short, jumpy lines and vivid color that shot upward, expanded, pulsated, and fell back down. Sutton explained these differences in terms of Negro music. In the morning, classes were accompanied by the sound of people in the mission singing Negro spirituals. Conversely, in the afternoon they heard hot swing music emanating from the music store adjacent to the mission. The students, he claimed, kept the rhythm with their feet, and the resulting images showed pencils and brushes in tune with what they were hearing.[61]

In April 1938 Sutton traveled north, apparently at the invitation of the FAP, to visit other projects established for the Black community. This trip coincided with planning for an exhibition in May of art by Negro children at Children's Art Gallery in Washington, DC, where work from the Jacksonville extension was to be displayed. Sutton also visited the Howard University Art Department and the Harlem Community Art Center. When he returned to Florida, he received a congratulatory note on his work with Negro children from Russell Parr, the FAP's regional director. Parr expressed admiration for mural sketches based on Negro spirituals from the Jacksonville program that were on display in DC and recalled having seen them when he visited Sutton's classrooms earlier. Fuller had recently informed Parr that Sutton was planning an event in which the children's chorus of the WPA music project in Jacksonville would sing the spirituals in the space where these sketches were displayed. Black leaders from throughout the state were expected to attend, marking the second anniversary of the gallery.[62]

The Jacksonville program was especially admired for the children's art instruction; works produced there attracted local and national attention and were seen regularly in FAP exhibitions. For many observers, it epitomized

the value of these extension programs, in which Black children, given encouragement to express themselves with minimal interference, produced uniquely "authentic" images. Differences were noted between the work of children living in northern cities and work by those in the South. A review of a 1939 Negro children's exhibition contrasted the subdued color and social observations evident in the works of New York children with the vivid paintings coming out of Jacksonville. Strong emotions were observed in images of a young boy kneeling in prayer, a crucifixion scene, and a congregation witnessing a river baptism, saved from sentimentality by strong color and composition. Sutton, according to a review in the *Atlanta Daily World*, fostered a "racial ideology" that captured religious sentiment without stereotyping (fig. 6).[63]

Between January 1937 and February 1938, Sutton delivered a series of lectures to varied audiences on the subject of Negro art.[64] The content of these talks suggests that Sutton drew on a number of sources, most obviously the writings of Alain Locke, whose critical essays had been appearing since the mid-1920s and whose 1936 study *Negro Art: Past and Present* was published as a kind of manual for educators. Sutton sought to inform himself about the development of both African and African American art and the impact of the former on modern European art, all of which was consistent with Locke's approach to Negro art. He also seems to have followed catalogs and reviews of the annual Harmon Foundation shows, sometimes citing passages almost verbatim from the press coverage. These talks routinely recognized the stimulus and opportunity for future development provided by the FAP, noting that what had been accomplished in a brief time in Florida was evidence that, given a chance, the Negro could do as well as anyone else in the field of art. The collective impression of Sutton's lectures is of cautious optimism tempered by skepticism, of hope for the future mediated by harsh realism about the past. What united them was the idea that race identity in America is an unstable and poorly understood cultural construction in search of a voice neither monolithic nor entirely bound by history.

The original manuscript for "High Noon in Art" concludes with a description of plans to create a State Negro Museum and Art Gallery, including a two-story building that would house galleries, offices, and an auditorium. The possibility that the Jacksonville Negro Art Gallery might grow into a statewide Negro museum seems to have originated with Eartha White and was promoted by Sutton within the Florida FAP. An undated

brochure, probably from the mid-1930s, documenting activities at the Clara White Mission refers to its sponsorship of WPA programs such as federal art and writers' projects, and notes that under consideration was a "State Museum where relics and documents and everything pertaining to Negro history will be kept."[65] As stated in the brochure and reported by the *Chicago Defender*, the mission hoped to raise funds to support programming and construction of a building through the pledge of an as yet unidentified matching gift.[66] An organization called the Eartha M. M. White Museum Committee had been formed, whose objectives were to preserve the rich heritage of memoirs accumulated by Eartha White, to develop community interest in fostering the museum, to search for and stimulate cultural expression and artistic talent, and to encourage the preservation of historical data and information relating to a shared traditional background.[67]

Sometime in 1937 or 1938, Eartha White built and then enlarged a cottage to house the museum, probably in Moncrief Springs. A photograph dated 1937 shows White inventorying antique items, and another is captioned "At one time a museum of African American history, this coquina cottage was built by Eartha White in 1938. It was located in Moncrief Springs, a large recreational park operated by Miss White from about 1940 until her death." There are also archival photographs of a construction team that seems to be building an addition to an existing structure and an undated image of a road sign that reads "Eartha M. M. Whites Historic Art Museum, 4850 Moncrief, phone EL 4-4162," suggesting that it was either already open or close to opening. A 1978 dedication brochure for the founding of the Eartha M. M. White Memorial Art and Historical Resource Center, housed in the Clara White Mission building, states that the Moncrief building was enlarged to accommodate the museum collection. This brochure also notes that a good deal of the contents of the collection, including historical documents and objects, were lost, damaged, or stolen after White's death in 1974. Reconstructing the history of this remarkable collection and museum is further complicated by a devastating fire in 1944 that nearly destroyed the West Ashley Street property and its contents. It is likely that crucial documents pertinent to the WPA activities located there, including the FAP gallery and planning documents for the museum, were lost in this fire.[68]

It is interesting to consider this initiative in the context of the stated FAP goal that permanent art centers would eventually emerge from the temporary organizations established by the projects. Many CACs were supported

by funds raised from municipal governments or civic organizations, but Holger Cahill clearly preferred situations in which there was genuine grassroots interest. This became an issue with respect to his confidence in Fuller as Florida's state FAP administrator. In March 1938 he addressed what he understood to be a weakness in her approach to expansion: he felt that she relied too much on civic leaders without generating sufficient community interest, which could undermine the establishment of a permanent structure. Cahill raised this issue again several days later in a communication regarding tentative approval of plans to open a center in Key West. There must be a community commitment to making this a permanent agency, he stated, regardless of the scale of the proposed project. "We are not trying to start temporary art centers solely for the education of under-privileged people."[69]

Doubts about Fuller's leadership in Florida were also raised by Defenbacher, who complained to Parker that healthy development was impeded by her failure to generate broad-based support for the centers. Fuller, he argued, was expansion-minded but relied almost exclusively on a few people, mostly public officials, whom she was able to manipulate into providing support. The directors of these initiatives functioned as puppets, carrying out routine work to ensure smooth operating, but they were never sufficiently in touch with the communities they served to fight for good ideas with potential long-term impact. The will or desire of the people was ill served with this model, especially given the emergency, and thus temporary, nature of the FAP. While municipalities might be in the business of supporting WPA projects, Defenbacher said, "This present municipal support is entirely insecure, because it represents the pressure of outside money rather than the fundamental pressure of inside people."[70]

Yet when Fuller raised the possibility of a permanent Negro art center with Parker in 1936, he showed no real enthusiasm: "As to the possibility of a Southern Museum and Gallery for Negroes, I think we should be very sure of the need and sources of support which would be assured before taking any definite plans in this direction."[71] Reservations about Fuller's leadership may explain Parker's cautious response to the idea of a Negro state museum, although it is not clear that the Jacksonville Negro gallery lacked the local grassroots support that national FAP administrators sought. It is true that energy for the museum seems to have emanated from White, and by association Sutton, but it was not unprecedented for a community

art center to be transformed into a permanent facility as a result of gifts from individual benefactors. And given the economic and social constraints that African Americans lived under in the segregated South, it seems reasonable to conclude that the best way to succeed in such an endeavor would be through the efforts of an entrepreneurial citizen with political influence and a track record of prior accomplishments. If something permanent was to emerge, the responsibility and initiative would ultimately fall to the handful of people who had been committed to the original vision.

CONCLUSION

Florida and North Carolina provided very different examples of early FAP efforts to accommodate the conditions of segregation and still offer opportunities for Black communities. In Raleigh and Greensboro, the fate of the Negro extension centers was closely tied to the skill of administrative personnel who oversaw them and the depth of commitment on the part of sponsoring institutions. Where these were strong, as seems to have been the case in Raleigh, efforts met with relative success. But the struggles in Greensboro suggest that personal attitudes and lack of trust could easily derail well-intentioned but low-priority initiatives. What worked in Florida was in some ways at odds with the spirit of the CAC program. Eve Fuller was ambitious and, according to the FAP national office, inadequately consultative in generating community support. But these qualities also led her to launch a Negro unit headed by a single person who, like her, would take personal responsibility for organization and expansion. The collapse of the Greensboro extension program can be attributed in part to the lack of such a figure there with statewide responsibility.

Toward the end of the era, as the FAP refined its process for CAC development, these programs ran more smoothly and were better able to sustain their viability. Centers established in St. Louis and Chicago outlived the New Deal and in so doing at least partially fulfilled the FAP conviction that temporary government support would ultimately lead to the establishment of lasting institutions in the communities served. The LeMoyne Federal Art Center in Memphis occupies a unique position in this history. It came into being as the result of outreach by Frank Sweeney, the president of LeMoyne College, an HBCU in Memphis with a long history of engagement with the local Black community. He contacted Cahill directly,

asking for FAP funding to locate a Negro arts project at the college that could meet the needs of Memphis and the surrounding area. The organizational structure was similar to that of other centers across the country: space was provided and maintained by a local partner, in this case the college, the FAP provided staff, and the community provided supplies and materials through an advisory committee composed of prominent Black citizens. This center had widespread support in the Memphis Black community and the college and was closely followed by the local media. Under the leadership of the muralist Vertis Hayes, it became the foundation of the LeMoyne College Art Department, thus fulfilling its potential to develop into a center with permanent impact. The identity of the LeMoyne Center was positioned somewhere between high-profile autonomous initiatives such as the HCAC and the more modest southern extension galleries.[72]

The clear differences between Negro extension galleries and independent CACs in Black communities are dwarfed by those that separated these initiatives in majority and minority populations from one another. This is evident in the level of staffing and financial support on the ground as well as in the scale of efforts to raise funds that would allow these centers to continue their programs or be converted into permanent facilities. Resources were expected to come from within the communities themselves, and there were very real differences in their respective economic realities. Despite its fame and celebrated success, the HCAC struggled to keep its doors open and its services running. In 1941, under the newly appointed director Charles Keene, it moved from the original location on Lenox Avenue to a property on West 116th Street that it was able to occupy rent free, thus eliminating an expense that, per FAP regulations, was the host community's responsibility. The reopening was an occasion for much fanfare and was marked by a speech by Aaron Douglas, who recounted the HCAC's distinguished history and the role of the community in its success. Congratulatory telegrams were received from Audrey McMahon, Eleanor Roosevelt, Mayor La Guardia, and Peter Pollack, director of the South Side CAC.[73]

In May 1937 Defenbacher reported to the FAP administration on a sizeable gift from a private citizen to fund a permanent community center in Greensboro. He attributed the inclusion of an art center in this proposal directly to the success of the federal art center that had been operating there since July 1936. This gift did not have a discernable impact on the fate

of the Negro extension gallery, which closed the following year.[74] Nor does it appear that these extension galleries lived on in institutional memory. When FAP administrator Daniel Defenbacher, who developed the first art centers in North Carolina and became assistant to the national director for CACs, was interviewed in 1965, he was conspicuously reticent on details regarding members of the Black community in these programs; he went on at length about the development of programs in the South but did not mention the Negro extension galleries. When asked to recall whether Blacks were involved in the southern CACs, or whether there were any classes in which Black students studied alongside whites, he simply said no.[75] Defenbacher left the FAP in 1939 to direct the Walker Art Center in Minneapolis, a distinguished institution that grew out of a CAC supported by the FAP.

In his introduction to *Art for the Millions*, Francis O'Connor noted the absence of meaningful investigation into the impact of the CAC program. As an initiative that nurtured grassroots creativity and sought to expand the audience for American art, it was important, he argued, to understand "the extent to which it succeeded during the 1930s and what effect that effort had on cultural developments in later decades."[76] O'Connor was calling for analysis beyond statistical reporting that might provide insight into the CACs' contributions to achieving larger goals. The FAP was an experiment designed to bring art to the people and provide work for artists in financial need, but its wider vision was of collective creative energy stimulated by government patronage that would have a positive impact on the development of American art.

Joan Saab has pointed out that the competing priorities of CACs make it difficult to assess how comfortably they existed with the FAP's broader assertions.[77] Owing to their diverse operational models, the impact of CACs developed for and within Black communities is especially challenging to measure. Regardless of where they lived, African American children were deemed to be socially at risk for delinquency, culturally deprived, and in danger of losing their "native" traditions. The FAP promoted the therapeutic value of art education as an antidote to all these things, with apparent success. But it is not clear how these Negro art centers also contributed to the larger project of national renewal, or to the formation of a distinctly American art that reflected shared ideals about culture and democracy. They certainly provided opportunities for Black artists, but to what extent did they transcend their educational, social, and economic functions and

contribute to telling a national story about redefining America and reshaping its cultural production?

Programs established in large urban Black neighborhoods such as Harlem seemed well suited to fulfill both the practical and the ideological goals of the FAP. The HCAC employed artists, furthered their development, kept youth off the streets, and, arguably, sustained a meaningful program of cultural revitalization already well under way. Extension programs in southern Black communities, by contrast, employed very few people and were rarely expected to provide opportunities for the professional advancement of Black artists; rather, their functions were almost exclusively social and educational. These differences are in part attributable to the fact that artists, irrespective of race, were underrepresented as a professional class in the South. But it is also true that broad excitement about the stimulation of cultural vitality associated with areas such as Harlem was not easily transferable to the modest extension centers in the southern states. Nonetheless, historians have recognized that, at least in rhetorical terms, the CAC program was uniquely positioned to create a process whereby Black culture might be merged into an evolving narrative of American culture.

The FAP claimed great potential to foster the development of African American art by encouraging Black artists to mature in the context of their own unique environments. But it remained a challenge to support these artists in a way that acknowledged them as important participants in the creation of culture while simultaneously treating them as fully engaged members of a professional class. The greatest impact of artists assigned to the education projects was as teachers of nonprofessionals, most of whom did not aspire to careers in the arts. And it quickly became obvious that the most consistently celebrated artistic works by African Americans associated with the projects were those produced by children taking classes in CACs. This system was not exactly conducive to increasing the number of African Americans who could call themselves professional artists, nor did it necessarily provide equal opportunity to advance their own work or achieve visibility as significant contributors to the democratic expressive ideals that Cahill embraced. Thus, despite participation in the opportunities provided by the FAP, many African American artists remained suspended in a model that could embrace them as emerging members of a collective movement, but rarely accepted them as accomplished individual artists.

Advocacy

In the introduction to *Art for the Millions*, Francis O'Connor noted that the essays gathered for the volume addressed three dominant themes: art as communication, the accessibility of art, and the impulse to organize. Communication and accessibility reflected the overarching concern during this period with the relationship between art and society. But artists were drawn to organizing as a way to confront both their own economic realities and the pressing domestic and international crises of the 1930s. O'Connor explained this newfound militancy in terms of several intersecting factors, including the poverty experienced by many artists during the Depression, the successful model of activism embodied by the Mexican muralist movement, the growth of the labor movement overall, the employment conditions of the New Deal art projects, and widespread interest in socialist ideologies. The phenomenon of artists' organizing and its significance in this era has become a major theme in New Deal research.

The most prominent organization of the era, the Artists' Union, had its origins in the Unemployed Artists Group formed in the summer of 1933 as an affiliate of the John Reed Club. Its numbers grew exponentially as momentum gathered to develop programs that would address massive unemployment in the arts community. Renamed the Artists' Union in early 1934, it became the primary advocacy group for artists seeking support

from the New Deal projects, functioning as a trade union that pressured the government for expanded opportunities and negotiated more favorable working conditions. As New Deal scholars frequently observe, artists came to think of themselves as cultural workers and understood their circumstances in terms of challenges facing American laborers, broadly defined. The AU sought and eventually obtained recognition from the labor movement; after several years of activism on behalf of artists, it received a charter from the CIO late in 1937, renaming its organization United American Artists in 1938.[1]

Audrey McMahon, who headed up the New York City FAP, pointed out that while these organized artists' groups embraced larger concerns about unemployment during the Depression, they were primarily concerned with their respective constituents. Working conditions for artists were at the core of protests and negotiations; artists sought protection and expansion of federally funded employment opportunities, and they voiced objections to stringent relief requirements and various discriminatory practices. Individual grievances were typically brought to local project administrators and, when possible, resolved there. But McMahon noted that group representation via the union had clear benefits, especially for inexperienced artists who had difficulty articulating their demands. At the same time, the naïveté of the organizations themselves sometimes resulted in questionable decision making. Years later, when asked to recall her experiences as a project administrator, McMahon expressed ambivalence about the contributions of the AU. Her encounters with union leadership were sometimes bitter and unruly, even though they were basically on the same side. And she believed that the actions of the AU did not help the overall public image of cultural initiatives that certain segments of the American public already viewed as suspect.[2]

Some contributors to O'Connor's anthology commented on what they perceived as an expansive mission for the artists' organizations, one that went well beyond their economic and political role. Lincoln Rothschild described the AU as operating on multiple fronts that reflected FAP goals overall. Holger Cahill hoped that the projects would provide jobs for needy artists and promote a particular ideal of the artist's role in society; the AU, Rothschild explained, was similarly concerned with both. While activism took place in the streets and in the offices of union and FAP administrators, their broad cultural platform was realized in the pages of *Art Front*, the AU's

official publication, and in the activities of the American Artists' Congress, with which it was closely affiliated.[3] Artist Chet La More agreed that the AU grew into its role as a leading voice in the democratic vision of the arts as articulated by Cahill. Traditional forms of elite patronage had failed to make art meaningful to the American people, a situation the FAP sought to correct. "The Artists' Unions," La More wrote, "have given the artists of America a new perspective for growth through which they will be able, in collaboration with all other American citizens, to build an art in our country predicated upon our historical ideals of democracy."[4]

Although the New York–based AU enjoyed special prominence in this narrative, artists' unions operated in multiple American cities. Several contributors to *Art for the Millions* wrote of the difficulties they encountered in trying to establish these organizations in communities where ideas about art and culture were very traditional and fiercely held. The Minnesota Artists Union saw the impulse to organize as an opportunity to revise ideas about artists and expand the public's understanding of what they contributed to the cultural life of the state. They advocated (unsuccessfully) for a rental policy to govern works lent to museum exhibitions and pushed for the establishment of CACs throughout the state. Artist Einar Heiberg described the Minnesota union's success in terms of bringing the artist out of the ivory tower to participate in a mass movement with benefits to the entire society. Artists took great satisfaction in establishing connections with similar organizations in other places and fighting for common goals.[5]

Robert Jay Wolff, a supervisor in the easel-painting division of the Chicago FAP, recounted the strong distaste in established art circles for the notion of a union for artists. He described a community that considered itself artistically progressive but was deeply offended by the alignment of artists with the model of cultural production as a kind of labor. The prospect of steady employment in the projects and a union that advocated for artists' rights was anathema to elite art patrons accustomed to thinking in terms of stylistic allegiances, not economic conditions. While they may have been enlightened with respect to matters of taste and modernity, their views of artists were dated and paternalistic. Wealthy collectors and even some practicing artists clung to romantic notions of artists as social misfits who required benevolent patrons to rescue them from their natural state of bohemian poverty. They thought it unseemly of artists to expose the conditions of their unemployment and align themselves with ordinary

manual laborers, and were outraged at the idea that "the relief station had taken the place of the garret, and the benevolent patron had become a government official," as Wolff put it.[6] Artists' unions forced citizens who understood themselves as supporters of the arts to confront their indifference to the economic well-being of the actual artists in their community, and to acknowledge their hostility toward disruption of traditional power dynamics.

Artists' organizations were the public face of the era and emblematic of its political character. New Deal historians have noted that artists in the FAP had a common employer against whom they could organize and make demands. But, as Rothschild pointed out, these groups had multiple functions, some of which were better understood as cultural rather than economic. Further, they provided opportunities for social interaction and comradery that worked against the isolation that so often defined the experiences of artists. At the first American Artists' Congress in February 1936, Stuart Davis applauded the proliferation of cultural organizations, underscoring the reality that one group could not do everything. This was an era of activism pursued through sustained attention to specific problems and coalition building to maximize impact. Fragmented attention was an implicit danger as artists navigated this landscape of multiple cultural fronts, but loss of momentum was a larger hazard.[7]

THE HARLEM ARTISTS GUILD

Many Black artists aligned themselves with the impulse toward cultural democracy embedded in the art projects and embraced the general climate of activism. Their unique circumstances, however, both current and historical, supported the idea that they would best be served by an organization centered entirely on their concerns. The Harlem Artists Guild, founded in 1935 by a group of New York–based African American artists, enjoys undisputed status as a significant force in the cultural politics of the decade. Accounts of the HAG's founding and its involvement in high-profile initiatives of the 1930s can be found in most standard histories of African American art and artists, and in histories of New Deal art and arts activism.[8] These origin stories coalesce around a series of specific events and an increasing impatience with the forms of advocacy and support that had dominated the previous decade. New Deal historians have tended to

emphasize the extent to which involvement in the FAP, the AU, and the AAC shaped an emerging concept of Black agency.[9] More recently, Erin Cohn has argued that while Black artists were profoundly affected by the inherently political vision of these initiatives, their identities as artist-activists were also formed by engagement with civil rights organizations such as the National Negro Congress (NNC).[10]

Looking back on these years, several artists who became associated with the HAG recalled the cultural moment in which the organization took root as an important turning point. Elba Lightfoot referred to the urgency of Black artists' finding their own voice and making people both in and outside their community aware of what they were doing. "It was imperative that we had an outlet of our own," she recalled. "We had problems that white artists might not have had, such as showing our work, being invited to exhibitions, opportunity for the jobs, and eligibility for scholarships. It made us serve as a sort of clearinghouse for these things that our artists needed. We just wanted the people to know we existed. We had the talent and we just felt that the black minority so endowed with talent and creative energy needed an arena for itself."[11] Lightfoot noted that the founders' original idea was to use the word "Negro" in the organization's title but that the group rejected that idea in favor of referring to place rather than race, implying an openness to any artist who lived in the area. When asked, however, if any white artists had joined the organization, she replied that none had, even though there were white artists living in Harlem who may have wanted to belong. Ernest Crichlow, who led the organization in the late 1930s, understood the need for a separate organization as cultural, rooted in different social, political, and artistic circumstances. Some members of the HAG never joined the AU, but he did not regard the two groups as being in conflict.

By some accounts, the HAG came into being as a gesture of defiance directed toward the Harmon Foundation; others locate its impetus in the discriminatory practices of the early government art programs. The HAG formed in the wake of two significant local events in March 1935, both related to an ongoing campaign to establish an art center in Harlem that would serve both the general community and the population of aspiring professional artists who worked there. The first, a municipal art exhibition sponsored by the Harlem Art Committee, prompted artists to redouble their efforts to secure an exhibition space that would provide them with regular opportunities to show their work. Then, several days later, rioting

broke out in Harlem, and in the aftermath Mayor La Guardia appointed a commission to examine ways to improve conditions there.[12] Access to culture via the establishment of a permanent art center was understood in this context as an investment in Harlem's future.

A planning document for the March 1935 municipal exhibition states that it was to be sponsored by the community of Harlem "with the assistance of the Art Project Service of the Works Division, Emergency Relief Bureau, New York City, administered by the College Art Association."[13] It explained the logistical arrangements, including costs, location, dates, publicity, and related programming. The exhibition was to include African objects, fine and decorative arts by professionals, and fine art by amateurs, in particular student works from various art classes in the community. The foreword to the exhibition pamphlet connects it directly to the campaign to create an art center in Harlem: "This exhibition is Harlem's response to the question, Does New York Need a City Art Centre?"[14] In an essay on the HAG written for the Federal Writers' Project, Claude McKay described Black artists' dissatisfaction with the handling of this show because so few of those exhibited had benefited from the employment opportunities provide by the government. In its wake, an organization made up of six Harlem artists was formed—Charles Alston, Aaron Douglas, Augusta Savage, Henry Bannarn, Gwendolyn Bennett, and Romare Bearden. They in turn called a meeting of artists who had been in the municipal exhibition administered by the College Art Association, and this gave birth to the Harlem Artists Guild.

Although he acknowledged the artists' objections to the Harmon Foundation, McKay seemed intent on challenging what he perceived as an unfair reaction to an organization that had done a great deal for Black artists. He pointed out that many members of the HAG had exhibited in other HF shows, and that while the foundation was flawed, "nevertheless it has done pioneer work in encouraging and fostering the talent of Negro artists. And some of the Negro artists sponsored by the so-called 'jim-crow' Harmon Foundation have been winning steadily a wider recognition."[15] This early account summarized priorities and ideals as articulated in the original preamble: the belief in the social purpose of art, the recognition that Negroes were destined to play an important part in the art of America, the importance of awakening the public to artistic needs and in so doing aid the greater development of art, the desire to cooperate with other art

organizations, the need to provide studios for artists and an art center where artists could get together to discuss ideas, and the need to find immediate work for the artists of Harlem.

McKay's narrative captures the moment when Harlem artists were transitioning from "306," the studio of Charles Alston and Henry Bannarn on West 141st Street, which had been an important gathering place, to the idea of establishing a more formal art center with public support. In another, perhaps later, document, the language about the social purpose of art and Negro contributions to American art was dropped, as were references to the need for an art center and studios. The HAG's purpose was now described as: "1. The encouragement of young talent 2. (a) The fostering of understanding between artist and public thru education toward an appreciation of art, and (b) Through cooperation with agencies and individuals interested in the improvement of conditions among artists, and 3. All those pursuits that shall have as their goal the raising of standards of living and achievement among artists."[16]

Although no single event fully explains its origins, the HAG, once established, assumed a prominent role in Harlem's cultural affairs; it was highly visible in controversies surrounding FAP public art projects of relevance to the Black community. Guild members participated in the activities of the AU and the AAC and sent representatives to various other activist organizations, including the Artists Coordination Committee, the NNC, and the Artists Conference of the Americas. In 1936 it worked with the AU to overturn administrative interference in the production of FAP-supported murals for the Harlem Hospital complex, a project for which HAG member Charles Alston served as supervisor. This incident received a good deal of media coverage and has been well documented in the secondary literature. It involved the rejection by local WPA authorities in New York City of mural sketches deemed unacceptable on the basis of racial subject matter, despite the fact that the hospital itself operated in a majority-Black neighborhood in the city. The HAG and AU successfully protested this ruling, which they understood not only as inherently discriminatory but also as the natural outgrowth of the conditions of segregation on the projects as a whole.[17]

While engaged in this protest in 1936 over the Harlem Hospital murals, the HAG was located at 321 West 136th Street. An early HAG membership list notes this as the address of Augusta Savage, Gwendolyn Bennett, Louise E. Jefferson, and Norman Lewis, who apparently moved there in

late 1935. On what appears to be a sheet of official HAG stationery that lists Charles Alston as chairman and Aaron Douglas as vice chairman, the organization's address is given as 401 Edgecombe Avenue (fig. 7).[18] Correspondence from December 1937 on AU stationery lists the HAG as an affiliated organization located at 409 Edgecombe Avenue, which according to several HAG membership lists was Aaron Douglas's address. The undated copy of the later preamble states that the organization would be located at the 135th Street branch of the YMCA, where it was to have weekly Tuesday evening meetings. As of July 1938, the HAG was meeting at 290 Lenox Street, the location of the HCAC. The close alignment of these organizations was no doubt prompted by the fact that in December 1937, Gwendolyn Bennett was functioning as both director of the HCAC and chair of the HAG, but this arrangement seems to have persisted after she stepped down from leadership of the latter.[19]

Organizational approaches to race advocacy within the HAG sometimes emerged in the context of unfolding circumstances on the ground and were not always consistent. Against the backdrop of a round of FAP cuts, the guild pressured Audrey McMahon to take race into account in issuing dismissals and reinstatements. She informed Cahill that the HAG regarded failure to give special consideration to the overall circumstances of Black artists as a form of discrimination. Her view was quite different; she noted that the New York City FAP had avoided consideration of race as a way of working against discrimination and segregation, a position largely consistent with the arguments advanced in the context of the mural controversy. But the HAG now demanded on behalf of its members that their race be registered and that those dismissed from the project be reinstated as Negroes. They expected that once so registered, Black artists would be exempt from future dismissals; if those dismissed could not be reinstated without the displacement of white employees, there should be a quota established for Black participants.[20]

HAG members made a public case for greater influence on shaping their own future in the pages of *Art Front* and the context of the AAC, where they were invited to stake a claim in this emergent progressive landscape. Throughout 1936, *Art Front* regularly covered issues of concern to the African American artistic community, sometimes linking its struggles to broader arguments about freedom from oppression and denial of opportunity. The merits of racially identified art were famously litigated in the pages

of *Art Front* in a series of exchanges between Alain Locke, James Porter, and Meyer Schapiro. They also weighed in on the Harlem Hospital mural controversy, underscoring their support for the struggle against discrimination that these debates embodied.

An official statement by the HAG against the practices of the HF with respect to the foundation's influence on African American art appeared in an issue of *Art Front*. The Texas centennial planning committee had selected the HF to curate a "Negro art show," and the HAG took this opportunity to denounce the HF as an agency that perpetuated racially inflected artistic judgments. The guild's aim as an alternative organization was "to do everything within our power to advance the Negro's position as a potent factor in the art of America, and such a position, we believe, must be held because of the intrinsic artistic value of our contribution to art rather than because of matters of race." An editor's note that followed this statement reiterated a call for the freedom of the Negro artist to pursue this end, stating that the Texas show itself could only be supported if free of discrimination and racial caricatures. "Real" Negro art, the editor maintained, spoke to Blacks' struggle as a people to achieve liberation alongside others similarly fighting capitalist oppression.[21]

In the main, writers for *Art Front* showed sympathy for struggles faced by African American artists and praised the government-sponsored programs that were now providing much-needed support for them. Nonetheless, they were careful not to exaggerate the results of that support, in contrast to project officials, who claimed, for example, that the WPA-sponsored Harlem Arts Festival represented a turning point for Black artists. In a speech delivered at the festival, Victor Ridder, who was about to step down from his post as WPA administrator in New York City, told the crowd that the ability to provide opportunities for the Black citizens of New York was his greatest source of pride, and that, as far as he was concerned, discrimination was dead. Lester Granger of the National Urban League took issue with this overstatement, pointing out that what Black citizens sought was not a segregated program such as the festival but complete integration into WPA programs across the city. Gratitude toward Ridder was misplaced when there was still no cohort of Black administrators empowered to observe and act on discriminatory practices within the WPA itself.[22]

The HAG also used commentary in the pages of *Art Front* to reinforce its prominence in the cultural politics of the era, including the crucial role

the organization played in advocating for a permanent art center in Harlem. When Gwendolyn Bennett agreed in April 1937 to contribute an article on the HAG, she underscored its growing numbers and described the future of the organization in terms of the ongoing fight "for the Negro artist's legitimate place as a worthwhile force of society which he is a part." Amid accounts of the guild's various activities, such as successful efforts to address the employment of Black artists in the projects, including an expanded number of supervisors, Bennett made a strong argument for its proactive position in planning for an art center. A proposal by the mayor was moving along, she claimed, that would realize "a program put forward by the HAG," which was ready to assist in its implementation. She also noted that guild members had regarded some prior attempts to establish such a center with suspicion and intended to keep a "watchful eye" on the current process to ensure that it was proceeding in the right direction.[23]

These comments were probably a reference to Alain Locke, who had been arguing for years that Harlem would benefit greatly from a cultural center to consolidate artistic initiatives and promote arts education. After the Harlem riots of March 1935, Mayor La Guardia solicited a response from Locke about how to boost morale in Harlem and thus avoid future incidents. Locke noted, among other things, that art and culture could play a prominent role in the rehabilitation of Harlem. Even before the riots, Locke had drafted proposals for a so-called Harlem Cultural Center that he shared with Mary Brady of the HF. According to Jeffrey Stewart, Locke had given up on the proposition by the summer of 1935 but saw the issuance of a published response to the riots as an opportunity to revive it. Nonetheless, Stewart concludes that the FAP-supported art center as finally realized was not the project Locke hoped to launch; it became instead a symbol of his declining influence in Harlem cultural affairs and the ascendance of artists associated with the HAG. Locke, Stewart argues, was essentially outmaneuvered by the HAG, which, with the backing of the FAP, was more persuasive in obtaining space and resources.[24]

The Harlem Artists Guild and the National Negro Congress

The events that led to the founding of the HAG overlapped with planning for two major social and cultural initiatives of the era: the American Artists' Congress and the National Negro Congress. As the political militancy of the early 1930s, epitomized in the arts by the John Reed Club, gave way to

the concept of strength in unity, activism entered a new phase. The so-called Popular Front that emerged sought to forge alliances between communists, socialists, and New Deal progressives. Within the AAC, a classic Popular Front initiative, leadership worked hard to manage the specter of potential disagreement between its respective factions. Emphasis was placed on unity and cooperation, sometimes resulting in the pursuit of a strained coherence that elided discord.[25] Founded in 1935, the NNC similarly sought to consolidate and forge alliances between multiple constituencies engaged in civil rights advocacy in the context of the New Deal, including labor unions, fraternal societies, churches, and various civic organizations. Like the AAC, the NNC relied heavily on coalition building and was similarly challenged by the need to manage tensions among its member organizations as it sought to sustain a strong activist agenda. Both organizations did so, in part, by stressing issues and objectives rather than strict adherence to a prescribed ideology. But despite these gestures toward openness and tolerance of conflicting beliefs, both organizations ultimately collapsed under scrutiny of their alleged ties to the Communist Party.[26]

The inaugural meeting of the NNC was held in February 1936, directly overlapping with the first meeting of the AAC. In March 1936, *Art Front* reported that the AU had sent a delegate to the NNC conference in Chicago, and confirmed its own support for a civil rights agenda underscored by a mutual commitment to universal political, social, and economic equality. The AU and the AAC were also closely aligned in their goals and membership but sought to define themselves as complementary rather than redundant initiatives. It was understood that the AU would concern itself primarily with economic issues, while the AAC would focus more broadly on civil liberties, freedom of expression, and, especially, combatting fascism. The relationship between the NNC and the HAG was more informal, reflecting the reality that although the arts were included in its programming, the NNC sought a much broader impact through a strategy that brought together multiple disparate organizations—social, political, religious, and cultural—to advance civil rights.

Historians tend to think of the HAG as an offshoot of the AU, which suggests that it derived its activist energy from the dominant organizations of the majority culture. But it is worth considering, as Erin Cohn suggests, the extent to which the cultural agenda of a civil rights organization like the NNC may have intersected with this energy and stimulated it. Culture and

cultural advocacy played important roles in the NNC's agenda from the start, and members of the HAG were active in the organization in various ways. Panels on culture were convened at the NNC national conferences to facilitate conversations among artists, writers, and performers and to promote activism among them. The organization sought to raise the visibility of Black creative expression through art exhibitions, and it advocated for expanded opportunities for Black artists on the FAP and in the culture industries at large.[27]

The February 1936 Chicago conference that launched the NNC included a session on culture chaired by Richard Wright titled "The Role of the Negro Artist and Writer in the Changing Social Order." Augusta Savage attended as a representative of the HAG and participated in the panel. The conversation addressed a range of challenges faced by Black artists seeking a place in American culture, including efforts to exploit them and the chronic conditions of suppression and neglect in which they labored. Participants identified the need to mobilize in the context of the Depression by taking part in social movements and organizations such as the NNC, about which they expressed great hope, especially for its ability to foster and support artists' cultural and social labor. Several months later, the NNC sponsored a symposium in Chicago honoring author Arna Bontemps that included an exhibition of Black Chicago artists.[28]

Wright also participated in a cultural session at the second NNC national conference, held in Philadelphia in October 1937 and chaired by Sterling Brown. The cultural panel of the 1937 meeting passed several resolutions, including support for an expanded FAP and the establishment of a Bureau of Fine Arts that would be granted permanent status, both key components of platforms advanced by the AU, the HAG, and the AAC. The panel acknowledged that through the FAP many African Americans had for the first time gained access to enlightened cultural programming and had been encouraged to engage in forms of creative expression rooted specifically in their personal experience. Locke spoke at this event, and his talk, published in the proceedings, affirmed his commitment to the mission of the NNC and the importance of social realism in art. Jeffrey Stewart notes that Locke used his participation in the Philadelphia conference to forge a new image of himself as a radical critic in the wake of his declining influence on the Black cultural scene. On the defensive about his enduring connections to the HF and the discrediting of his racial art theories, Locke, Stewart

argues, sought to distance himself from the connotations of the 1920s New Negro Renaissance in the interest of becoming a more relevant "critic of the 1930s school of racial thinking." This signaled a shift in Locke's thinking from aestheticism to art as an agent of social change and liberation, one that would serve him well in future years.[29]

As the decade progressed, cultural advocacy played an increasingly prominent role in the NNC, especially in Manhattan. In the spring of 1938, the NNC's newly formed Negro Cultural Committee involved itself in protests to try and save the WPA-supported Federal Theatre Project from funding cuts that threatened to close it. The Negro Cultural Committee also sponsored exhibitions, sometimes coordinated with the HCAC and the HAG. In his book *Communists in Harlem During the Depression*, Mark Naison notes that by the end of 1938, protecting and increasing opportunities for Black cultural workers was a high priority of the NNC in New York. In Harlem, he observes, it was less focused on labor issues than councils in other cities were, in part because competing groups concerned themselves with labor activism in New York. Because its operational model depended on building coalitions with a wide range of organizations, the NNC sought other issues around which it could encourage affiliation. A large percentage of Black artists employed by the New Deal art projects were located in New York, and thus attention to cultural opportunities held the promise of galvanizing support.

But this focus on cultural issues can also be explained in terms of the Communist Party's relationship to the NNC and to the Black intellectuals who shared these priorities. According to Naison, opportunities for white-collar employment provided by the WPA art projects were a boon to a Harlem intelligentsia long engaged and deeply invested in the development and promotion of Black cultural expression. Their attraction to the Communist Party was located in part in its progressive ideas about race, which included recognition of African Americans' valuable contributions to American culture. The party in turn gained status by working to secure economic benefits and institutional support for Black artists, especially in the projects. While the Communist Party's impact on the NNC remains controversial and was certainly a source of tension within NNC leadership, this mutual investment in culture was expedient and logical. In Harlem, the cultural politics and civil rights agenda of both organizations were directed at artistic leaders who understood their task in the same terms that the

art projects did: to shift access to and control of cultural opportunities from elite structures to the community and support the artists who drove production.[30]

The balance between economic activism and cultural advocacy that marked the NNC was echoed in the HAG, but its relationship to the NNC was at times tentative. In January 1938, Gwendolyn Bennett received a letter from the AAC regarding a proposed collaboration between the NNC and the HAG for an event to be held during Negro History Week. The Detroit chapter of the NNC wanted to organize an art exhibition but did not feel there were enough local artists of interest, so it was requesting works from the HAG. Bennett was interested in cooperating if certain logistical require-ments could be met, and she noted that drawing from a large show recently staged at the HCAC opening would make this easier. In a letter confirming that the works were being crated for shipment, she expressed her pleasure at the opportunity to cooperate with the Detroit NNC and her hopes for similar collaborations in the future. This exchange suggests that the HAG may have enjoyed some recognition within the national organization but did not necessarily have a close working relationship with NNC regional chapters. The original letter went to the AU with the request that it be for-warded to Bennett.[31]

In the fall of 1938, as the NNC increased its focus on the cultural sector in the Manhattan council, members of the HAG struggled with how best to maximize their potential engagement in these initiatives. The NNC was a regular agenda item at HAG meetings throughout the fall; there were reports on NNC activities and discussions about the extent of the guild's influence over artistic matters therein. Motions were made to authorize payment of affiliation fees and to obtain better information about NNC activities by sending a delegate to the weekly meetings held in New York City. Ronald Joseph pointed out that the NNC often showed art by white artists at its events, and argued that, as an affiliated organization, the guild should be providing the artworks the NNC might need.[32]

At a meeting of 27 September, HAG members were informed that the NNC's eastern regional conference would be held in Baltimore in the first week of October. Attendance at the Baltimore conference was further discussed at the meeting of 4 October, where James Yeargans made the case that it was in the guild members' best interests to inform the NNC about events in their current cultural season and future plans. The HAG

had regularly sent delegates to NNC conferences, and Yeargans reminded members that they had been a significant presence in the NNC's Negro Cultural Committee at the Philadelphia meeting in 1937. Yeargans further stated that the AU, a "white organization," was sending representatives, and argued that the HAG, as a Negro cultural group, should certainly do the same. Fred Perry stressed that paying dues to maintain an official affiliation and attending occasional conferences were not adequate; it would be more meaningful to be involved on a regular basis. Perry attended the Baltimore conference and made an extensive report to the membership at the next meeting; he was subsequently elected to serve as the future HAG representative to the New York chapter of the NNC.[33]

At a later meeting, Perry observed that the NNC seemed at a low point and in need of reorganization, much like the guild itself. Perry referred to the diminished state of the NNC at a time when the HAG was considering how to resolve an internal disagreement about whether it should participate in an initiative being sponsored by the AU on behalf of Jewish refugees. On 6 December, Ronald Joseph, the guild representative to the Coordinating Committee of the Artists' Union, reported that the AU was seeking support for a newly conceived project to raise the visibility of the Jewish refugee problem through public protests; there was also a plan to raise money through an exhibition that would split sales profits between artists and the fund. Some HAG members questioned the propriety of fundraising for foreign refugees when their own needs were so great, and expressed concern about the message this might send to the Black community.[34]

An ensuing proposal for a compromise position precipitated strong debate within the HAG about its responsibility to address social justice issues outside its focus on the racial oppression of African Americans. While there was sympathy for the AU initiative, some felt that proceeds from sales by HAG artists should not go to an outside organization representing someone else's problems, no matter how deserving. Others argued for solidarity on the issue of oppression, suggesting that it was perfectly appropriate for the HAG as a cultural organization to acknowledge the existence of mutual oppression by openly identifying with the plight of the refugees. They sought a solution that would allow the HAG to share the proceeds between the refugee fund and the Southern Negro Youth Congress, thus supporting both an AU initiative and an African American group.[35] Eventually, a motion was made to propose an anti-lynching exhibition in

conjunction with the April meeting of the Southern Negro Youth Congress in Alabama. Some members also wanted assurance that their contributions to the AU effort would explicitly wed Negro oppression to the refugee issue. On 13 December, Ronald Joseph reported back on his discussion with the AU about guild support of the general principles behind the refugee committee, and its hope that Negro problems could be brought out in the program in a meaningful way. Union members clarified their chief concern for refugees but did not object to acknowledging connections.[36]

The Harlem Artists Guild and the Artists' Union

At the heart of this discussion about the Jewish refugee initiative was ongoing conflict about how to manage the HAG's relationship with the AU. Some members believed that their primary goal should be to achieve status and influence in their own community by contributing to cultural enrichment and gaining exposure for their work. Others felt that they gained the most prestige and benefit through strong alignment with an organization, such as the AU, that had national recognition and impact. Charles Alston made this case consistently and believed that all guild members should belong to the union. Romare Bearden and Harry Henderson concluded that even those who seemed inclined to favor the cultural over the economic function of the HAG regarded a formal relationship with the AU as in their best interest. This was especially true in the context of cutbacks to WPA programs in the fall of 1938; if guild members were not in good union standing, their bargaining position could potentially be weakened. But despite the obvious advantages to being in the AU, HAG members still had reservations about supporting all of its initiatives and priorities.[37]

The two organizations realized that they could have the greatest impact by working together but seemed unclear about their obligations to each other. Questions were raised routinely about the HAG's position vis-à-vis the AU, and HAG delegates to the AU periodically complained that Black artists did not support its initiatives in sufficient numbers. At a November 1938 meeting, James Yeargans reported that an AU picket line formed to protest the threat of cuts to WPA art programs included only three Negroes. In December, he described another large picket line in which "many Negroes were present but not from the Guild."[38] Unlike the relationship to the NNC, where the HAG was a coalition member, questions were more closely linked to the issue of how much active participation was necessary,

and whether guild initiatives would in turn be recognized by the AU as legitimate union activity. Also, if joint membership was required, there was concern about the burden this would place on guild members who might not want to pay dues in both organizations.

In August 1938, Gwendolyn Bennett, on behalf of the HAG's executive committee, requested a formal meeting with the AU leadership to discuss future relations, noting that "the press of matters of interest to both our organizations has caused us both to lose sight of what the relationship now is."[39] A report on the summer activities of the HAG, filed by Bennett and appended to the 20 September minutes, refers to a meeting at AU headquarters between the executive committees of both organizations. Their relationship was discussed, and "a joint committee of Guild and Union executives was formed to go into the whole matter and bring back a public report" to their respective members. The HAG went back and forth during the fall of 1938 on the question of joint membership responsibilities. A proposed meeting between the AU and the HAG to clarify their future relationship was routinely deferred in anticipation of the public report. Notes from 3 January 1939 record a motion to table discussion on this question until that report was available.[40]

Chet La More of the AU attended the 10 January 1939 meeting and a lengthy exchange ensued, in which an attempt was made to clarify membership requirements of the AU in relation to the HAG and to articulate both their differences and their overlapping interests. The AU regarded itself as a trade union consisting of fine artists, commercial artists, and cartoonists. Membership was predicated on the fact of employment, and it sought to protect the jobs of those working in the projects. To be considered for membership, unemployed artists had to meet professional standards established by the projects. The HAG, by contrast, owed its existence to a particular situation in Harlem and operated on a much broader front than the protection of jobs. The organizations shared members largely because of their employment status on the projects. The relationship between the two was presumed to be cordial and fraternal, involving the exchange of delegates and reports. Guild members confirmed that cooperation with other organizations had been part of an original platform that had emphasized the HAG's intrinsic relation to all art, not simply that isolated within their own community. La More stressed that while he did not wish to give the impression that the two organizations should formally separate, he did feel

that a rule requiring joint membership would effectively render the HAG a division of the AU, which would then govern its program and in so doing potentially destroy its autonomy.[41]

Inside the Harlem Artists Guild

In the summer of 1938, Gwendolyn Bennett's annual report of the executive committee made clear that the HAG was experiencing membership and governance issues that had undermined its capacity to be an effective organization. Lack of unity and of a cohesive financial base from which to carry on its activities were chronic stumbling blocks. For this reason, the executive board passed legislation that summer declaring that only dues-paying members could participate in the HAG's activities: "This measure was the outgrowth of almost a year's discussion and thought as to how to overcome the one great evil in the HAG's set-up, namely, a constantly fluctuating membership on which neither administrative committees nor individual members may count in times of stress—a membership which fluctuates as to attendance, as to financial support, as to spiritual reliance."[42]

While the fault lines within the HAG were about logistical and economic issues, they also turned on alternate views of the group's mission. As stated in the preamble to its constitution, the HAG was meant to serve multiple purposes, from political activism to the cultivation of young talent; it also sought to play a role in the aesthetic education of the Black community.[43] One of the great frustrations of HAG leaders during its final years was that their ambition to continue this tradition of bringing cultural programming to Harlem was constantly undermined by necessary efforts to keep pace with the economic challenges facing their members. The summer 1938 report described constant pressure on the organization during the previous year to react in the face of cutbacks to the federal art projects. Bennett noted that this crisis mentality led to tensions in the organization, as there were never enough committed and active members to realize both the economic and the cultural missions the guild had set itself. Exhibition organizing was considered a high priority, and Bennett cited with satisfaction shows of members' work at the Detroit Institute of Arts, Fisk University in Nashville, New York University, and the HCAC opening. Often the economic and cultural goals of the HAG overlapped, as in its role in bringing an art center to Harlem that would provide employment for artists and cultural programming for the community. The guild also actively supported campaigns to

pressure the US Congress to establish a permanent Bureau of Fine Arts that would guarantee future federal support for the arts. But when economic and cultural goals came into conflict, Bennett worried that cultural programming suffered.

Bearden and Henderson identify a meeting held on 13 December 1938 as emblematic of the tension within the ranks over these issues. Chairman Ronald Joseph had proposed that the group hold an extended conversation to address internal disagreements over its mission (cultural and economic), its committee structures, and its overall administration. Charles Alston, one of the founders of the HAG, who no longer attended meetings with regularity, suggested that in this context members restate the overall purpose and aims of the organization. The initial impetus for establishing the HAG had been the need for exhibition opportunities, workspace and housing, and audience development, problems, as Bennett described them, that were economic, social, and aesthetic. Alston noted that the HAG "was formed for both cultural and economic progress of Negro artists—to get the community interested in art, in artists."[44] He believed that the efficiency of the AU made it possible for artists to think less about the economic problems and moved that the HAG's relationship to the AU be settled once and for all. Bennett was frustrated that this had been a bone of contention since the HAG's inception and believed that passing the motion would not solve the real problem, which was to make the guild itself a more professional organization. As she had stated in the annual report, stability and unity were crucial to the HAG's survival and effectiveness. Both things required a committed membership and a properly functioning system of governance.

The HAG governance structure included an executive committee and standing committees devoted to culture, membership, exhibitions, social events, publicity, welfare/grievance, and the public use of art. It had official delegates to the AU, the NNC, and the Artists Coordination Committee, and was also very involved in the programs of the HCAC, where meetings were held. The guild sought to maintain working relationships on numerous fronts, and to promote the interests of its members in various contexts. Each of its standing committees was called upon to report at the weekly meetings, but the minutes reveal great unevenness in their capacity to function effectively.

Roles in the organization changed frequently as heads of committees resigned and were reappointed. From 1938 to 1939, the HAG was chaired

by Bennett, Ernest Crichlow, and Ronald Joseph in succession. Although various lists show as many as seventy members overall, attendance at weekly meetings during this period was rarely more than eighteen and sometimes as low as fifteen. Among those who came most often, Gwendolyn Bennett provided the strongest continuity from the early years of the HAG. Aaron Douglas and Augusta Savage did not attend meetings during these years; Charles Alston, Henry Bannarn, and Norman Lewis came only sporadically. The size of the meetings varied greatly, but during this period the core attendees were Bennett, Robert Blackburn, Walter Christmas, Frederick Coleman, Selma Burke, Lillian Dorsey, Sollace Glenn, Charles Keene, Jacob Lawrence, Gwendolyn Knight (Lawrence), Frederick Perry, Robert Pious, Ellis Wilson, Dorothy Wallace, James Yeargans, and Sarah West.

Increasing membership became a priority in the face of constant complaints about how insufficient numbers made it difficult to get work done. When plans for the coming year were presented at the first official meeting, on 20 September 1938, membership chair Frederick Coleman stated his hope not only to expand the numbers but also to attract some "big names." It was suggested that new members could be sought from art schools attended by Black students and from the ranks of the FAP.[45] Members were also very clearly concerned with recognition of their participating artists, which most agreed was constitutive of both their economic and cultural functions. During the fall of 1938, they deliberated about whether the guild should have an internal jury that might serve as a filter when exhibition opportunities emerged. Were they to form a jury, some reasoned, it should be for admission to the HAG itself; that way, only qualified artists who were also dues-paying members could exhibit under its auspices. The goal was to build the organization, but they wanted to avoid a situation in which artists could simply pay for the opportunity to be in a show.[46]

At the same time, the HAG encountered obstacles in its efforts to secure African American representation on the jury for the World's Fair's contemporary American art exhibition. In September 1938, Ronald Joseph reported that the Artists Coordination Committee had requested the names of Negro artists who might serve on the New York Committee of the World's Fair. After lengthy discussion, Bennett, Joseph, Burke, and Perry were recommended.[47] But guild members remained concern about the status of Black artists in the jury process. The exhibition planners had debated whether the jury should be composed of representatives from the Artists Coordination

Committee's member organizations or should reflect "tendencies in art." As a compromise, each group presented a potential slate from which the jury could be appointed. As Joseph explained it, the jurors were selected mainly based on their status in the art world, which meant gallery representation. Without this, many Black artists appeared unqualified to serve on the jury.[48]

Sarah West raised objections to what she understood to be the appointment of three Negroes to the jury as alternates only. Debate on this issue turned on the understanding of what it meant to be an alternate juror. If an alternate juror participated only as a substitute for someone who could not appear, this was unacceptable to some members. But if the jury consisted of alternating groups that cycled in and out of service, they would feel better represented. The members sought reassurance that there would be Black artists on the main jury, but this did not appear to be the case. On 29 November, Joseph reported to the HAG on his discussion with the Coordination Committee regarding this issue: "They do not think that there is any Negro, or that Negroes have contributed 1/9 in art which would qualify them for a 1/9 representation on the jury. If the membership had thought a while, they would have seen the same thing and would not have to be told this by a group of whites. So, it is definitely impossible to get a Negro on the Main Jury. They will not have alternating Juries, but we will get a chance since the judging will be very long."[49]

James Yeargans pressed Joseph on the obvious lack of understanding in these groups that the circumstances of Black artists had led to their underrepresentation in the arts. Joseph replied that this had been taken into consideration, and it was for this reason that Black artists were chosen to serve as alternates even after the jury had been formed. Their limited participation was telling in the face of pronouncements by Holger Cahill and other organizers that the national system for selection would ensure fairness and would result in a diverse and inclusive manifestation of "democracy in art," by which he meant geography, technique, and artistic point of view, but clearly not race.[50]

Advocacy, production, and cultural programming were all part of the ecosystem in which the HAG sought to make its mark, resulting in constant debate over how best to spend its limited time and energy. The 13 December meeting saw an uncomfortable exchange between members on the question of who wished to run the organization and who wished to concentrate

on recognition through artistic production. The minutes show that Frederick Coleman, "quoting Mr. Lawrence," explained that "there are some people who are not interested in organization who want to paint—there are some who want to run the organization who can't paint." Yeargans, referring to the same remark, stated, "I think Mr. Lawrence hit the nail on the head when he said some want to drive (run the organization) and some want to paint." Coleman seemed to convey that Lawrence thought of organizing as an alternative to painting, perhaps for the less gifted among them. Yeargans, by contrast, presented this more as a choice given the pressures of the time, when one action needed to support the other but both could not be accomplished.[51]

At this meeting, Fred Perry speculated that declining attendance might be explained by the possibility that the HAG had "outgrown its usefulness." But Yeargans stressed the continuing need to advocate for recognition on multiple fronts: "I do not think we are going to receive equal rights in the cultural field if we expect the white man to give them to us." Lawrence replied, "I think the white man will recognize your culture if you have anything to give," to which Alston added, "In the long run we will not be judged by emergencies, but by achievements and these only. Production is a very, very important thing. We should see to it that complete membership exhibits throughout the country. Our bid now is for prestige. It is important for Guild members to appear in shows, nationally and internationally. Then our words and complaints, economically, will have more weight." Bennett, ever attuned to the negative impact of internal squabbling, added, "No-one who does a good organizational job has time to paint.... People make mistakes, but we should look at the service they give."

ADVOCACY AT THE END OF THE DECADE

By 1939, the specter of reorganization and funding cutbacks in the FAP placed the collective fate of the HCAC and HAG in jeopardy. Concerns ran high that scaling back the WPA projects would have a disproportionate impact on the African American community. Black professionals were unlikely to replace the opportunities they offered with positions in a private sector that was effectively closed to them.[52] In the arts community, loss of subsistence income was compounded by the realization that, for many, assignment to the projects was the only means of practicing and improving

skills associated with their professions. A July article in the *Chicago Defender* on WPA funding cuts and their potential impact on the arts community challenged the FAP to provide evidence that Black Americans had to date been treated equitably in terms of access and participation. While administrators reported favorably on the work being done by Black artists on the projects, they did not furnish information about proportional representation.[53] This information was more readily available in New York, where the cancellation of the Federal Theatre Project, along with the implementation of an eighteen-month rotation policy that was expected to further reduce participation, mobilized the Harlem arts community.

In the spring, the WPA underwent a massive reorganization that resulted in funding and decision making being shifted from the federal government to local authorities. These changes placed more control in the hands of municipalities and in so doing undermined the national identity and independence of WPA-sponsored programs.[54] One result was to erode the sense among Black artists that the federal government would remain a reliable patron and act in ways that promoted their interests. Further, charges of discrimination in the WPA were more likely to emerge from the context of state-, as opposed to federal-, level administration, where localized racial attitudes had greater impact. Support for the arts was increasingly tied to local funding agencies that in some locales tended to focus on less controversial educational projects such as the CACs. But in other communities these initiatives were under intense political scrutiny; by 1939, the HCAC had become a target of investigation by Congress's House Un-American Activities Committee, which sought to discredit it and its leadership as subversive.[55]

A major conference titled "Negro Culture Faces World of Tomorrow" was announced in early May 1939 as an organized response to challenges anticipated in the wake of changes in the FAP. The sponsors reflected a united front of African American cultural leadership that included Gwendolyn Bennett, Langston Hughes, Countee Cullen, Richard Wright, Sterling Brown, and Alain Locke, joined by a variety of activist and professional organizations. In the detailed text of this "Call to Harlem Community Cultural Conference," complete with registration form, the art programs of the New Deal were described as the "greatest single opportunity for the Negro artist to work at his craft." They had not only meant opportunity for artists, "but the Negro community was able to share in the cultural

achievements of its sons and daughters through a program whose slogan is 'art for all the people.'" Appropriately, this call came "at a time when the very life of the Arts Projects, with all their inherent opportunities for Negroes, is endangered."[56]

In four sessions held on 6 and 7 May, participants attended keynote discussions, lectures by prominent speakers, and panels that addressed literature, art, theater, music, and dance. The stated aims of the conference were:

1. To consider what the Federal Art Projects have meant to America generally and to consider specifically the extent to which Negroes have benefitted from the FAP, both economically and culturally.

2. To arouse community support in maintaining and extending the existing facilities for employment among Negroes in the cultural field and to gainsay [sic] the continuance of the Federal Art Projects as the LARGEST SINGLE EMPLOYER OF NEGROES IN ALL THE ARTS.

3. To explore the need for a coordinating body of Harlem citizens and organizations that will interest itself in sustaining and widening cultural horizons for Negro men, women and children; **through stimulating use of already existing facilities in the Arts; through research to determine the cultural needs of the community; through campaigns against distorted and prejudiced versions of the Negroes' role in building America and its culture and through the presentation of plans to extend the Negro's opportunities in the cultural fields, thus presenting him in his proper light as an integral part of the fabric of American life and culture.**[57]

It was further noted that a sense of urgency required that certain specific measures be taken, including the reestablishment of the Negro unit of the Federal Theatre and obtaining assurances that the work of several music centers in New York and the HCAC not be jeopardized, that administrative positions be continued and expanded, and that a bill be passed in Congress to create a permanent Federal Bureau of Fine Arts.[58]

Reports in the Black press following the conference noted that it was to function as a kind of call to action. Charges of racial discrimination had been brought against the FAP administration by the Negro Art Committee

of the Workers Alliance with the support of Harlem's civic and labor leaders. They cited failure to promote Black workers to supervisory positions and unjust dismissals, as well as efforts to segregate them within the projects.[59] Leaders of the conference announced a mass meeting to be held on 9 June to mobilize workers and fight dismissals. An article in the *Amsterdam News* provided data on the scale of federally supported arts employment in New York and the proportion of minority participation. It reported that of the 8,847 people employed by all the arts projects, approximately 10 percent were Black, and only fifteen occupied supervisory roles in a total of 764. The visual arts program employed roughly two thousand workers, of whom fifty were Black, with only two supervisors.[60] A follow-up article on the June meeting noted that the speakers included city officials, politicians, and cultural leaders such as Gwendolyn Bennett, then director of the HCAC. Support for the conference also came in telegrams from Audrey McMahon of the FAP, Sterling Brown, and the Reverend A. Clayton Powell, among others.[61] The group seems to have met regularly throughout the summer and in August undertook a sustained effort to register all African Americans dismissed from the projects in hopes of having them reinstated or reassigned. They also encouraged individuals and affiliates to exert pressure on elected officials and congressional committees considering changes to the FAP employment rules and appropriations.[62]

The situation for African Americans in the New York FAP was also in the news that summer because of controversy surrounding white models working at the HCAC. The five community art centers in New York shared a pool of models who posed for art classes and alternated on a rotating basis irrespective of race. According to an article in the *Pittsburgh Courier*, individuals from the Woodrum Committee had visited the HCAC as part of an ongoing investigation into Federal One. Following congressional testimony about the center, an internal administrative decision was made to preclude white models' posing for classes in New York made up of Black artists. The AU, which represented workers of both races in disputes with the FAP, filed an official protest against this decision with Audrey McMahon, head of the New York FAP. The *Pittsburgh Courier* referred to the situation as a "Jim-crow ruling" that would further weaken the HCAC, already decimated by staff reductions and funding cuts. The *Courier* attributed the decision to the desire on the part of national administrators to avoid bad publicity likely to inflame southerners already challenging the viability of the FAP.[63]

As these developments unfolded, the national administration of the FAP solicited information on initiatives targeting the Black community in New York City. Deputy Director Thomas Parker wrote McMahon in June 1939 requesting "a complete and confidential report from you as soon as possible dealing with work which your project has been doing with Negroes, either as members of the staff or as students." Parker noted that the New York project had made progress in this area and that he wanted to assemble information he could pass along to a new project trying to do the same. He stressed that he hoped for a report that went beyond an account of work accomplished and provided "a frank discussion of the problems and handicaps encountered and how they were overcome." McMahon commissioned this report but expressed regret in July that it was not moving along in a timely way, as she had not been able to give it sufficient attention. The report, prepared by Sidney Kellner of the New York FAP's Information Division, was finally sent to Parker in August.[64]

In this context, activists enlisted both long-standing and newly formed allies to fight for the survival of Black artists and to protect the gains they had made through the projects. In some cases, this required that old rivalries be set aside. According to Alain Locke's biographer Jeffrey Stewart, as support from the FAP declined, individuals like Locke and Mary Brady of the Harmon Foundation, who had been pushed to the sidelines as African American artists sought independence and alignment with national initiatives, once again became pivotal figures in brokering opportunities.[65] Immediately following the "Negro Culture Faces World of Tomorrow" conference, Locke wrote to Brady about developing a proposal for a "Society for the Promotion of Negro Art."[66] He imagined an organization that would bring together and coordinate agencies and initiatives working to further interest in and support of Negro visual art. Exhibition planners such as the Howard University Gallery of Art, the HAG, the HF, and the Harlem Museum of African Art could be incorporated as an educational foundation. The HF was well positioned to donate works and provide information about artists; Locke mentioned the possibility of obtaining support from the Carnegie Corporation and prominent individuals such as Marian Anderson.[67] Thus, in the waning days of the great experiment in which the federal government had become a major patron of American artists, Locke was returning to the model he had pioneered, which seemed likely to

be needed once again, that of African Americans proactively attending to the promotion of their culture and the support of their artists.

CONCLUSION

On its face, the HAG was a prototypical artist-advocacy organization of the New Deal era. It was created both because Black artists had unique problems and because they occupied a distinct position in relation to their community, with attendant responsibilities rooted in shared racial heritage. While the economic mission of the HAG was directly tied to the same conditions that led to the formation of the Artists' Union, its approach to cultural programming differed. The initiatives of the AU, *Art Front*, and the AAC can be located solidly within the context of Popular Front ideology and the FAP rhetoric of cultural democracy. Many of these ideals were shared by members of the HAG, but its cultural agenda originated in discourses that had evolved decades earlier. In that sense, while emblematic of the impulse to organize in the 1930s, the HAG existed in a different space of cultural meaning and significance. It can be only partly explained by the economic conditions of the Depression, and as a collective body it concerned itself with advocacy in ways distinct from other organizations of the era.

Struggles within the HAG demonstrate the way issues salient to the New Deal era tripped over challenges facing African American artists that were more or less chronic. Black artistic activism in the 1930s frequently intersected with an earlier "New Negro" discourse only partially modified by the realignment of cultural priorities as the nation came to terms with the Depression. As Romare Bearden and Harry Henderson pointed out in their *History of African-American Artists*, the HAG understood itself from the outset in terms of earlier arts advocacy in Harlem. They described an organization whose priorities were to further the interests of its members in concrete economic ways, while also contributing to the projects of education and outreach that had been going on since the 1920s when these tasks fell to multiple civic organizations. HAG constituents saw in the FAP a new kind of patron, one that offered both direct financial subsidies and a sense of belonging vastly different from that offered by the Harmon Foundation, which seemed patronizing and controlling by comparison. But the progress

achieved by government support notwithstanding, HAG members continued to engage in debates about the aesthetic and logistical issues that affected mainstream recognition of Black artists, a major preoccupation of the previous decade. And despite claims about the coming of a new age in which African American artists would be able to escape the paternalistic interests that had determined their fate, ties to prior institutional and rhetorical structures were never fully broken.

During the interwar decades, the overarching narrative of African American art remained one in which the boundaries between reaction and advocacy and between economic and cultural issues were neither entirely clear nor particularly meaningful. Cultural activism, irrespective of organizational affiliation, was fundamentally about increasing the recognition of Black artists and improving their economic status. This required a multifaceted approach, begun in the 1920s, which included providing opportunities for instruction, generating exhibitions to raise professional profiles and encourage sales, and advocating on their own behalf in both specific organizations and the larger Black community. The HAG was also committed to fostering basic cultural education and to providing a forum for advancing complex debates about aesthetic issues that had their origins in a very different historical context. As an organization, the HAG sought to carry on the crucial work of its predecessors even as it carved out a unique role for itself in the activist climate of the 1930s.

Visibility

Like many Negro art shows in the early twentieth century, the March 1935 neighborhood exhibition, sponsored by the Harlem Art Committee, displayed contemporary African American art with African sculpture. Underscoring a continuity promoted by writers such as Alain Locke, the organizers expressed the hope of educating their community and stimulating interest in the noble artistic traditions of their race, which extended from the culture of ancient Africa to works being done today.[1] A year later, the FAP district headquarters in Harlem hosted an event called the Harlem Festival and Exhibit, jointly presented by a citizens' committee and the WPA, showcasing cultural work supported by the government art projects. As reported in the *Amsterdam News*, the exhibit spread out from the building to the courtyard, around the corner to Augusta Savage's Uptown Art Laboratory, and to a nearby church that displayed works by the members of the HAG.[2] The guild show was reviewed by *Art Front*, which stated that "within a few years the American Negro painter will stand alongside the musician as an important contributor to American culture."[3] Notably absent from the WPA Harlem festival and its coverage was the presence, either actual or rhetorical, of African art.

Before the FAP, the work of African American artists was seen primarily in Negro art shows organized by Black communities, often with the support

and cooperation of groups like the Urban League and the Association for the Study of Negro Life and History. From the late 1920s until it suspended its exhibition program in the mid-1930s, the Harmon Foundation operated as the primary promoter of so-called Negro art on a national scale. Other organizations, such as the College Art Association, worked with and through the HF to realize similar group shows. The formation of the FAP marked a turning point in the view of many Black artists, who went from being a neglected cohort of creative Americans with limited visibility to membership in an officially recognized category of the deserving unemployed. They joined the ranks of a professional class that suffered from both the collapse of the financial markets and the long-standing failure of the public to recognize their inherent value to American society. From the start, these shared circumstances encouraged optimism about the possibilities for Black artists eager to achieve mainstream recognition and participate in the creation of a new, more democratic American culture.

In addition to the practical reality of financial support, one much-anticipated change foretold by the philosophy of the FAP was a shift from the standard practice of exhibiting "Negro artists" as a separate group toward their broader representation in general shows devoted to American art. But the Negro art show never entirely disappeared, and it is worth noting the extent to which the FAP itself embraced this model despite its inclusive rhetoric and nominally race-blind policies. As FAP programs evolved, Negro art shows were recognized as both desirable and necessary, strengthened, their supporters argued, by the boost in visibility and training afforded to Black artists by the projects themselves. This idea was promoted in initiatives such as the extensive *Exhibition of Negro Cultural Work* held at the HCAC at the end of the decade, an impressive roster of artistic achievement supported almost entirely by WPA initiatives and displayed in a high-profile FAP institution focused on Black cultural expression.[4]

At the same time, very few African American artists were featured in the large curated national exhibitions of American art that sought to take the pulse of new "democratic" American art at the end of the decade.[5] The failure of the FAP to increase the status of Black artists consistently and effectively on a national scale can be explained in part by the nature of its exhibition program. Widespread dissemination of art and visual culture to the larger public was a foundational principle; the exhibition program of the FAP consisted of multiple facets designed to accomplish

different things in service of this mission. It sought to bring artists and the public closer together in CACs by increasing exposure to art among non-traditional audiences and encouraging amateur artistic practice. But it also used the exhibition program to showcase work produced by project artists, exemplifying the inherent value of the various creative divisions. As Mary Morsell of the FAP exhibition division explained, allocation exhibitions sent to CACs and other educational venues upon request worked together with invitational and curated exhibitions mounted in museums to present a robust and diverse cross-section of project art.[6]

It was not unusual for the work of amateurs and children to be shown together with that of professional artists, even in national shows, thus underscoring the significance of cultivating talent and artistic interest at the grassroots level. This practice exposed Holger Cahill to criticism from those whose primary allegiance was to a form of government art support that focused on excellence rather than quantity and process. But recent New Deal historians have explained this mixture as fundamental to Cahill's populist and democratic platform, which sought to erode elitism and expand audiences.[7] The merging of the amateur and the professional had been a staple in Negro art exhibitions from the start, especially in places like Harlem, where workshops flourished long before the FAP exerted its influence. It is arguable that this practice had very different implications in a minority community whose professional artists were both stereotyped and systematically excluded from mainstream art institutions, especially commercial galleries. Nonetheless, this exhibition model was infused with new meaning in the context of the FAP; it became ideologically valuable and significant rather than simply an expedient way to accommodate the practical realities African American artists faced.

Black artists fared reasonably well in the allocations of project work that made up exhibitions circulated through the education programs, but their numbers were limited in the signature FAP "representative" exhibitions of American art. This situation was certainly influenced by Cahill's knowledge that the number of Black artists on the creative projects was proportionately small. But it also reflects a jury selection process that embodied his notion of artistic democracy as largely a matter of celebrating regional and stylistic variations. Regional variation was a primary determinant of subject matter, while stylistic classifications suggested aesthetic alignment. As regional signifiers, Black subjects were not linked to the race of the artists. And while

there may have been assumptions about a "Negro" approach to art held over from the previous decade, it did not rise to the level of national importance as a stylistic phenomenon. Cahill was proud of the opportunities the FAP provided Black artists, but to elevate their status on a national stage he ultimately turned to a model of all-Black art shows established long before the New Deal took shape.

NEW YORK CITY MUNICIPAL ART GALLERIES

Most African American artists employed by the projects were located in the New York metropolitan area. For this cohort, another initiative that ran parallel to the FAP might have held similar opportunities for their increased visibility. Early in 1935, a citizens' committee convened by the mayor the previous fall began planning for the opening of an exhibition space known as the Municipal Art Gallery (MAG), which would show and offer for sale works by New York City artists. This initiative grew out of the Artists' Union's demand that the city provide jobs for unemployed cultural work- ers and a space for artists to exhibit and sell their work. The MAG system created by this committee operated outside the WPA, although the latter provided some financial support, and many of the exhibiting artists were on the projects.[8]

Use of the MAG was essentially determined by artists who organized themselves and applied to exhibit in the space. The original facility could accommodate multiple group shows at a time that were generally up for three weeks. Marchal Landgren, who directed the gallery program, recalled that in 1936, its first year of operation, 750 artists participated in sixty-eight group shows. The space was frequented by artists and the general public alike; purchases could be made directly from the shows, and artists benefited from the attendance of dealers, who might be inclined to represent them in the future. The Municipal Art Committee also held annual retrospectives that consisted of select works representative of the group shows. In 1936, 1937, and 1938, the MAG hosted national exhibitions of American art as part of its annual summer festival. These were presented in conjunction with state authorities, who selected regional artists or held competitions for entry.

MAG exhibitions were organized around the concept of affinity, or what Landgren called "family resemblances," which was loosely understood to mean a group of artists with something in common.[9] Typical themes might

be master-student relationships, engagement with a particular medium, shared stylistic interests, or expressive intent. To avoid labeling that might encourage critical bias, the shows were simply numbered. A proposal that established artists who already had exhibition opportunities be excluded was rejected in the interest of avoiding negative stigma that might shape public opinion of lesser-known artists. The goal was to present the widest possible range of work without the dominance of any tendency or cohort. This democratic approach was echoed in the emphasis placed on public taste rather than deference to professional judgment. The annual retrospective included works selected by the artists' groups as well as those voted on by visitors, even when these judgments were at odds.

Some of the group shows consisted of individuals who belonged to regional art societies and organizations. For example, members of the Bronx Artists Guild, the Staten Island Artists, and the Brooklyn Society of Modern Artists exhibited together, and the AU also sponsored shows. Given the scope and organizational premise of the MAG initiative, one might reasonably expect to find some presence there of New York City–based Black artists, but that was not the case. Black artists do not appear to have participated in the shows as individuals, and the Harlem Artists Guild was not visible as an organization with obvious affinities that might have availed itself of the space. This can probably be explained by the overlap between this program and the initiative to establish a CAC in Harlem. In a report of the Municipal Art Committee summarizing the scope of its activities from 1935 to 1938, the completion of plans for the HCAC is noted. The municipal galleries had operated out of temporary spaces until December 1937, when a permanent facility was secured. The timing overlaps directly with the inauguration of the HCAC. This suggests that the HCAC's creation was understood as a kind of alternative means of accommodating the needs of Black artists separate from those of other New York City–based groups and practitioners.[10]

THE HARLEM COMMUNITY ART CENTER AND THE HARLEM ARTISTS GUILD

Accounts of the HCAC have demonstrated that the cultural landscape in which this groundbreaking institution was formed and operated made it unique in the universe of CACs. As has been noted, it grew out of community arts activity that predated the FAP, unlike many other CACs across

the country that were opened to generate artistic excitement in areas where there was none. Once established, it functioned simultaneously as an art center for the people of Harlem and an exhibition space and training facility for Black artists aspiring to professional status. This complex identity is linked to the circumstances of its origins, which drew energy from civic-minded citizens and practicing artists alike. In his book *Federal Relief Administration and the Arts* (1969), William McDonald explained the eventual metamorphosis of the HCAC into a de facto art school in terms of the emerging need to place energy on technical training for artists rather than encouraging art as a hobby.[11] But the HCAC nonetheless remained a community art center, with the HAG operating as a kind of professional branch whose members not only staffed and ran the center's educational programs but also organized exhibitions and pursued external opportunities to promote the work of its artists.

Once the HCAC was established, HAG meetings were held there, and the two organizations became so closely connected that the lines between them seemed at times to blur, particularly during the final years of the decade, when Gwendolyn Bennett was deeply involved in the administration of both. Their financial support systems were different; like all CACs, the HCAC relied on funding from various sources, including civic groups in the Harlem community and the administrative structures of the WPA. The HAG was financially dependent on dues-paying members and occasional fundraising events that it sometimes undertook jointly with the HCAC. Some HAG members raised concerns about sharpening the distinction between the two groups so as to ensure adequate resources for both operations. In January 1939, Sollace Glenn renewed his earlier recommendation that the Harlem community ask the mayor about establishing a MAG in Harlem, proposing a site on 135th Street.[12] This suggests that the HCAC was not necessarily an adequate alternative to having a federal art gallery for Black artists unburdened by the additional functions of a CAC.

To an extent, the approach to cultural programming at the HCAC mirrors that of the FAP overall, in which artistic vitality and creativity were closely linked to education and the cultivation of grassroots enthusiasm. Holger Cahill made this connection often, including at the opening of the HCAC, where he stated, "no great artist comes out of schools and colleges of art but out of centers like this."[13] That said, the HCAC fulfilled multiple

functions that were typically assigned to separate divisions in the FAP. And the members of the HAG simultaneously struggled to advance the interests of Black artists within the projects themselves and to ensure the success of the HCAC. The strategic alliance between the HAG and the HCAC grew out of the need to merge the functions of an artists' advocacy organization, a municipal art gallery, an art school, and a community art education program into a hybrid entity whose goals and activities were at times difficult to reconcile.

The differences between these "branches," and their complicated relationship with the projects, were cast into sharp relief in 1938, the first full year of the HCAC's operation. The 1938–39 season began with an elaborate proposal from Sollace Glenn to enhance the visibility of work by HAG artists in Harlem. Glenn believed that the guild could exercise considerable influence within the community through a proactive plan to raise the profile of its artists. His goal—to get the work out in the interest of encouraging sales—was widely shared by the membership. At the 11 October meeting, Glenn noted that shops on 125th Street could replace the "stereotypical" art they customarily showed with work by members. He also proposed that the guild form what in effect would be a "workshop" collection, from which allocations could be made upon request, thus avoiding inefficiencies when requests came in.[14]

In a follow-up discussion, Glenn suggested that the Harlem arts community seek ways to capitalize on the large influx of tourists expected to visit the New York World's Fair, scheduled to open the following spring. This could not be accomplished by individuals, Glenn believed, but would require the coordinated efforts of various organizations, including the Harlem Citizens' Cooperative Group, the Harlem Chamber of Commerce, and the City Chamber of Congress. He also advised that the Black community demonstrate its understanding of "the tie-up between industry and art," echoing a theme that had long preoccupied arts activists in Harlem and had strong resonance in the federal art projects as well. Glenn's extensive recommendations were directed at immediate actions that collectively would galvanize the World's Fair audience and in so doing create a lasting impression of Negro art:

1. We must have portfolio of prints and watercolors to place in stores that sell art—Wanamaker's, Macy's and Bloomingdale's. Whether

we sell or not we will get publicity. Hearn's, Bloomingdale's and McCreery's use art for decorating purposes.... Through Harlem Board of Trade we can make overtures to small business men. We could rent paintings in exchange for goods.

2. There will have to be at least three representatives on this committee who will be able to talk to the people in the department stores and show our work. There will be a[n] agent on this committee so your money will be protected.

3. We should have a Municipal Gallery in Harlem for World's Fair show; what we need is a gallery. If we appeal to the Mayor and his Committee I am sure we will get it; it is not an expensive proposition.

4. We should lend paintings to professional people (doctors, lawyers, etc.) in Harlem so that people visiting offices can see them.

5. We must have neighborhood shows in Harlem, either outdoor or indoor—a Caravan show in which you have a number of paintings in a truck and someone in charge to go into a neighborhood and show these paintings one at a time.... It will focus public opinion right on this community (the artists in).

6. Social Committee—during the World's Fair we will have to have rounds of studio parties in which visitors go from artists' home to the other. We should have a Harlem Arts Ball—a ball to end all balls.

7. Housing Information Service—When out-of-town artists come here we should be able to tell them where to go to live cheaply.

8. Sketching Meets—In order to get publicity all artists get together at a specified location and sketch.

9. Coordination with other groups—we should get cooperation of all groups and have an Artists' Union Week during which time we would have definite programs, discussions. etc.

10. We should have an executive secretary of the Guild whose work it would be to attend to all of our business problems ...

11. I should like to urge every member present to be sure to get a copy of the "Negro's Contribution to Art" by Professor Charles C. Seifert ...

12. In closing I should like to remind you that Augusta Savage is the first member of the Guild to do an important piece of work. We should make her honorary president of the Guild as gesture of our esteem.[15]

At around the same time, as the HAG was considering ways to raise the visibility of professional arts activity in Harlem, the HCAC hosted an exhibition called *Art and Psychopathology* that was sponsored by the teaching division of the projects and Bellevue Hospital. The FAP press release described it as "the first comprehensive and orderly presentation of the art of mental patients."[16] The show came into being in the wake of studies commissioned by the FAP on the impact of art in treating psychiatric patients. In her contribution to *Art for the Millions*, Bennett mentions the exhibit with pride, noting that it was a glimpse into how delinquent and maladjusted children could become "stable material" who would grow into future citizens.[17] Several New Deal historians have noted the significance of the *Art and Psychopathology* show, but none has questioned the implications of mounting this show in Harlem or examined it in light of the complex and overlapping agendas of the HCAC and the HAG. Attention has been largely focused on the research that led to the show itself and on the importance of art teaching within the overarching philosophy of the FAP in general and the CACs in particular.

Jonathan Harris writes at length about the *Art and Psychopathology* exhibition and suggests that the FAP-sponsored research had confirmed the utility of art in developing the coherent sense of self required for mental patients to reenter society successfully. He characterized FAP teaching overall as a process that contributed to the wholeness and wellness of children, making them better future citizens, a sentiment that echoes Bennett's description of the exhibit. According to Harris, these programs became an attempt to place therapeutic artistic creation in the service of the larger FAP goal to unite citizens in the New Deal nation-state. The importance of art education and its relationship to the psychological and social health of children were staples of FAP discourse, especially with respect to the development of CACs. As Sharon Musher observes, health care, education, and social work professionals were enthusiastic about the positive potential impact of the arts on the poor and vulnerable members of society. They joined community leaders who believed that art classes could help combat delinquency by providing an outlet for aggression and other pent-up emotions. Joan Saab notes that the popularity of the exhibition and the widespread attention it received helped bolster the image of the FAP as socially useful.[18]

The research in question involved FAP art teachers' building on previous experiments by mental health care workers at Bellevue who investigated

how nonverbal forms of communication such as art might aid in the iden-
tification and expression of repressed tendencies in their patients.[19] The
foreword to the FAP's brochure on the *Art and Psychopathology* exhibit
states that material in the show did not result from traditional art classes in
which an instructor taught in the customary sense. Instead, patients were
stimulated to paint and draw as the instructors observed and took notes.
A report on these experiments published by one of the participating mental
health professionals noted that graphic art was a means of establishing a
rapport with patients who had difficulty expressing themselves, and that
it served as a window into the unconscious. Both the experience itself and
the knowledge gained were said to have therapeutic value. The director
of the FAP's teaching division stated, without elaborating, that this work
also had important implications in the field of aesthetics.[20]

The exhibition brochure organizes the works into multiple categories
differentiated by diagnosis, ranging from schizophrenia and encephalitis to
various kinds of emotional problems experienced by children, adolescents,
and adults. There are also categories of works by healthy individuals, such as
children's figure drawings and abstractions. For example, "Scribblings and
Abstractions by Children" is followed by "Use of Primitive Form Principles
in Mental Defective Children." In the section titled "Adult Psychoneuro-
ses and Psychoses," the category schizophrenia includes sixteen entries,
of which approximately half are nonfigurative. These works have descriptive
titles such as "Pastel Abstraction," "Pastel Geometric Figures with Writing,"
"Purple Scribbling," "Primitive Forms with Writing in Crayon," "Primitive
Body Image in Red and Black," and "Primitive Concentric Circles in Red
and Yellow."[21] According to Saab, the show created a comparative context
in which creations by so-called normal children and adults were exhibited
with those produced by individuals who suffered from a variety of psycho-
logical disorders. This was meant to underscore the differences between
the untutored mark making of children and amateur artists from the visual
expression of the mentally ill.[22] While Saab correctly reasoned that such
juxtaposition aided in differentiating the images produced by the "healthy"
from those by the "unhealthy," it is worth noting that the word "primitive" is
used only to describe the works created by the patients and in one category
to reference the work of a nonwhite child.

Scholars have recognized that the multiple allusions to primitivism in
the context of discussing the art of children and psychotics created a kind

of outsider discourse that supported the research findings, but in the main they do not find the show itself problematic. It seems reasonable to ask why it took place in Harlem, or at the very least to note the obvious implications of its unfolding against a backdrop of well-known critical tropes such as racial primitivism and presumptions about African American artists as naïve creators. Instruction in the Harlem art workshops that preceded the FAP educational initiatives stressed spontaneous expression and the importance of not limiting the production of children by insisting on the mastery of traditional artistic conventions. This practice was continued in the projects and in both cases resulted in the frequent stereotyping of art made by African American children.

Black professional artists, on the other hand, sought to increase their knowledge and status by learning from the HCAC instructors, many of whom came out of the mainstream art world. These experiences took place in a space that alternately showed the work of amateurs enrolled in FAP classes, artists associated with the HAG, and, in the *Art and Psychopathology* show, the mentally ill. What these three categories have in common was a critical lexicon in which the word "primitive" is applied to describe what is produced. Notwithstanding the attempt to differentiate the normal from the mentally ill, the context of this exhibition could only complicate the relationship between African American artists and a racialized critical discourse that had vexed them for decades.[23]

ALAIN LOCKE AND THE RETURN OF THE NEGRO ART SHOW

By the end of the decade, the renewed vitality of Negro art shows and initiatives can be explained as both a function of the FAP and a reaction to it. It is clear that professional artists operating in Harlem never regarded federally funded programs as the ultimate solution to their visibility challenges. Members of the HAG regularly exhibited as a group in venues independent of the projects, and they were keenly aware of their circumstances as temporary. Shortly after the May 1939 "Negro Culture Faces World of Tomorrow" conference, which considered the future of Black culture in the wake of the government-sponsored art programs, Augusta Savage launched the Salon of Contemporary Negro Art. The gallery opened to much fanfare and attracted a mixed-race crowd that included the prominent writers Max Eastman and Sherwood Anderson. In her opening remarks, Savage explained

that she was attempting to address a long-felt need that Black artists should have their own gallery with professional standards of presentation. Many of the participating artists would have been familiar to anyone following the Negro art scene either through the Harmon Foundation shows or the activities of the HAG and the HCAC.[24]

As the FAP underwent reorganization and funding cuts, Black artists increasingly looked to earlier strategies and alliances to increase their visibility in an artistic landscape that remained largely segregated. Savage's salon opened several months after Sollace Glenn had proposed that the HAG pressure the city to open a municipal art gallery in Harlem. These events took place in the aftermath of what was regarded as the most important Negro art exhibition of the decade, *Contemporary Negro Art*, organized by the Baltimore Museum of Art in February 1939. The Baltimore show, according to Jeffrey Stewart, was evidence of Alain Locke's reemergence as a major critical voice and arts entrepreneur. Locke continued to benefit from his long-standing ties to the Harmon Foundation and also had a productive relationship with the FAP, which had come to function much as the HF had before it: as an arbiter of standards and a major source of information on so-called Negro art. The ambitious art exhibitions and government-sponsored public art commissions that targeted Black artists during the final years of the projects came about through strategic collaborations within an expanding network of promotion. Locke once again stood at the center of this matrix, signaling a shifting power dynamic away from Harlem in general and the HAG in particular.

Stewart points out that it became increasingly evident, as the FAP began to wind down, that the HF remained the only organization capable of raising the profile of African American artists on a national level through exhibition organizing. Thus Locke's continuing relationship with the foundation gave him an advantage.[25] The HF had acted in an advisory capacity on the Baltimore show, and when Locke became the official coordinator of the extensive exhibition planned for the American Negro Exposition of 1940 in Chicago, he brought in the HF's director, Mary Brady, for logistical support and to extend the show's outreach and impact. HAG critics of the HF like Augusta Savage and Romare Bearden were not included in the Baltimore show, nor was Gwendolyn Bennett, who had replaced Savage as director of the HCAC and was on the executive board of the HAG. That said, some of the artists active in the HAG at the end of the 1930s were selected, including Norman Lewis, Sollace Glenn, Ronald Joseph, and Fred

Perry. The issue does not seem to have been the HAG per se but rather vocal criticism directed at the HF, specifically from members who had taken a stand against its policies and influence.

Locke's authority was reinforced by the completion of several important projects in the final years of the FAP. His oversight of the art exhibition for the 1940 American Negro Exposition in Chicago coincided with the publication of his critically acclaimed portfolio volume *The Negro in Art: A Pictorial Record of the Negro Artist and the Negro Theme in Art.* In the fall of 1940, moreover, he was appointed to the board of National Art Week, an initiative started in the 1930s to promote the exposure and sale of works by American artists. Then, in December, he was invited to select works for an exhibition at the Library of Congress being held in conjunction with the seventy-fifth anniversary celebration of the Thirteenth Amendment. This was followed, in 1941, by his collaboration with Edith Halpert on a ground-breaking exhibition of Negro art at the Downtown Gallery. In all of these endeavors, Locke carefully managed the complex constituencies invested in the development of African American art and sustained the relationships necessary to ensure his continuing role in shaping its vision.

As the New Deal government art projects increasingly shaped the cultural landscape, one loss was the continuity Locke had long insisted on between Black American artists and the legacy of ancestral Africa. His writings in the 1930s moderated this connection somewhat, as the ascendance of cultural nationalism in American art seemed to contain promise for the increased visibility of Black artists.[26] But Stewart points out that he was disdainful of what he understood to be objections on the part of some New York City–based Black artists to the proposal that they exhibit at the World's Fair in the international pavilion alongside African art. These artists insisted that their work be seen in the American gallery, and from Locke's point of view this rejection of identification with African art was misguided. Stewart explains Locke's frustration with these artists as emblematic of both his growing Black nationalist views and his impatience with the ideological thinking of the HAG. "Black artists exhibiting at the fair thought of themselves only as representatives of the American nation," Stewart writes, "when America did not even consider them citizens."[27] While Stewart emphasizes Locke's increasingly militant political views, the resistance of the younger New York artists was also anathema to Locke's position as a theorist and critic. In the mutually reinforcing contexts of

his seminal publication *The Negro in Art* and the American Negro Expo in Chicago, Locke seized the opportunity to restore the connection between African artistic heritage and American Negro art, a position central to his thinking for decades that now received renewed emphasis.

The American Negro Exposition, explicitly tied to the Thirteenth Amendment's seventy-fifth anniversary, became known as the Negro World's Fair. Held in Chicago during the summer of 1940, it overlapped directly with the second season of the New York World's Fair and the Golden Gate International Exposition in San Francisco, both of which included exhibitions of modern American art in which there were very few examples of works by Black artists.[28] The art displays at the American Negro Exposition, by contrast, consisted of multiple parts, including a juried exhibition of contemporary art and two memorial shows, one devoted to early African American artists such as Henry O. Tanner and E. M. Bannister and another to the more recent figures Malvin G. Johnson and Albert A. Smith. There was also a small selection of works from the HF, a display of children's art from the FAP, and an exhibit of African art. In the introductory statement written by Locke, who chaired the art committee of the Expo, the exhibitions were described as "the most comprehensive and representative collection of the Negro's art that has ever been presented to public view."[29]

The National Art Committee of the American Negro Exposition included Mary Brady of the HF, James Herring and James Porter from Howard University, and a number of prominent African American artists from across the country. Alonzo Aden served as curator, selections for the contemporary exhibition were made by separate juries representing the eastern and western United States, and a third jury determined awards. In sum, this was a veritable Who's Who of prominent figures in the Negro art world working in tandem with administrators from the various government art projects and museums. Daniel Catton Rich, director of the Art Institute of Chicago, served on both the western and awards juries, and the eastern jury included both Holger Cahill of the FAP and Edward Bruce, who directed the US Treasury Department's Section of Fine Arts. Locke, who is listed in the program as a consultant for the Harmon Foundation, sat on the eastern and awards juries. Sculptor Richmond Barthé (eastern) and painter Archibald Motley (western) were on the selection juries, as was the Chicago-based illustrator Charles Dawson, who served as the sole African American artist on the awards jury; that jury also included

two representatives from the Illinois government projects: George Thorpe, who directed the Illinois FAP, and Peter Pollack, a supervisor who would become the founding director of the South Side Community Art Center.

While the Chicago exhibition established a historical frame for Negro art that included African art, in this context Locke also tied the work of modern Black artists to mainstream trends in the development of a characteristically American art, a common theme in his writings. A wide range of subjects and styles was very much on display, markers of both the professional maturity and the diversification of Black artists. While Locke underscored the ground shared by artists working in America at this historical moment, he also cast the Chicago Expo as a narrative of progress in terms of both skill and expressive depth. "More and more," he wrote, "you will notice in their canvasses the sober realism which goes beneath the jazzy, superficial show of things or the mere picturesqueness of the Negro to the deeper truths of life, even the social problems of religion, labor, housing, lynching, unemployment, and the like."[30] Notably, the first-place prize in the category of oil painting went to a work titled *Man with Brush*, a self-portrait by Georgia artist Frederick Flemister that references the deep historical roots of this genre in Western painting.[31]

The exhibitions of the American Negro Exposition were closely linked to the publication of Locke's groundbreaking book *The Negro in Art* and mirrored its central themes; collectively, they were a vivid example of Locke's underlying approach to the history of what he called Negro art, experienced in real time on a massive scale. This was a major triumph for Locke given the uncertainty he faced in the years prior to the book's publication. He had originally conceived of *The Negro in Art* as an extension or updated version of his Bronze Booklet from 1936, *Negro Art: Past and Present*, in which he explained the concept of Negro art as constitutive of both the cultural production of Black people and that which takes Negro life as its subject irrespective of the race of the artist.[32] Three parts were proposed for the second book: the "Negro Theme in American Art"; "Work of American Negro Artists"; and the "Negro Subject in European Art (optional)." As published, this initial outline and content changed; the first part became devoted to the Negro as artist, the second to the Negro in art, and the third to the ancestral arts. The first part showcased primarily American artists, while the second was more international, thus collapsing the first and third parts as outlined in the original proposal.[33]

Frederick Keppel of the Carnegie Corporation was unsympathetic to the general principle that race was a compelling category of artistic analysis, a position against which Locke pushed back with eloquence and resolve. He described the project as a powerful educational vehicle that would both stimulate racial pride and encourage Black artists. In response to Keppel's comments, which characterized the project as a "mistaken" enterprise, Locke surmised that were the focus solely on Black artists there would be less of a problem with respect to emphasizing race. But his commitment had always been to establish the larger context in which the Negro as an artistic subject and producer emerged.[34] And he stressed in the book's foreword that "care has been taken not to misconstrue the art of the Negro as a ghetto province in the world of art."[35] As Jeffrey Stewart explains, the structure of the book enabled Locke to craft a narrative in which Black artists are connected to both European and African art, thus establishing a "world tradition of announcing Negro subjectivity through art" that is not connected to the skin color of the artist.[36]

In his search for images of works by African American artists, Locke benefited greatly from his positive relationships with both the HF and FAP; he thanks these organizations and acknowledges their leaders by name. The FAP in particular looms large in this project and is celebrated by both Locke and the FAP administrators to whom he expresses gratitude. In his introductory remarks for part I, "The Negro as Artist," Locke identifies an emergent self-realization among modern African American artists but cautions that this cannot be fully achieved without adequate support and recognition. While the HF shows brought attention to the work of Black artists, it was the FAP that rescued them from the oblivion threatened by the Depression: "The generous inclusion of the Negro artist in these programs has not only saved the very existence of creative art among us, but, as numerous acknowledgments will indicate, has been responsible for the production of the present flowering of the younger Negro art."[37] Locke specifically mentions the importance of the CAC mission to bring art to the people, especially in the South, and the crucial role of the centers in reconnecting Black artists with folk materials from which they had become estranged.

Locke's success in raising the visibility of Black artists in these multiple contexts had a cumulative effect and quickened the pace of his initiatives. When Archibald MacLeish, Librarian of Congress, wrote to Holger Cahill in November 1940 of his plans for an exhibit hosted by the Library of

Congress to mark the seventy-fifth anniversary of the Thirteenth Amendment, he mentioned that he had been in conversation with Locke, who wanted to see a representative show of contemporary Negro art as part of the celebration. Locke had suggested to MacLeish that 40 percent of the show be derived from the Chicago project, 40 percent from the New York area, including the FAP and the HF, and the remaining 20 percent from Atlanta and DC.[38] The multilateral collaboration emblematic of early 1940s Negro art promotion was very much in evidence in this project. A December press release announcing the exhibit, called *Creative Art of the American Negro*, indicated that the show had been assembled by Locke, MacLeish, Cahill, and Mildred Holzhauer, director of the WPA's Art Program Exhibition Section. It also identified contributing institutions, including the Howard University Gallery of Art, the HF, and the FAP. Material from the FAP came mainly from New York and Illinois, but the Florida, Pennsylvania, Delaware, and Massachusetts projects were also represented.[39]

The narrative description of the show emphasized the emergence of the African American artist as an award-winning professional whose development had been fostered by varied institutions, among them the HF, HBCUs such as Fisk and Howard, and, most significantly, the FAP: "Government patronage has been a dynamic stimulus in the past five years, through employment of Negroes on the WPA Art Program and the Section of Fine Arts of the Public Buildings Administration, and through the formation of WPA community art centers in fertile fields. These government developments have given opportunities and incentive to eager minds. The rapid maturing of the Negro into more original expression during the past five years is evident in the present exhibition."[40] The press release combined well-worn approaches to Black artists, such as stories of persistence in the face of hardship, with acknowledgment of awards and honors achieved in juried shows and selective museum exhibits. Individuals singled out for special recognition included Eldzier Cortor, whose trajectory from sign painter to professional artist was compared to that of the early colonial Americans; Archibald Motley, who stood "in the vanguard of present-day artists of his race"; and Samuel Brown, whose work was now widely recognized and frequently cited by FAP administrators eager to promote the success of its programs.

Framing the show as evidence of professional development among Black artists effectively encouraged viewers to move past the notion that Negro art was being discovered, although critics continued to suggest that until

now it had not received much attention. Rather, the Library of Congress show invited examination of the work in terms of specific strengths that might not have been visible a decade earlier. A reviewer for the *Washington Post* characterized the exhibition as manifesting the technical prowess of skilled, intelligent, professional artists, not tentative amateurs. Another critic recognized the compelling variety in subject matter that documented national life as Black Americans experienced it, from cotton pickers, jitterbugging, rural southern shanties, and urban squalor to elderly Black people quietly reflecting on memories of slavery from their youth. Nonetheless, references to inherent Negro characteristics, a staple of earlier criticism, persisted. Reviewers wrote of Black people's love of color, their feeling for sculptural design, and a strong sense of rhythm often associated with Black music. These timeless qualities now worked in tandem with a modern sense of awareness about daily life and a more educated technique.[41] An abridged version of the LOC show, selected by Cahill, was eventually circulated by the American Federation of Arts as a traveling exhibition.

THE RECORDER OF DEEDS INITIATIVES

In addition to exhibitions, visibility could be enhanced through the receipt of commissions to produce public art underwritten by the government projects. African American artists were enlisted as both supervisors and assistants on various mural and sculpture programs throughout the country, some receiving individual commissions. They were generally better represented on relief-defined programs like those of the FAP, but some were able to secure assignments from the elite programs run by the Treasury Department. As previously noted, because such programs were competitive and more closely connected with conventional notions of professional achievement, entry was more difficult for artists who had been denied the opportunities that most white artists enjoyed. But by the 1940s participation in the projects had itself become a kind of qualifying factor, and the number of Black artists who might be considered for various commissions increased. It was common practice for administrators to solicit advice and recommendations for new projects from the ever-expanding network concerned with the promotion of Black artists.

A set of commissions for the new Recorder of Deeds headquarters in Washington, DC, exemplifies the complexity of this process in a situation

intended specifically to create opportunities for African American artists. In the early 1940s, several public art projects were undertaken to adorn the agency's new federal office building. According to the historian Sara Butler, the Recorder of Deeds decorative complex holds singular status as an example of New Deal public art guided by a Black patron for adornment of an integrated space in the nation's capital. Drawing on an extensive body of primary sources, Butler explains in detail how William J. Thompkins, the recorder of deeds, lobbied for the new building and carefully selected a decorative program that would centralize Black heroism throughout American history in the context of interracial cooperation. Contrary to the received wisdom that these works functioned largely as commemorative images of African Americans in national history, Butler argues that the various individual projects executed for this space collectively represent an example of incipient civil rights activism.[42]

The works were produced through a series of separate commissions, each with a different set of requirements. They consisted of a set of murals for the lobby, an easel painting documenting the groundbreaking ceremony for the new building, and a commemorative plaque of President Roosevelt. The murals, on the general theme of the "contribution of the Negro to the American Nation," were sponsored by the Recorder of Deeds for the District of Columbia with the cooperation of the Treasury Department's Section of Fine Arts. In the competition announcement, specific subjects for each of the seven panels were described in detail along with technical specifications and supporting bibliography. They included scenes involving Crispus Attucks, patriot of the American Revolution; Benjamin Banneker, inventor and surveyor of the future Capitol Building; Negro participants in the Battle of New Orleans of January 1815; Colonel Shaw's Negro regiment at Fort Wagner in 1863; Frederick Douglass appealing to President Lincoln to enlist Negro soldiers in the Civil War; Cyrus Tiffany's courage in the Battle of Lake Erie in 1813; and Commander Robert Peary and Matthew Henson at the North Pole in 1909.[43]

In keeping with Section of Fine Arts practices, the mural competition was refereed and anonymous; the jury was made up of artists and administrators, among them representatives from the Section, the Recorder of Deeds office, and Howard University. Thompkins had hoped to restrict the competition to Black artists but was apparently overruled by Section administrator Ned Rowan, who had been charged with overseeing the

project. Thompkins was, however, successful in shaping the jury, ensuring that at least one African American would be added to what was initially an all-white jury.[44] The easel painting, by contrast, was an invited commission over which Thompkins seems to have had more discretion. Another competition was held for the plaque, this time restricted to Black artists.

Thompkins viewed this initiative as an opportunity for Black artists to tell the story of American history from their own unique perspectives, and he independently sought advice from artists in the African American community. But he lacked expertise in public art and enlisted Section administrators to handle the logistics; they were responsible for facilitating the commission process and overseeing execution. Sara Butler explains that although Thompkins continued to exercise a great deal of influence over the program, once the Section was brought in, he struggled to retain control of the project. Their priorities also differed. Thompkins was intent on monitoring the content, which included intense focus on race representation and historical narrative, whereas Rowan concerned himself with formal and aesthetic issues, operating within the parameters of the tightly regulated approach to public art that characterized the Section.[45] Notwithstanding the significance of this decorative complex, with its powerful assertion of race agency in the telling of history, the experiences of the African American artists involved reflected the complicated landscape they had to navigate in dealing with a powerful government agency known for its narrow and strictly held ideas about artistic expression.

Although the mural project was open to all American artists, there was a direct attempt to encourage submissions from Black artists. Efforts to assemble a mailing list of potential African American applicants were made long before the official competition was announced. In January 1942, Rowan reached out to Edith Halpert, requesting contact information for the artists who had been featured in the Downtown Gallery show that ran from 9 December 1941 to 3 January 1942. Halpert had already sent him the catalog but replied that because some aspects of the exhibition were assembled by groups, she did not have a complete record of contact information on individual artists. She forwarded what she had and suggested that he be in touch with Peter Pollack at the South Side CAC for the Chicago addresses. Halpert also expressed pleasure that such a competition was "open" to Negro artists because there was great talent in the group. Rowan acknowledged her approval and asked if she would care to comment on specific individuals.

Although she had her preferences, Halpert felt that it was more useful for her to indicate those who, in her opinion, were not well suited to mural work.[46]

In April 1943 William Edouard Scott was notified that he had been awarded the commission for the Lincoln-Douglass panel, the only African American artist to be selected. Scott was completing a large mural project at Fort Huachuca, Arizona, when he drafted sketches for the Recorder of Deeds competition, and he had worried about the quality of the work he submitted.[47] But Rowan conveyed the jury's sentiment that the sketches were to be admired for their sincerity and conviction, qualities he hoped would carry into the completed work. In contrast, Rowan communicated to Hale Woodruff that despite strong coloration and design in the sketches he submitted, there was an exaggerated emphasis on pattern: "The breaking up of small areas becomes a mannerism which robs the design of a feeling of authenticity." Scott sent cartoons for the mural in May, and by midsummer minor concerns were conveyed to him about the composition, including issues involving scale and the proximity of the two major figures. Correspondence regarding the mural's progress continued throughout the fall. In December 1943, in response to photographs of the completed mural, Rowan again offered suggestions about correcting certain passages to retain a balanced level of convincing realism throughout. This emphasis on formal details was not inconsistent with the Section's overall approach to mural commissions, which could be quite heavy-handed. After the murals were installed, Rowan expressed appreciation for Scott's careful attention to his suggestions.[48]

The mural project went smoothly, and in the summer of 1943 Scott was invited to submit sketches for a second Recorder of Deeds commission, an easel painting commemorating the groundbreaking ceremony for the new building. This work does not seem to have developed with the same ease as the mural, in part because Scott was overextended. Thompkins selected the individual participants to be represented in the composition and made photographs of them available to the artist. When asked for a sketch in June 1943 of a work that was to include some twenty-five portraits, Scott requested that he be able to send detailed versions of only a few figures and focus on the others in the finished work. The artist later expressed doubt as to how well he had executed the commission, which he described as the most difficult of his career.[49]

A third commission for a Recorder of Deeds project was announced in June 1943, this one for a dedicatory profile plaque of Franklin D. Roosevelt.

Unlike the previous mural project, the announcement specified that the sponsoring body wished to have the commission go to an African American. Artists whose names were on file (presumably from the previous project) were invited to submit photographs of their works. Some well-known Black sculptors, including Henry Bannarn, Meta Warrick Fuller, Augusta Savage, and Sargent Johnson, responded to this call too late for consideration. In July 1943, the commission was awarded to Selma Burke, who was selected by a jury consisting of many of the same individuals who had served on the mural project. The plaque took two years to complete and was the subject of a great deal of back-and-forth, which captured both frustration with the process and dissatisfaction with the outcome. Underlying the exchanges between Burke and the project's administrators was the apparent judgment that Burke, a prominent member of the Black artistic community, was an artist of limited ability who was susceptible to flattery from her non-Black friends and therefore difficult to advise.[50]

There is no question that the Burke plaque project was micromanaged, even by Section standards. In the spring of 1944, Rowan wrote Burke that while the general layout was satisfactory, the relief details were not adequate to recommend payment. He suggested that she start over, adding, "I would also advise that you look at the best relief sculpture in the Metropolitan and particularly study the Egyptian for simplification and design. They did eyes convincingly and hair and eyebrows with a sense of real design."[51] A month later, Rowan noted improvement sufficient to recommend payment but continued to be concerned about specific aspects of FDR's head. He had arranged for Burke to get critical input from sculptor Oronzio Maldarelli of Columbia University, and he cautioned her to "beware of the praise of people who know nothing of the subject but who are fond of you and would like anything that you do. I want only your best in this work."[52] For his part, Maldarelli told Rowan that his efforts to guide her were futile; he described her attitude during a recent studio visit as indifferent, insolent, and resentful of his criticism. Rowan thanked him for his frankness and expressed doubt about the outcome: "My great fear, as I have expressed it to the artist, is that her own sense of judgement is compromised by the over enthusiastic praise of some of her admirers."[53]

Tension surrounding the project continued into the fall amid threats to liquidate the commission. In November, Rowan heard from the sculptor Ralph Stackpole, who had a similarly negative assessment of the work

and wondered if Burke suffered from the lack of confidence typical of a younger artist. Again, Rowan blamed the problem on Burke's admirers: "One of the sad things is that too many of her white friends praise everything she touches, a situation I experienced in the studio at a time I was to inspect the work. I was contradicted at every turn. She is a completely grand person and I can understand their loyalty and affection for her, but they don't seem to realize that they are not helping."[54] When he conveyed Stackpole's judgments to Burke, he wondered if she might benefit from a second sitting with President Roosevelt. While she agreed to another sitting, she pushed back against Stackpole, who she believed did not share her conception of the project. Stackpole, she claimed, probably expected a more "modernist" and stylized interpretation, whereas her idea had been to create a "common citizen's concept of our leader."[55]

By March 1945, two years after the commission was awarded, Rowan finally seemed to feel that Burke had made sufficient progress. James Herring had reported to Marshall Shepard, Thompkins's successor as recorder of deeds, on a recent visit to Burke's studio with the prominent art critic Walter Pach; both men were impressed with Burke's plaque, and Pach told Herring that he could use his name in recommending the work as a "competent and dignified plastic composition."[56] Mrs. Roosevelt also weighed in with high praise. Rowan's final approval, granted in May 1945, was based on these favorable reactions. Although considered a high point in Burke's career, the Roosevelt plaque process signified the pitfalls for Black artists who found themselves successfully awarded government commissions but not entirely trusted to meet the standard expected.

CONCLUSION

In the early years of the FAP, when CACs were being set up in the South, requests for all-Black exhibitions in the Negro extension galleries were sometimes rejected because there were not enough project-related works to exhibit. By the end of the decade, however, there was plenty of project work and willing partners to create increasingly comprehensive Negro art shows. As FAP priorities shifted in the early 1940s, Holger Cahill continued to emphasize the projects' positive impact on the development of African American artists and to make their work available for exhibitions when it was requested. While the emergence of the FAP did not mean the end of

the Negro art show as a paradigm, it can be argued that the projects gave these shows a kind of national significance they had previously struggled to attain. From the standpoint of the FAP, however, this was a niche concern. When the Worcester Art Museum asked Cahill in the fall of 1941 to recommend candidates from the projects who should be included in an exhibition devoted to American painting from 1930 to 1940, he did not suggest a single African American artist.[57]

It is useful to consider the issue of visibility in the context of canon formation. When Francis O'Connor set out to study the New Deal government art projects, he did so as a way of better understanding the formative aspects of abstract expressionism. Although the research project grew well beyond that focus, the fact remains that O'Connor was working backward from within a narrative that recognized artists like Jackson Pollock as emblematic of a certain level of artistic achievement and importance. Not surprisingly, this early research did little to increase the visibility of the many American artists who worked in the projects but never went on to become significant abstract expressionists, including most Black artists, who were largely invisible in the postwar modernist canon. Be that as it may, by the time the projects were under way, an African American canon had begun to form, partly as a result of Alain Locke's critical writing and the programs of the Harmon Foundation. In addition to asking how the projects shaped a generation of Black artists, it is also important to understand how participation itself altered these evolving critical formations.

To raise questions about the status of Black artists in the FAP hierarchy may seem inconsistent with a programmatic philosophy at least nominally focused on identifying patterns of cultural production rather than individual achievements. Nonetheless, when it came to organizing large exhibitions that exemplified the value of these initiatives in terms of fostering the development of American art, juries were formed and judgments were made. The existence, by the end of the 1930s, of multiple constituencies promoting African American art further complicates questions about canon formation. Numerous organizations and individuals had a stake in tracking the visibility of Black artists in the projects. Both the HF and the HAG collected information on participation, as did Locke and James Porter in the context of their historical and critical writings. But these materials have functioned more as data than as markers of status, the exception being artists who became supervisors (Charles Alston and Augusta Savage) and

those who received commissions on competitive nonrelief projects such as the Public Works of Art Project and the Treasury Department Section (Archibald Motley and Aaron Douglas).

A comparative review of the various contexts in which the works of Black artists appeared during this era suggests that with respect to canon formation, the FAP was mutually reinforcing rather than transformative. Those who had achieved prominence in Locke's early writings, or in HF shows and awards, were consistently included in Negro art shows at the end of the decade and into the war years. This list included Richmond Barthé, Aaron Douglas, Palmer Hayden, Sargent Johnson, William H. Johnson, Archibald Motley, and Hale Woodruff, who by the 1930s were well-known figures in this world. Similarly, many of the same artists discussed in Locke's *Negro Art: Past and Present* (1936) were later illustrated in *The Negro in Art*. This was unsurprising given that Locke himself initially regarded *The Negro in Art* as a portfolio of illustrations based on his earlier writings.

But there are significant differences between these two books. Romare Bearden, Gwendolyn Bennett, Elizabeth Catlett, Ernest Crichlow, Jacob Lawrence, and Norman Lewis, for example, are in the 1940 portfolio but not the 1936 publication. This is partly a function of their ages but is also related to the increased prominence of some artists in the context of the government art projects. There is also quite a bit of overlap between artists included in the later Negro art shows, which were heavily influenced by Locke's judgment, and those whose work appears in the 1940 book but not that of 1936. In the latter category were Eldzier Cortor, Charles Davis, Bernard Goss, Elba Lightfoot, Edward Loper, Charles Sebree, and Charles White.[58]

When FAP administrators turned their attention to opportunities for Black artists in the projects, they consistently referred to a handful of individuals whose achievements they wished to highlight. In this cohort, which included Charles Alston, Samuel Brown, Allan R. Crite, Lois M. Jones, Ronald Joseph, Sarah Murrell, Earle Richardson, and Georgette Seabrooke, were many artists whom Locke had identified in *Negro Art: Past and Present* as examples of the "younger generation." By 1938, when Thomas Parker delivered his Tuskegee talk, the three artists most often singled out by FAP administrators were Alston, Brown, and Crite, repeatedly recognized for inclusion in the 1936 *New Horizons* exhibition at the MoMA.[59] Their dominance persisted even as the accomplishments of other artists grew. Recognition in the

national shows was central to Locke's judgments as well. In *Negro Art: Past and Present*, Locke noted that "the showing of Negro artists in the recent WPA regional and national exhibitions has been striking evidence of the greater productivity of our artists under such sound, liberal patronage."[60]

By many metrics, Charles Alston was the most consistently visible African American artist of this generation. Within the FAP, Alston was chosen as the first Black supervisor, and his work appeared in both *New Horizons* and the American Federation of Arts traveling version of the Library of Congress show. He was also included in most of the independent Negro art shows and was a prominent presence in Harlem-based artists' activities. Looking back on the New Deal art era, Alston recalled his assumption that being able to create work while on the projects would eventually increase visibility. If the work was out there, he reasoned, sooner or later it would come to the attention of a wider public.[61] He advocated something similar when he spoke at HAG meetings about the importance of production and making sure that members were represented in national shows. Visibility mattered but, like many other Black artists of his generation, Alston disliked the label "Negro art" and the isolation of African American artists from the mainstream art scene enacted by organizations like the Harmon Foundation.

Alston's negative view of these shows did not, however, extend to the exhibition organized by Edith Halpert for the Downtown Gallery at the end of 1941. *American Negro Art, 19th and 20th Centuries* was the first show of its kind held at a mainstream commercial gallery. The exhibition was closely tied to the release of Locke's *The Negro in Art* and was sponsored by a committee of prominent citizens that included Mayor Fiorello La Guardia, Archibald MacLeish, A. Philip Randolph, and Eleanor Roosevelt. Among its aims were to raise money for the Negro Art Fund, to promote museum acquisitions of work by Black artists, and to encourage galleries to represent the participants. Because the exhibit took place in a Madison Avenue commercial gallery, it had the effect of increasing the visibility of Black artists with the art public, which Alston believed raised the probability that other gallerists would notice their work.[62] Thus, despite the promise that the New Deal art projects would usher in a new era, Black artists in the 1940s found themselves more or less where they had been when the HF ceased exhibition operations in 1935: with the realization that their visibility, and ultimately their survival, depended on their ability to acquire mainstream gallery representation.

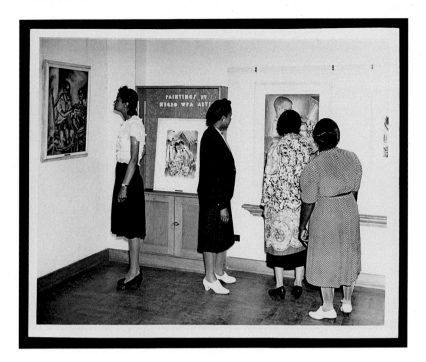

FIGURE 1 Paintings by Negro WPA artists, Crosby-Garfield School Extension Gallery, Raleigh Art Center, Raleigh, North Carolina, ca. 1936–1943. Holger Cahill Papers, Archives of American Art, Smithsonian Institution.

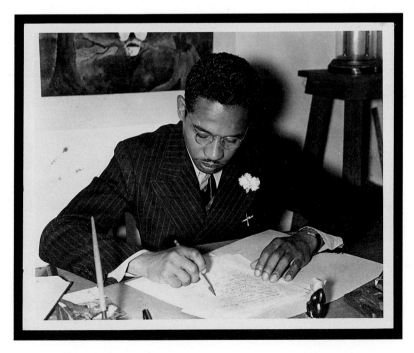

FIGURE 2 Harry H. Sutton Jr., director of the Jacksonville Negro Art Gallery. Holger Cahill Papers, Archives of American Art, Smithsonian Institution.

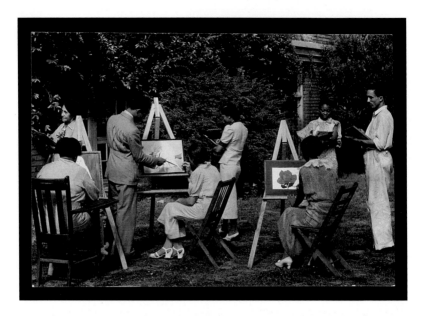

FIGURE 3 Students in art class, Negro Unit, Jacksonville Negro Art Gallery, Jacksonville, Florida, ca. 1936–1943. Holger Cahill Papers, Archives of American Art, Smithsonian Institution.

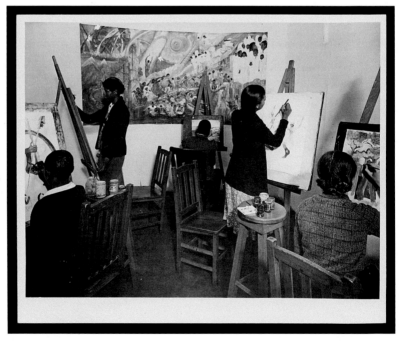

FIGURE 4 Painting class at Jacksonville Negro Art Gallery, Jacksonville, Florida, ca. 1936–1943. Holger Cahill Papers, Archives of American Art, Smithsonian Institution.

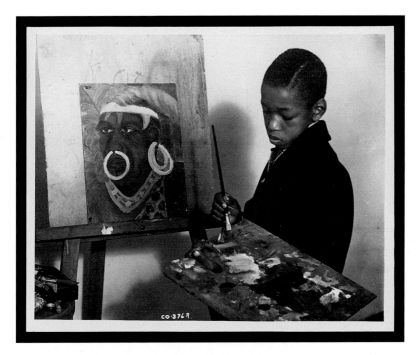

FIGURE 5 *Negro Imagination*, Jacksonville Negro Art Gallery, Jacksonville, Florida, ca. 1936–1943. Holger Cahill Papers, Archives of American Art, Smithsonian Institution.

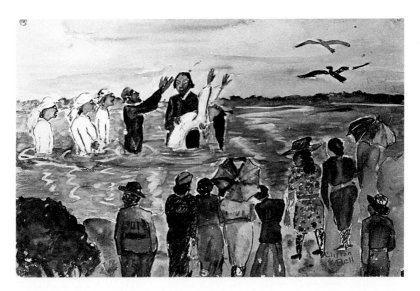

FIGURE 6 Charles Foster, painting created by children at the Jacksonville Negro Art Gallery of the WPA Federal Art Project, ca. 1940. Photo courtesy of the State Archives of Florida, Florida Memory.

(A bit of HISTORY)

harlem artirtr guild
401 Edgecombe Ave.　N.Y.C.

Charles Alston *Chairman*
Aaron Douglas *Vice Chairman*
Louise Jefferson *Recording Secy*

Gwendolyn Bennett *Cor. Secy.*
Augusta Savage *Treasurer*
John L. Wilson *Sergt. at Arms*

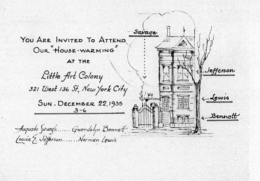

You Are Invited To Attend
Our "House-warming"
At The

Little Art Colony
321 West 136 St, New York City

Sun . December 22, 1935
3-6

Augusta Savage Gwendolyn Bennett
Louise E. Jefferson Norman Lewis

See :

A HISTORY OF AFRICAN-AMERICAN ARTISTS
by Romare Bearden & Harry Henderson
Pantheon Books - New York
Random House 1993

FIGURE 7 Scrapbook page with Harlem Artists Guild logo and an invitation to a "House-warming" at the Little Art Colony on 22 December 1935. Louise Jefferson Papers, Amistad Research Center, Tulane University, New Orleans, Louisiana.

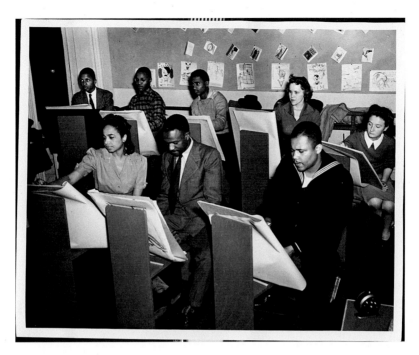

FIGURE 8 Adult art class at the People's Art Center, ca. 1943. Saint Louis Art Museum Archives, Photographs Series D, Box 13, People's Art Center 22.

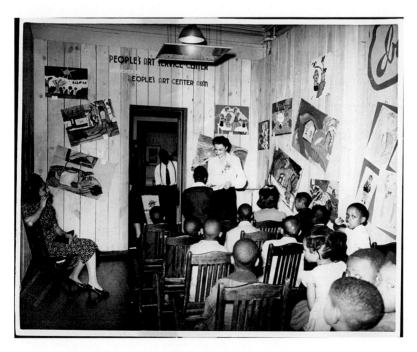

FIGURE 9 Student exhibition at the People's Art Center, ca. 1943. Saint Louis Art Museum Archives, Photographs Series D, Box 13, People's Art Center 12.

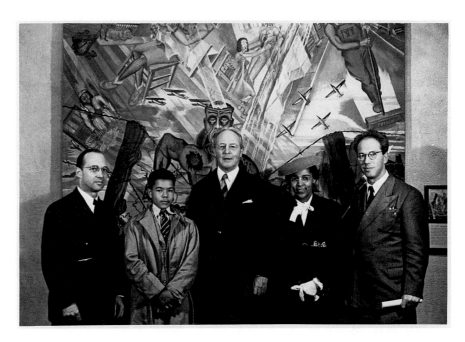

FIGURE 10 Guests at the private preview of the exhibition *Young Negro Art*, the work of students at Hampton Institute, in the Young People's Gallery in the Museum of Modern Art, 11 West 53rd Street, New York, 5 October 1943. *Left to right*: Dr. Ralph Bridgeman, President-Elect of Hampton Institute; Ludlow Werner, son of the editor of *New York Age*; Dr. William Jay Schieffelin, oldest trustee of Hampton Institute; Miss Flemmie P. Kittrell, Dean of Women at Hampton Institute; Dr. Viktor Lowenfeld, psychologist and head of the Art Department at Hampton Institute. Publicity photograph released in connection with the exhibition *Young Negro Art*, 26 October–28 November 1943. Photographic Archive. The Museum of Modern Art Archives, New York. Digital image © The Museum of Modern Art / Licensed by SCALA / Art Resource, New York.

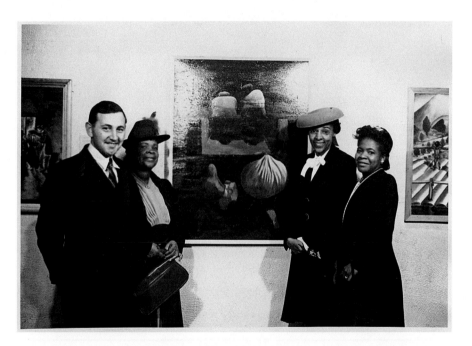

FIGURE 11 Guests at the private preview of the exhibition *Young Negro Art*, the work of students at Hampton Institute, in the Young People's Gallery in the Museum of Modern Art, 11 West 53rd Street, New York, 5 October 1943. *Left to right*: Victor D'Amico, Director of MoMA's Educational Program; Mrs. Bessie Northern; Miss Flemmie P. Kittrell, Dean of Women at Hampton Institute; Mrs. Junius Redwood, wife of the artist whose painting is shown above. Publicity photograph released in connection with the exhibition *Young Negro Art*, 26 October–28 November 1943. Photographic Archive. The Museum of Modern Art Archives, New York. Digital image © The Museum of Modern Art / Licensed by SCALA / Art Resource, New York.

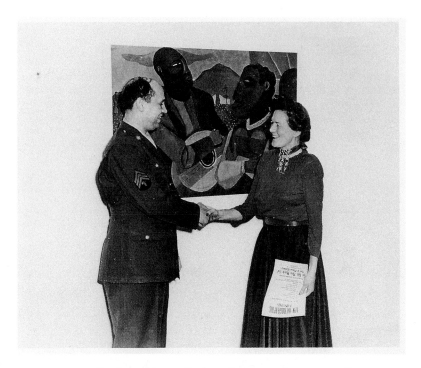

FIGURE 12 Romare Bearden and Caresse Crosby at the opening of *Ten Hierographic Paintings by Sgt. Romare Bearden*, G Place Gallery, Washington, DC, 13 February 1944. Courtesy of the Romare Bearden Foundation Archives.

FIGURE 13 Photo of Isaiah Williams, Edsel Cramer, and Hughie Lee-Smith with *Untitled* (Dorie Miller), 1944, detail of newspaper photo captioned "The History of the Negro in the U.S. Navy," *Great Lakes Bulletin*, 21 April 1944. Archives of American Art, Washington, DC. Courtesy of the National Museum of the American Sailor.

FIGURE 14 Carl Van Vechten, *Servicemen at the Stage Door Canteen*, 19 April 1943, Richmond Barthé (*left*) and Coby Ruskin (*right*). Black-and-white photograph, approximately 24 × 16.5 cm. Carl Van Vechten Papers Relating to African American Arts and Letters. James Weldon Johnson Collection in the Yale Collection of American Literature, Beinecke Rare Book and Manuscript Library.

FIGURE 15 Carl Van Vechten, *Servicemen at the Stage Door Canteen*, 17 February 1943. *Left to right (front row)*: Frank "Killer Joe" Piro bent backwards by Charles Sebree; (*back row*): Phil Denman, Owen Dodson, Don Smith, and Allen Porter. Black-and-white photograph, 24.5 × 19 cm. Carl Van Vechten Papers Relating to African American Arts and Letters. James Weldon Johnson Collection in the Yale Collection of American Literature, Beinecke Rare Book and Manuscript Library.

Aftermath

New Deal cultural philosophy regarding art in a democracy carried definite promise for Black artists. Infused with an ideological commitment to a more democratic American art in terms of both appreciation and production, federal art programs offered Black artists opportunities they had previously been denied. The WPA FAP sought to employ the largest possible number of individuals in programs that were inclusive and nondiscriminatory by design, if not in implementation. Stereotypes and limited understanding of Black culture persisted, but the attitudes of the artists themselves changed. As creative men and women living through a national crisis, availing themselves of the same economic opportunities offered to their non-Black peers, they believed that they were part of something larger than race. This understanding of the impact of the New Deal art projects on African American artists has persisted, with some variation, for more than half a century. But the focus on increased opportunities for, and the subsequent achievements of, individual Black artists associated with the projects does not adequately convey the complexity of their experiences or the legacy of the projects themselves.

THE EVOLVING DISCURSIVE FRAME

By the time Alain Locke's well-known "portfolio," *The Negro in Art*, was published in 1940, the FAP was winding down. Nonetheless, the newly

renamed Work Projects Administration marked the book's release with a
lengthy announcement praising its achievement ("the greatest portfolio of
its kind ever produced") and its author ("internationally known educator
and art authority"). The notice pointed out that nearly all the recent Afri-
can American artists featured in the first part of the book ("The Negro as
Artist") had been aided by the WPA art projects.[1] In the foreword, Locke
offered generous recognition of the government programs; he thanked
the FAP for its cooperation in preparing the materials for publication and
singled out Holger Cahill and Thomas Parker of the national staff and the
local administrators in New York, Illinois, Pennsylvania, Massachusetts,
Ohio, and Delaware. Of the FAP itself, he noted how much it had done "for
the recent development of Negro Art through its substantial inclusion of
Negro artists in various projects."[2]

When the occasion presented itself, the public relations machinery of
the FAP underscored the positive impact its programs were having on artists
in the Black community. But it is reasonable to assume that FAP administra-
tors were generally not well informed about African American art when the
programs were launched. The artists themselves, while appreciative of these
programs, had to work on their own behalf through organizations such as
the Harlem Artists Guild to secure greater representation and opportunity.
And perhaps the most resonant FAP initiative directed specifically at the
African American population, the establishment of "Negro extension gal-
leries" and community art centers to serve segregated communities, was
more closely linked to Cahill's philosophy of access, his understanding of
"art for the people," than to his interest in the development of African Amer-
ican art.

These fault lines were identified early on by the artist and historian
James Porter, who, while cautiously optimistic about the New Deal art
projects, was skeptical regarding their future impact. Writing at the end
of 1939, as federal funding seemed increasingly endangered, Porter noted
that while the FAP's significant efforts to foster creative ability in the Black
community could not be disputed, they were following in the footsteps
of African American art educators who had been doing this for years.
He also cautioned against premature assessments of the long-term effects
of these government programs. Their value lay in the potential to create
an engaged and informed public that would allow the next generation of
Black artists to flourish. In Porter's view, this process was undermined by

the threat of impermanence in government-supported programs: "If any criticism can be brought against government application of resources to the needs of art education it must be that certain worthy projects, set up especially for Negro communities and employing Negro teachers, were not continued long enough to attain maximum effectiveness of service within those communities."[3] He made specific reference to the art projects for the Black community in places such as Jacksonville and Greensboro, which had succeeded in reaching people but were diminished by funding cuts.

As a trained historian, Porter addressed not only the fleeting nature of the projects but also logistical challenges that continued to hamstring the study of Black culture as a continuous and complex phenomenon, one that must account for its past as well as its immediate present. In his 1942 essay "Four Problems in the History of Negro Art," Porter noted that the recent context favored a more democratic view of the arts, including serious consideration of objects such as folk art that might traditionally fall outside narrowly defined categories. But this more expansive view of culture had yet to have an impact on African American art inquiry and was especially evident in the neglect of objects made by and for the Black community before the twentieth century. As a result, the history of African American art lacked the support furnished by the excavation of a shared national past that had encouraged a reconsideration of American art overall.[4] Porter also worried that a flawed history of African American art was being perpetuated at the expense of recognizing that differences in art are mainly attributable to geographic, economic, and social variables. He reasoned that to remedy this problem, Black artistic production of all ages must be connected to the circumstances of its origins and to parallel developments in American art overall.

For his part, Locke circled around ideas that had characterized his writing for decades, adjusting them to accommodate changes in the landscape precipitated by the FAP projects. In the pamphlet accompanying Atlanta University's first annual exhibition of the work of Black artists in 1942, he stressed the positive development of connecting African American artistic expression to actual lived experience rather than to the sterility of studio practice. The location of the show in the South was notable in this context, as it promised to focus on the distinctive contribution made by Black artists based there and to place it in conversation with national trends. But Locke also claimed that the show would educate southern audiences on the recent

progress of Black artists who hailed not solely from large (primarily northern) urban epicenters but also more remote areas such as Richmond and Greensboro. Nonetheless he, like Porter, worried about the loss of momentum as the projects wound down and stressed the need to find an audience that would sustain it: "with the necessary waning of older sources of art patronage and support, there is the necessity of carrying this new art to the general public and convincing them of their vital role in supporting it."[5]

Both authors sought to connect African American art to the mainstream of American culture, albeit in different ways. Locke wrote about the urgency of Black artists' desire to define their individuality at a time when American culture was finding its own unique voice. Porter, by contrast, remained focused on a history of African American art that was woven into the larger story of American art, not at the level of theory but in terms of practical reality and circumstances. The thread that brought these narratives together is the importance both men placed on education and visibility in generating an audience for African American art. While Black artists had made progress, they needed support from African American viewers if they were to continue their forward trajectory. This focus on audience development in the 1930s was not, of course, unique to the African American community. The hope for a populist revolution in the arts that would result in a larger audience was widely shared among artists of this generation.

Accounts of artistic development in the post–World War II era have long held that the period of the New Deal art projects gave rise to altered expectations and newfound confidence in the generation of artists that followed, and that is certainly true of Black artists as well. But the art produced within this context suffered a more uneven fate, often rejected as provincial in ways that demonstrate regrettable failure to transcend the cultural moment in which it emerged. The art critic Clement Greenberg's writings are frequently understood as facilitating this paradigm shift, in particular his presumed rejection of popular, and populist, models of culture in favor of the concept of an enlightened avant-garde. Recent authors tend to view the 1940s as a return to more conservative models of thinking and patronage despite what appears to be an emerging aesthetic that is more obviously radical. Not surprisingly, they often anchor their arguments in Greenberg's well-known essay "Avant-Garde and Kitsch."

The privileging of Greenberg's influence in the postwar era has become a matter of debate, but it is instructive to recall that "Avant-Garde and Kitsch,"

published in 1939, overlapped directly with Locke's and Porter's accounts of progress in African American art. In this seminal essay, Greenberg argued for a notion of true culture that was to be contrasted with the reaction- ary mode exemplified by mass culture. Greenberg made this argument in terms that suggested the need for a revolutionary disruption of conven- tional thinking about culture as it was broadly understood. He challenged what he called "kitsch" on philosophical, critical, and ideological grounds, and the stakes were high. Locke and Porter, in comparison, remained pre- occupied with understanding, access, and development; they wrote about institutions, opportunities, and audiences. Understandably, their goals for Black artists were vastly different, and their expectations were mediated by the unflinching social, political, and economic realities they faced. They aimed not for wholesale disruption of existing norms but rather for progress toward more inclusive models within those norms.[6]

LEGACIES

The success or failure of the New Deal art projects is almost always mea- sured through the lens of what happened when they ended in the 1940s. The presumption has long been that the FAP succumbed to disillusionment and to intense political and aesthetic criticism, all of which tainted its legacy. Jonathan Harris, for example, in *Federal Art and National Culture*, described the gradual erosion of ideals that underwrote the FAP, such as a communal model of making art and the belief that by bridging the gap between artist and public, the nation would recognize the vital importance of the arts in sustaining democracy. The collapse of 1930s activism is much discussed in accounts of the period, with repeated references to the House Un-American Activities Committee and the failure of a congressional bill to establish a Bureau of Fine Arts that would have made government support for the arts permanent. But this perspective has shifted over time, and a more nuanced account has emerged of the various ways in which the FAP projects did or did not succeed in achieving their goals.[7]

There were multiple indicators that priorities started to change in the early 1940s. Art programs at the World's Fairs signaled a return to more traditional models of art display and consumption. In the private sector, art promotion was increasingly tied to market principles rather than to populism. Isadora Helfgott points out that, in retrospect, the agents of

popularization seemed more committed to education and social change than they were to structural realignments of the market, a condition that frustrated some artists who had hoped for a more transformative impact. The reputation of organizations that promoted American art improved, but that did not necessarily lead to an increase in actual art sales. This was an important lesson when the New Deal era ended and it became evident that popularization disconnected from politics, assisted by sympathetic coverage in the mass media, could be a powerful form of brand enhancement.[8]

As the concept of a mass audience for art was appropriated by emerging actors with a vested interest in capitalizing on it, new types of intermediaries were deployed to bring art to the public. Mass market publications played a pivotal role in sustaining the attention of a newly expanded audience; in this context, abstract art shared discursive space with continuing efforts to promote more conventional and accessible forms of artistic expression. *Life* magazine featured prominently in this landscape as a vehicle that catered to the new mass audience for art but did not challenge the conventional hierarchies that the FAP had sought to dismantle. The magazine offered wide access to art-related material, with regular coverage not only of individual artists but also of museums and art collectors. Illustrated feature stories on events and personalities in the art world reached a mainstream readership that did not necessarily understand itself as an art-interested public. As Helfgott argues, *Life* normalized art in American life by making it accessible and newsworthy; it functioned as a kind of print version of the FAP community art center, bringing art to the people, but without the emphasis on direct participation.[9]

This model of art appreciation and promotion privileged art audiences over art objects, and it cast the publisher in the role of mediator. Joan Saab cites the infamous *Life* "roundtables" on modern art as compelling evidence that the notion of art as experience, put forward by John Dewey and institutionalized in the FAP, had been eclipsed. Conducted in the postwar era, these featured prominent experts enlisted to explain the qualities of modern art to a mass public as yet unfamiliar with its aesthetic practices and unconvinced of its value. As Saab notes, this was largely a top-down conversation that regarded the public as an audience on the receiving end of insight meant to instruct and convince them. Rather than seeing them as active participants in the process of discovery, the roundtables enlightened readers not only on the aesthetic importance of this art but also on its

connection to notions of personal freedom and democratic individualism at the heart of American identity during the Cold War.[10]

Agents operating in the private sector, including individual collectors, corporations, and unions, stepped into the space the WPA projects had created, often working in conjunction with mainstream museums and arts organizations. Because of their historical exclusion from these spheres of influence, Black artists were more severely affected than others by the collapse of the projects. They remained largely outside the art market system and the pages of mass media publications, and they were newly challenged by the economic and critical consequences of chronic invisibility. But as Richard Powell and others have noted, the 1940s were characterized by a vibrant Black cultural scene. All-Black shows continued to flourish, growing in complexity and operating in an expanded network.[11] Their meaning was arguably altered by the FAP insofar as the context for these shows was not philanthropy, as it had been with the Harmon Foundation, but rather a national conversation about defining American art and culture.

The postwar art world has for years been understood as a conscious rejection of the New Deal cultural landscape by a generation of abstract artists who went on to revolutionize contemporary art. Black artists were thought to be particularly disadvantaged in this climate because of their continued investment in the humanistic goals of social realism. This commitment to socially conscious artistic practices persisted in a hostile political and aesthetic environment that threatened to further isolate them and undermine their objectives. African Americans had been the focus of intense political scrutiny during the 1930s, especially in urban centers such as Harlem, where arts activism in the Black community was consistently understood as inseparable from left-wing political agitation. Postwar investigations into alleged communist influences in the art world led by Michigan congressman George A. Dondero demonstrated that this scrutiny of artists' political leanings was unrelenting.[12]

These circumstances gave historically Black institutions and organizations an especially important role to play. As Stacy Morgan explains in *Rethinking Social Realism: African American Art and Literature, 1930–1953*, Black artists, like their non-Black peers, were able to sustain their artistic practice after the New Deal by enlisting alternative forms of patronage. Once financial support for these programs disappeared, they turned to African American businesses, and especially to HBCUs, as sponsors. Working with

African American institutions allowed them to position their visual nar-
ratives of Black life and history in public spaces that could reach a larger
audience without inviting the kind of political scrutiny that characterized,
and sometimes compromised, government-supported projects. Morgan sees
institutional support for Black mural painters after the projects as a major
factor in the continued vigor of social realist art at a time when there were
economic and aesthetic pressures in the larger art world to abandon it.[13]

Edmund Barry Gaither has identified the multiple roles filled by HBCUs
at this time, from providing post-WPA employment for Black art educators
to cultivating historians and critics, such as Locke and Porter, who furthered
the understanding of African American art and positioned it in the larger
context of American art. In contrast to the traveling exhibition model of the
Harmon Foundation, these institutions offered stable, dedicated physical
spaces for exhibiting African American art that, unlike the government art
projects, were permanent sites of art teaching and discussion, albeit chron-
ically under-resourced. Pointing to initiatives such as the annual Black art
exhibition at Atlanta University, an HBCU in Georgia's capital city, Gaither
notes that these juried shows provided exhibition opportunities that con-
firmed the professionalism of Black artists and charted their development
for a regional and national viewing public. In addition to sponsoring large-
scale mural commissions on their campuses at a time when interest in
public art was declining, HBCUs acquired numerous works for their art
collections, advancing and preserving art as a dimension of cultural heritage
for both students and the wider community.[14]

In the aggregate, as Gaither explains, HBCUs became important arbiters
of public conversations about the role of artists in society. In the 1940s, they
also provided instructive examples of how institutions could extend the
impact of the New Deal art projects by incorporating their ideals and prac-
tices into established educational programs. Howard University, a pioneer
among HBCUs in the development of art education, collaborated with the
government art projects during and after the New Deal. It featured project
work in its gallery and provided consultation on various government ini-
tiatives focused on African American artists. Howard was also notable for
its commitment to a curricular model that was not defined by race identi-
fication. Consistent with the art-historical approach of Howard professor
James Porter, Black artists were positioned in a continuum that charted
their development in terms of social context rather than racial attributes.

This principle also characterized the exhibition program of the Howard University Gallery of Art, which from its inception presented a broad range of visual culture and remained steadfastly committed to an integrated presentation of African American art.[15]

Several programs featured at Howard in the final years of the FAP exemplify the intersection of these trajectories. In April 1940 the gallery organized an exhibition of contemporary American painting to celebrate its tenth anniversary. Director James Herring explained the show in terms of the gallery's commitment during its first decade to present the history of art, broadly conceived. It sponsored exhibitions of African American art but studiously avoided the perception that its mission was defined solely in terms of racial art production. Regarding issues of identity in artistic practice, Herring noted, "Our policy has been to leave the discovery of racial and nationalistic artists to our chauvinistic friends. We have preferred to exhibit the works of all schools and trends regardless of ideology or any designated sphere." Herring also acknowledged an extensive network of partners that had made the gallery's programs possible, including prominent American art institutions and numerous federal art project agencies.[16]

Two years later, in conjunction with the seventy-fifth anniversary celebration of the university's founding, Howard mounted an extensive exhibition that again underscored this approach. Assembled by Herring, *The Negro in the American Scene* was devoted to the portrayal of African Americans in the works of non-Black artists. The catalog's primary essay, written by curator Charles Seymour Jr. of the National Gallery of Art, described the show as a "landmark," the novel theme of which brought the viewer beyond the aesthetic into a social history of America and American painting.[17] The student newspaper, the *Howard University Hilltop*, noted the broad spectrum of Black experience, past and present, exemplified in the show, with characters drawn from all walks of life. Leila Mechlin, reviewing the show for the *Washington Star*, praised its ambition and took pleasure in the opportunity it afforded to reflect on the present alongside the past. She also speculated on the capacity of an exhibition to improve race relations and enlighten viewers on a unique theme in American art.[18]

Howard hosted a regional conference of the College Art Association in conjunction with this exhibition, deepening its impact and widening the interpretive frame. "Art in the University, the Teachers College, and the Secondary School," held 9–10 March 1942, was introduced by the university's

president, Mordecai Johnson, who noted Howard's success at integrating the arts into its curriculum and fostering their appreciation in the larger community. Multiple sessions featured an impressive roster of presenters from the Howard faculty and various pockets of the art world. The art critic Forbes Watson spoke on American culture and the war effort, and Walter Pach delivered the final address, titled "The Effect of the Cultural Black-Out in Europe on American Art." Additional sessions focused on art instruction in teachers' colleges and secondary schools, and on college art galleries. James Herring gave a presentation on the history of art education at Negro colleges. Among the other participants were artists James Porter, Lois M. Jones, and James L. Wells, and arts administrator Edward Rowan of Treasury's Section of Fine Arts. Alain Locke, who was arguably the highest-profile figure in the African American art world, was conspicuously absent from the program.[19]

RACE, ART, AND COMMUNITY: THE ST. LOUIS PEOPLE'S ART CENTER

In April 1942, as Howard celebrated its seventy-fifth anniversary with a multidimensional program on art, culture, and education, and Atlanta University hosted its first annual exhibition of African American artists, the People's Arts Center (PAC) opened in St. Louis. It was the last FAP-supported CAC to open in a major metropolitan area with a sizeable Black population, and, unlike prior initiatives, interracial cooperation was fundamental to its self-definition. The rhetoric of "democracy in action," used to justify and celebrate the CAC initiatives of the FAP, was understood largely in terms of populism and expanded participation in the arts. But as exercises in participatory democracy, CACs made their points largely through broad access to support. Improved race relations may have been a desired outcome, but in practical terms, by remaining largely segregated spaces, CACs in African American communities reinforced local conditions of racial division rather than ameliorated them. The art centers established in Harlem and Chicago were nominally interracial, but St. Louis identified collaboration between races as central to its mission. The original charter emphasized a foundational commitment to "democracy in action," defined explicitly in terms of operating an arts program in a physically integrated space in the interest of improving race relations (figs. 8 and 9).

The fate of PAC also raises questions about the success of the FAP in terms of Cahill's objective that art centers would lay the foundation for the

development of permanent arts spaces in the communities they served. The national record on this is mixed; there are certainly examples of American cultural institutions whose roots can be traced to a WPA-era CAC. These range from modest undertakings with a continuing local focus, like the Greenville Museum of Art in North Carolina, to cultural organizations of international repute such as the Walker Art Center in Minneapolis. Many initiatives that had developed around Black community needs collapsed after the withdrawal of government funding, unable to obtain enough local support to ensure their survival. Others, such as the LeMoyne Federal Art Center in Memphis, were instrumental in the expansion of academic art departments within collaborating institutions.

The South Side CAC in Chicago became an enormously important and consequential project that was at the center of a Black cultural renaissance in the city. Although similarities between St. Louis and Chicago were noted in the early 1940s, as both were late in terms of availing themselves of FAP program support, there were very important differences. The South Side CAC was born of prior advocacy and a serious commitment to the success of practicing Black artists in the state and the community. Its origins paralleled the widely publicized and much-celebrated art exhibition of the 1940 American Negro Exposition, an event of national significance. While it was subject to the pressure of internal class and race politics, the South Side CAC ultimately survived as a vital force in the Chicago art scene.[20] St. Louis's People's Art Center, by way of contrast, was imagined as a project that would provide art instruction and experience to underserved populations, more in the spirit of CACs in the South than the professionally driven operations in Chicago and Harlem.

In the early 1940s, many FAP programs were reoriented to support the war effort, and new initiatives emerged to benefit the Black community. An important exhibition of Negro art at Fort Huachuca in Arizona was one of several efforts across the country that looked to the FAP as a resource to offer cultural experiences for Black soldiers.[21] CACs in small cities like Jacksonville, Florida, were transformed into recreational centers for African Americans serving in the armed forces. The original proposal for the People's Art Center incorporated the war into its rationale, and the site was chosen specifically because it was near a Black community *and* next to a Negro USO. When Cahill spoke in 1941 at the invitation of the interracial citizens' committee that had formed to establish a CAC in St. Louis,

he departed from his usual stump speech to note that race relations and war issues were fundamental to the proposal for the center. So intrinsic was the war effort to the center's identity that it was known as the "People's Art Service Center" throughout the war. Once opened, Black soldiers routinely attended classes, as did their families.[22]

A number of artists were employed by various New Deal government projects in Missouri; quite a few were hired by the PWAP, including the well-known social realist painter Joe Jones. But according to early histories of PAC, Missouri was slow to embrace the FAP, in part because of suspicions about the left-leaning sentiments of its participants.[23] The concept of national control in the management of the FAP was also a sticking point for its development in Missouri. St. Louis was already regarded as a center of radical activity within the state, and statewide concerns were raised about its undue influence if resources were concentrated in the city. In 1938 an advisory committee formed to secure sponsorship for mural projects and the collection of objects suitable for cataloging by the Index of American Design. But it was not until changes occurred in the FAP administration itself, allowing for more control in the states, that these conflicts could be effectively addressed.

The origin stories of PAC, as told in annual reports or in press coverage of its programs, consistently focused on a set of objectives that varied little in the first decade of its existence. While there was limited enthusiasm for establishing an arts center, it came about as the result of lobbying by a handful of community members who sought to expand opportunities in the arts through support available from the FAP. Planning documents suggest that the impetus for the center came originally from art educators and community leaders who were concerned that FAP opportunities were not reaching the Black community.[24] As with other CACs across the country, some advocates argued that the judicious location of a CAC in a Black neighborhood would both cultivate undiscovered local talent and decrease delinquency by providing suitable leisure activities. But these customary points were ultimately subsumed into a broader and more idealistic vision in which the center could become an experiment in desegregation though participation in the arts.

An organizational meeting to discuss the possibility of the center was held in April 1941, presided over by painter and religious leader W. A. Cooper, then pastor of the St. Louis AME Zion Church. The meeting

was attended by people of diverse racial backgrounds who had a variety of interests in the project's potential. Cooper led with a consideration of what a center might contribute to the Black community. He brought the perspective of a working artist to the discussion but was not alone in his enthusiasm for the potential value of such a creative outlet. John T. Clark of the Urban League, also present, had been introduced to the work of Black artists via an HF exhibition in St. Louis; he subsequently sponsored regular exhibitions of local Black artists that familiarized the public with both their talent and their limited opportunities. The Urban League was enthusiastic about the art center and instrumental in encouraging Black civic leaders to support it. Others in attendance, while sympathetic to the needs of the Black community, questioned the model of a center designed exclusively to serve that population. They proposed that an art center open to all, located on the edge of a Black neighborhood, might constitute a progressive challenge to the normative conditions of racial segregation and in so doing set an important example. The coalition of people who eventually became committed to PAC's success consisted of educators, philanthropists, and civil rights advocates, as well as representatives from the arts community.

PAC was dedicated to what it defined as a democratic way of life, by which was meant making art instruction and appreciation available to all members of the St. Louis community without regard to race, gender, age, religious creed, or economic status. As PAC often stated in its promotional materials: "From its inception, the Center has maintained its interracial complexion in board membership, staff, and student body—not as a stilted, self-conscious gesture, but as a spontaneous expression of the will to create across the barriers of race."[25] Looking back on its early years, one PAC Association board member pointed out that its impact extended beyond the services it came routinely to provide. By popularizing study of the arts, it prompted other educational enterprises to incorporate them into their curricula, and by a sustained commitment to an integrated board, staff, and student body, PAC encouraged civic organizations with similar aims to work cooperatively.[26] When the center opened, and for years afterward, it was praised for its dual intention to facilitate the development of artistic talent and improve race relations in the city. An essay by the St. Louis author and civil rights activist Fannie Cook captured the substance and spirit of this vision. At PAC, she wrote, "color is not pigmentation which makes a man unfit to eat at our lunch counters; it is something which makes

interesting models, thoughtful teachers, selfless board members, and happy, vigorous pupils."[27]

Less than a year after PAC opened, the FAP shut down, forcing the new center to confront the reality that it would have to close if it could not find other sources of financial support. It had by then attracted national attention as a place dedicated to free, open arts education. An article in the *Magazine of Art* reported that PAC had enrolled ninety-five Black and thirty-nine white students in its adult classes, including soldiers from the nearby barracks, and that visitors of both races could be seen wandering through the galleries.[28] Following a period of intense fundraising and reorganization, PAC's future stabilized in 1945, when it was granted admission to the network of programs supported by the Community Chest (later the United Fund) of Greater St. Louis. It obtained and renovated a new facility that enabled an expansion of course offerings. Rowena Jelliffe, codirector of Karamu House in Cleveland, was invited to speak at the dedication, suggesting an affinity between PAC and an older, distinguished institution known for its commitment to a similar vision.[29]

The ensuing decade marked a period of energy and growing success; a self-study in 1951 led to a series of changes meant to professionalize the operation. Among its recommendations was that trained teachers be hired to replace the prevailing ad hoc volunteer system.[30] PAC annual reports soon began routinely listing the educational qualifications of its teaching staff in its program descriptions. When Holger Cahill was invited to help celebrate PAC's tenth anniversary in April 1952, he recalled its original vision to explore participation in the arts as a "path through the troubling forest of race relations."[31] The Supreme Court's 1954 landmark decision in *Brown v. Board of Education* gave PAC a sense of pride for having been at the forefront of integrated education in St. Louis, and a renewed sense of urgency about the relevance of its mission.[32] During these years, activities at the center ranged from art exhibitions, to Chinese puppet theater, to interracial choral groups. PAC enjoyed frequent and favorable coverage in the local media, and members of the association board were invited to speak to other organizations about what went on there.

Despite its successful arts programs and recognition of its pioneering work on race relations, in the late 1950s PAC entered a period of discord that would lead to its eventual collapse. The United Fund, which had been its primary source of financial support, began to signal discomfort

with providing resources to an organization whose mission seemed more focused on cultural objectives than on the pressing health and social welfare priorities in the community. Over the years, PAC had restated its objectives in various contexts in various ways, but it consistently emphasized the long-standing commitment to providing arts experience to anyone who sought it. Supporters hoped to demonstrate that bringing people from diverse backgrounds together around a common interest could ease social tensions by underscoring the fundamental dignity of all human beings, and in so doing improve the quality of life in the community. The United Fund remained unconvinced on the latter point, and in 1960 dropped PAC from its list of funded organizations.

An alternative source of revenue to cover operating expenses came from the newly launched Spirit of St. Louis Fund, an initiative that stepped in to support the arts and other educational projects after the United Fund cuts. PAC was a key constituent in an alliance that hoped to stimulate a cultural renaissance in the city, but its association with the Spirit of St. Louis Fund marked a troubled moment in the center's history. During the period in which PAC came to rely on a relationship with the fund, the vision of democracy in action crucial to its identity and success began to fade. By the time it became evident that the Spirit of St. Louis Fund would itself be subsumed by plans to establish a municipal arts council in St. Louis, the fault lines within the organization had become something of a local scandal amid struggles to preserve it as an important part of the city's history.[33]

As the PAC Association marked its twentieth anniversary, focus shifted increasingly to the dynamics within the governing body rather than the center itself. From 1960 to 1963, the organization underwent close scrutiny, along with others seeking alignment with the Spirit of St. Louis Fund; this included commissioned self-studies and broad inquiries into the city's cultural resources and needs. In this context, dissension within the PAC Association board centered on several key aspects of its perceived mission and value to the community. A 1961 evaluation made the case for PAC's uniqueness, citing its distinction as an interracial and interfaith agency, among other features, such as the ability to offer art classes year-round, after school, and on Saturdays. It confirmed PAC's democratic and social functions in terms of promoting mutual respect among participants of diverse backgrounds and providing a therapeutic environment for disadvantaged citizens, including senior citizens and the disabled.[34]

A very different tone was struck in an internal document of the same year calling for an independent study to explore changes that might ameliorate the existing state of confusion within the organization. The memorandum specifically identified problems related to conflicting understandings of PAC's mission, value to the community, and relationship to race. PAC, this memo argued, served the community by teaching art; it was first and foremost an arts organization. With respect to race, its pioneering role as an integrated institution was acknowledged, but the notion of the interracial was connected here to the transcendent nature of art rather than to social progress. "Interracial" was, the memo pointed out, an adjective, not a noun: "We do not assemble to be interracial, though, we assemble to participate in a mutual interest, and it is the interest we have in common which really draws us together with others."[35] Regarding the possible composition of the team that might conduct such a study, the memo suggested that at least one Black person should be selected. This was a necessary but regrettable requirement, the author argued, in an age when liberal organizations, ever sensitive to the perception of being anti-Negro, had yet to outgrow the propensity to see race rather than simply individual qualifications.

Internal tensions over the role of race in the organization's mission were exacerbated by a September 1962 evaluation of PAC undertaken by the Spirit of St. Louis Fund. While PAC's funding history suggested that it considered itself to be concerned with social work and cultural education, the report pointed out that the bylaws did not define it as a social work organization.[36] Further, the bylaws stated that services should be offered to everyone without discrimination, but did not explicitly state that their purpose was to improve race relations. At this point, the board seems to have split on the issue of whether PAC's mission was directly tied to bettering race relations, even though that was clearly a foundational principle. Some staff and board members became increasingly concerned that the PAC Association was willing to sacrifice the center's identity and independence in order to sustain strong ties to the Spirit of St. Louis Fund. Exchanges became more pointed as the board moved in December to reconstitute itself in a way that would give control to one faction at the expense of the other, eventuating in legal action designed to enforce the proposed changes.

Early in 1963, the power struggle and disarray within the PAC Association became the subject of local media coverage, as the players aired their respective grievances and disagreements in public. A good deal of

attention was focused on the treatment of PAC executive director Mabel Curtis, who had led the center since 1950. Curtis resigned in December 1962 in the wake of continuing disagreements about PAC's future and subsequently claimed that a faction of the board had forced her out. Newspapers reported that Curtis had long been disturbed by what she regarded as the undemocratic actions of certain board members who were promoting their own agenda, namely, to protect PAC's affiliation with the Spirit of St. Louis Fund. Despite attempts to end the controversy, the fund suspended its support of PAC in March, pending a final resolution. By then, the director of the fund had officially recognized the anti-Curtis faction of the board that was trying to settle the matter in the courts.[37]

A turning point in the public understanding of PAC's internal problems came in April 1963, when an article in the *St. Louis Post-Dispatch* reported that racial politics lay at the center of the controversy. While PAC clearly suffered from financial and personnel problems, its greatest challenge, the *Post-Dispatch* suggested, lay in resolving a dispute within the leadership over the extent of PAC's emphasis on racial integration. The concept of racial harmony had been at the center of its mission from the start, but some board members felt that this diverted attention from its fundamental mandate to teach art. Specifically, select members objected to an administrative decision allowing groups to meet at PAC that focused on integration and racial equality but had no arts purpose.[38] This article was followed by a *Post-Dispatch* feature on PAC in May that described hope for renewed vigor of the organization in light of new leadership, including the replacement of Curtis, whom some had faulted for arrogance. While the story identified the challenge of an unwieldy board that had grown too large to solve its problems, it also noted strong disagreements about the role of the center, in part because many of its students lived outside the neighborhood in which it was located. These disputes had cost PAC the support of the Spirit of St. Louis Fund and might also keep it out of the council on the arts that was likely to supersede it.[39]

The May article precipitated a lengthy response from Mabel Curtis that laid out in detail the issues of racial discrimination and intolerance that she believed lay at the core of PAC's difficulties. As executive director, she felt it necessary to identify staff conduct that made a mockery of its ideals and was inconsistent with its mission of racial harmony, citing, for example, her criticism of a program director who used the expression "yellow peril"

to insult a Chinese instructor.[40] In the years after her dismissal from PAC, Curtis sought to document the extent to which issues of race had driven attempts to remove her as director. In addition to the information provided in her response to the May *Post-Dispatch* article, she enumerated multiple examples of behavior at odds with PAC's historical commitment to undermining racial intolerance. These ranged from the inclusion in an exhibition of a stereotypical image of a Black child eating watermelon to the willingness of board members to hold meetings in places where Black people were not welcome. She claimed to have been subjected to racially motivated criticism by board members who faulted her for bringing these transgressions to their attention, at one point expressing the opinion that some felt PAC was too important a community asset to be headed by a Black person.[41]

Board objections to the energy Curtis displayed in support of racial integration, as opposed to art instruction, certainly reflected the ongoing dispute over PAC's role in the community and its intrinsic identity. But Curtis herself believed that these objections were more likely explained by the board's deference to outside organizations unsympathetic to the model of interracial cooperation that PAC embodied. She was of the opinion that in seeking to remove the interracial character of PAC, the new board was intent on undermining its identity as a democratic entity in the interest of rendering it acceptable to peer institutions in the arts. The newly appointed board chair, she claimed, had apparently been told that an organization openly committed to interracial progress would not be admitted to the proposed arts council on which cultural groups like PAC would ultimately depend. In response, he decided, it was ill advised to appoint another African American to direct the organization and made his selection accordingly.[42]

Once the arts council formed, the PAC Association prioritized forming alliances that would ensure the center's survival and future relevance. In the summer of 1963, after David Millstone assumed board leadership, newspaper articles noted the outreach being undertaken to facilitate this agenda. Millstone, who was a painter and a member of the local business community, investigated options for expanding PAC's programs while at the same time reimagining it as part of a consortium of organizations that could undertake cost-sharing measures. In reporting to the board, he emphasized that in order to accomplish its mission, PAC needed strong programs with qualified teachers, and he hinted that, like Karamu House,

it might add theater to its offerings. These recommendations occurred amid citywide discussions about the creation of a multipurpose center devoted to human relations and culture that could house a variety of organizations under one roof. Millstone noted that the facility had tacit approval from both the United Fund and the arts and education council, and that PAC had already relocated there. Although PAC was now technically a member of the arts council, it was not part of its fundraising arm, raising again the question of financial survival.[43]

Ten months later, in November 1964, David Millstone resigned as the head of the PAC Association board, agreeing to stay on as a consultant while a new executive director was sought. Classes were suspended and Mason Cloyd was appointed acting board chair. Cloyd started vetting candidates and the board undertook an exhaustive audit to determine PAC's assets and consider its future needs. While the situation was serious, Cloyd claimed, it was not yet catastrophic, and it might be ameliorated through aggressive fundraising and the formation of strategic alliances. He mentioned specifically that they were exploring a possible relationship with Washington University wherein PAC might offer arts and crafts workshops to its students. A list of names had been assembled of people in the community whose interests suggested that they might be willing to commit time and resources to rescuing this venerable St. Louis institution.[44]

In a January 1966 Post-Dispatch feature following his relocation to New York, where he was pursuing a full-time career in painting, Millstone admitted that during his last months in St. Louis his attention had been divided between several things, to the benefit of none. He noted that he had taken over PAC after a management crisis, and that, despite a brief "hopeful interlude," controversy had once again hobbled the organization, prompting him to resign.[45] Cloyd took issue with Millstone's characterization of PAC's fortunes, particularly his implication that it had collapsed shortly after he left. The organization had been in trouble for years before Millstone took over, Cloyd argued, and it was mismanaged further during his tenure as director. The PAC Association ultimately had to sell assets to pay its debts and secure funds to keep the doors open. The People's Art Center was dying a slow death, and continued to exist only because of periodic efforts to revive it.[46]

PAC's eventual collapse has been attributed to numerous factors, from the problems created by a governing board that became too large to function efficiently to an identity crisis precipitated by external forces that

pulled it increasingly toward a model of culture that did not exist comfortably within its prior vision of social utility. But it is also clear that the changing landscape of race relations made it difficult to sustain the idealism that for years had balanced an ambitious community-based arts agenda with a commitment to interracial harmony. Some members of the community and the governing board came to regard PAC's emphasis on race relations as excessive.[47] In the tumultuous years of the early 1960s, factions within the PAC Association accused one another of essentially the same thing: subverting the People's Art Center to serve the interests of an external agenda. An institution that at one time had been able to imagine itself as the embodiment of democracy became one that staked its survival on alternate realities, reflecting an increasingly divided sense of priorities.

CONCLUSION

Interest in better understanding the New Deal art projects began to emerge in the 1960s; it grew out of renewed enthusiasm for the creation of a permanent government mechanism that would provide support for artists. This was eventually achieved through the foundation of the National Endowment for the Arts in 1965, the realization of an idea that had been a unifying force among American artists in the 1930s. That same year, the Black Arts Movement inserted race and identity into American cultural politics in ways that had not been seen since the 1920s, but now with an explicit emphasis on separatism and social justice. The new chasm that arose between the so-called mainstream art world and the Black community was nowhere more evident than in the fall of 1968, when the Black Emergency Cultural Coalition launched a protest against the Whitney Museum for organizing an exhibition on American art of the 1930s that failed to include a single Black artist. This was the beginning of a period of intense activism, drawing attention to exclusionary practices, both implicit and explicit, that continued to render Black artists effectively invisible in the story of American art.[48]

The coalition's protest against the Whitney exhibition centered primarily on the hypocrisy of the museum's narrative of inclusion. The show was cast as a "revisionist" view of the Depression era that sought to expand understanding of artistic production beyond the simplistic notion that social realist art dominated the period, to the exclusion of other approaches. Much like the large-scale exhibitions organized to demonstrate

the achievements of the FAP at the end of the 1930s, the Whitney exhibit presented stylistic variety as de facto evidence of a diverse American art world. Well-known Black artists like Romare Bearden and Jacob Lawrence were represented in the Whitney collection and had shown work there, but this sweeping retrospective did not include them. To counter and expose a seemingly willful act of omission, the newly founded Studio Museum in Harlem mounted a show called *Invisible Americans: Black Artists of the 1930s* that ran from 19 November 1968 to 5 January 1969 and presented what was in effect a parallel canon of Black artists who had been part of the historical moment the Whitney sought to illuminate. The show was organized by Henri Ghent, director of the Brooklyn Museum's Community Gallery, a key figure in the Black Emergency Cultural Coalition.

Given the near-universal recognition that participation in the New Deal art projects had contributed significantly to the development of Black artists, the exclusivity of the Whitney show spoke volumes about their legacy. In the end, the relationship of African Americans to these initiatives existed fully within, and was defined by, an evolving matrix of attitudes toward art and race in twentieth-century America. The programs neither succeeded nor failed, but rather served as a barometer of the capacity in any given historical moment for a shared investment in the social value of art to function as a mechanism to advance democracy. The message of the Whitney protest was that this problem was ongoing, that it had not been ameliorated by the apparent gestures of equal opportunity enshrined in the federal art projects. As Henri Ghent pointed out, Black artists were still effectively absent from white consciousness; they could not be taken seriously by an art world that refused to see them.[49] The New Deal art projects without question opened opportunities for African Americans to participate in the cultural life of the nation. But perhaps the most important aspect of their legacy was to make abundantly clear that sustaining visibility would remain a matter of advocacy.

Epilogue

JACQUELINE FRANCIS

In the foreword to *Contemporary Negro Art* (1939), the catalog accompanying the Baltimore Museum of Art's exhibition of the same name, Alain Locke offered his view of this group survey's import: its "main significance seems to be the promising prospects indicated for the future development of Negro art." Optimism is evident in this statement and throughout Locke's essay, in which he asserts that American art is becoming "more democratic and representative." He makes the case for progress by identifying leading interwar Black artists, connecting nineteenth-century American representation of Black people to the Harmon Foundation exhibitions, and citing "the helpful influence of the Federal Art Project [for] not only underwriting the precarious productivity of the Negro artist but broadening considerably the base of popular art appreciation and use."[1] A long-time advocate for and patron to many of these FAP artists, Locke had done his part to create an audience and a market for Black American artists.[2]

Nonetheless, African American artists and their supporters greeted the 1940s fully aware that this well of artistic production was far from well known. In an article published a few months after *Contemporary Negro Art* appeared, Locke wrote with heightened urgency about the need for "reinforcements of voluntary and sacrificial outside supports . . . for the popular support of the Negro artist."[3] His use of military jargon was notable, and

not only because he, like many of his contemporaries, probably sensed that the United States would eventually enter World War II. In this article, titled "Advance on the Art Front," Locke's use of the term "Negro art" was expansive (rather than exclusive), for he clearly hoped that Black American artists' work could be seen as expression that could be in conversation with other ethno-culturally and nationally designated artistic efforts.[4] That is to say, Locke positioned the works of these American artists of color as aspects of national expression that would be seen abroad. Overall, Locke, building upon the Black artists' cultural capital gains in the 1930s, sought to increase the awareness and appreciation of their work during World War II.

Was "Negro art," which Locke and other observers described as developing and advancing, a legible style or an evident way of working in the early 1940s? What was the measure of African American artists' "coming of age," a phrase pregnant with meaning about life's cycles and group behavior? Did the FAP leave a legacy? What "happened" for Black artists, formerly on the New Deal art projects, as they tried to make careers during the war years? What organizing tactics, forged during the Great Depression, were adopted for individuals' and collectives' uses? What forms did exhibitions—solo and group—take at a time when a new art industry was emerging? What did the early 1940s "mean" for African American artists?

In this epilogue, I discuss the tenor of the early 1940s, starting in 1943, the year that the FAP closed its programs. In the aftermath of the Depression, most Americans simply tried to hang on in the first years of the 1940s, as lean times lingered. The wealthy safeguarded their assets. Gallerists took a conservative approach to managing their business by winnowing their rosters of artists. The financial tides decidedly turned in 1943. Fueled by the wartime economy, the American art market picked up speed. As Locke's foreword to *Contemporary Negro Art* suggests, every effort to raise the profile of African American artists during the first third of the twentieth century had to be followed with even more effort, including energetic promotion of individuals and programs that presented them as a group.

My focus is visibility, instrumentalized in two exhibitions: *Young Negro Art* (1943) at the Museum of Modern Art and *The Negro Artist Comes of Age* (1945) at the Albany (New York) Institute of History and Art. These World War II–era shows were among the signposts of a rising US art market. As Mary Ann Calo has observed in this book, art made by Blacks *was* visible in the United States in the 1940s, for the "Negro exhibition" was

a format still produced by commercial galleries, cultural centers, and public and university museums in American cities. Still, if Black creatives in dance, film, literature, music, and theater were becoming American celebrities during the war years, their counterparts in the visual arts remained virtual unknowns who had to be "introduced" and "reintroduced" to American minorities and the country's majority group.

During the World War II years, "American" exhibitions were offered with urgency in the United States; they were patriotic, collective, spirit-boosting vehicles. "American art" exhibitions, like those dedicated to "Negro art," were long-favored ways to present art to audiences who cared about distinction, authenticity, particularity, and cultural affiliation. That is, curators of "American art" and "Negro art" shows similarly argued that the work on display in their spaces was different from what was considered dominant in Europe and, especially, the work of historical, long-dead European artists. While arguments that there was a distinctive, contemporaneous "American" art remained unsettled in the early 1940s, museums and galleries continued to mount such presentations for audiences accustomed to that rubric. Apart from Jacob Lawrence, only a handful of US-based artists of color, backed by curators, collectors, and writers who advocated for them, participated in integrated "American" museum exhibitions in the World War II years.[5] Solo gallery and museum shows that focused on the work of living Black American artists, which afforded the featured artists opportunities to be recognized uniquely as individuals rather than as part of a homogenous group, remained rare and novel enterprises during this decade.[6]

I add to this discussion of wartime exhibitions, which included the repackaging and rebranding of "Negro art" shows, a consideration of the photographic presentation of the African American artist-soldier as a trope.[7] Museums, galleries, and the US government produced photos of uniformed men, among them Black American artists, posed in proximity to works of art they had made. These publicly distributed images effectively linked patriotism to creativity, promoting the message that these artists were hard-at-work contributors to the safety and surety of the American nation. In Carl Van Vechten's photos of interracial groups in a New York City venue called the Stage Door Canteen, the volunteer spirit of civilians helping to run the space and the sociability among men of the Allied forces suggested that community and comity had been realized during wartime. Among those who featured in these images were the gay African American

artists Charles Sebree and James Richmond Barthé. Van Vechten was a gay white American writer and photographer who was among the Harlem Renaissance's most avid patrons. I argue that the concepts of activism, visibility, and participation are readable in these staged black-and-white photos. Moreover, I consider those presented in them Van Vechten's collaborators, for they contribute to his project of picturing integration across the boundaries of race and ethnicity, sex and gender, and nation and culture.

DEVELOPING ART, DEVELOPING ARTISTS: *YOUNG NEGRO ART* (1943) AT THE MUSEUM OF MODERN ART

The Museum of Modern Art's *Young Negro Art: An Exhibition of the Work of Students at Hampton University* (1943) exemplified early twentieth-century discourse of "racial art" and of segregating thinking about what Black American artists did and who they were. It was organized through the allied efforts of like-minded friends: Victor D'Amico, the MoMA's director of education, and Viktor Lowenfeld, an art professor at Hampton Institute, an HBCU in Virginia. Both men were strong advocates of art education transmitted through institutions, namely, the museum and the academy. Yet as art historians Charlotte Barat and Darby English have written, both men held stereotypical views about Black people; their outlooks found their way into the presentation of artists they introduced to audiences interested in modernism.[8] The press release for *Young Negro Art* is dominated by the voices of Lowenfeld and D'Amico. It quotes them at length. D'Amico, if not the author of the text, certainly was its director. As a statement, the press release is simultaneously supportive and paternalistic. The works—twelve paintings, twenty-five drawings, one mural—would be displayed in the museum's Young People's Gallery. In the same paragraph, nationalist and patriotic tones are struck, for the eight states from which the African American participants hailed are listed and the military service of some of the male exhibitors is noted. Of the work, it is opined that "the pictures cover a wide range." One artist—John T. Biggers—is singled out for having the greatest number of works on display (twelve). These declarations, offered in the release's first paragraph, were followed by pages of text that demonstrate that *Young Negro Art* was a limited philanthropic gesture that stopped well short of inviting the show's artists to join a congress of American modernists.

In language that resonated with that of the *New Yorker*'s review of the Downtown Gallery's *American Negro Art* exhibit, D'Amico constructed a frame for Negro expression:

> The Negro possesses a rich creative power which is sometimes highly individual and sensitive. He is imaginative and responsive when properly guided and encouraged, but can easily become inhibited and imitative under inflexible and formal teaching. There are few teachers who truly understand the Negro's profound creative ability and who are capable of instructing him without destroying or at least perverting his visual perception and his instinctive talent. The same may be said about teaching white students, but is more applicable to the Negro because he is more malleable and sensitive, and therefore more easily influenced.... I have seen Negro students under the direction of Negro teachers imitate certain obsolete patterns of the School of Paris, but when properly understood and guided, their power and will to express seem boundless. The work of the students at Hampton Institute is a healthy and promising example of the creative potentiality of the American Negro.[9]

In D'Amico's view, Black artists' creative expression sprang from an inborn racial trait; the best artists, he suggested, would never have seen or been interested in European and European American histories of art and visual culture. D'Amico credited Lowenfeld as a teacher who understood his Black students and had begun extracting their latent skills. Yet *Young Negro Art* was not a culmination, according to D'Amico. "This exhibition," he surmised, "is therefore more important as an indication of the creative potentiality of art in the American Negro and as a wholesome and intelligent approach in training him, than as a collection of finished works of art."[10] Lest visitors regard *Young Negro Art* as a display of accomplished paintings and drawings, D'Amico offered a caveat: the exhibition was a promise of something that he hoped would become manifest in the very distant future. In contrast to Locke, who, in 1939, anticipated "Negro art" in the offing, D'Amico, in 1943, predicted that Black Americans were on a long journey of personal discovery and development of their atavistic talents.

Except for Biggers, the participants in *Young Negro Art* are not mentioned by name until the final two pages of the six-page release. They appear

in the last section, "Biographical Notes of Exhibiting Artists," organized in alphabetical order according to family name: Annabelle Baker, John Bean, John T. Biggers, Joseph L. Mack, Alfred James Martin, Junius Redwood, George Spencer, and Frank Steward. Their works' titles and mediums are presented next to their names, below which are paragraphs offering tidbits of information about their parents, their preparation for and study at Hampton, and their starts as artists.[11] Mack's entry provides a representative example of these profiles:

MACK, Joseph L. Pieta, oil
 Mother and Child, oil
 Despair, oil
Son of Hubert Mack, a brick mason, of High Point, North Carolina.

Reported for induction at Fort Bragg, not long ago, after receiving his Bachelor's degree at Hampton. He entered Hampton Institute as a major in Building Instruction (Interior Decoration), with the hope that he might also pursue courses preparing him for a career as a cartoonist and magazine artist.

Mack spent his first two summer vacations on the campus earning his college expenses as a house painter, but by 1941 his talent for another kind of painting had won him a scholarship in art. While in college he prepared exhibits, arranged stage sets and decorations for proms, assisted in painting the Hampton murals at Fort Eustis, created and painted a prize-winning float for his social club in the 1942 Homecoming parade, and designed the Senior Yearbook.[12]

In these lines, the writer plots Mack's trajectory to Hampton and offers a sense of busy college life among the era's energetic young creatives. Achievement, ambition, duty, industry, practicality, and talent define Mack, who probably provided the details for the admiring profile. Nevertheless, the absence of the makers' voices in Young Negro Artists is telling. No publication accompanied the exhibition, a fact that stands in contrast to the platform given to the artists of Americans 1942: 18 Artists from 9 States, a MoMA exhibition organized in the previous year.[13] These exhibitors—among them the Mexican American of Otomi Indian heritage Octavio Medellín and European immigrants Hyman Bloom, Raymond Breinin, Samuel Cashwan, Rico Lebrun, and Knud Merrild—were presented as Americans.[14] These artists

told their own stories in the exhibition's catalog, a publication that was illustrated with headshots and reproductions of their work.

Documentary images of *Young Negro Art* are photographs of those who attended the private preview of the exhibition and subsequent tea service in the museum's dining room on 5 October 1943 (figs. 10 and 11). They offer scenes of interracial socialization: staged photos of whites and Blacks. None of the exhibitors was present—neither the five men in the service nor the two men and one woman still on Hampton's campus. Fronted by many of the attendees in the photos, Biggers's *Dying Soldier* (1942) and Redwood's *Night Scene* (1943) were the stand-ins for the absentee artists themselves. Both paintings drew the attention of the press—Biggers's expressionist panel for its undeniably clear antiwar and antiracist tenor and Redwood's genre scene painting for perceived racial expression. An *Art News* critic surmised, "In one picture only—that of Junius Redwood—do we find the great gifts of color, dignity, and sincerity which are the Negro's natural heritage. Of the screaming propaganda of John T. Biggers picture, the less said the better."[15] While journalists frequently mentioned Biggers and *Dying Soldier* in published items about *Young Negro Art*, it was Redwood who gained the most in the intermediate aftermath.[16] MoMA acquired *Night Scene* the following year.

ARRIVAL: *THE NEGRO ARTIST COMES OF AGE* EXHIBITION (1945)

In 1944, administrators at the Albany Institute of History and Art, working with an interracial advisory committee of academics, art writers, artists, gallerists, and philanthropists, planned the exhibition *The Negro Artist Comes of Age: A National Survey of Contemporary American Artists*. All were dedicated to raising the profile of these artists, many of whom were their friends, colleagues, clients, and collectors. That two of the team members—painters Aaron Douglas and Hale Woodruff—were participants in the show, their names listed among the advisors in the exhibition's catalog, demonstrated that close networks were a matter of course. It was as if the Albany Institute project leaders believed that visitors would be untroubled by the appearance of a conflict of interest, for the importance of positioning Black American artists as Americans and challenging the category of all-Negro exhibitions was self-evident and urgent.

In title and in structure, the Albany Institute's exhibition was an attempt to realize these bifurcating objectives through the metaphor of maturity.

At the time of the show's opening in January 1945, "coming of age" was a resonant phrase. Economists and readers of the *Atlantic Monthly* may have connected it to "The Negro Comes of Age in Industry," an influential article published in the magazine in September 1943 by African American economist and White House advisor Robert C. Weaver. Academic readers as well as avid consumers of popular culture would probably have summoned Margaret Mead's *Coming of Age in Samoa*: this 1928 book made its author the most celebrated anthropologist in the world, for she was widely lauded in the press and profiled in cinema newsreels in subsequent decades.[17] Today, the subtitle of Mead's text—*A Psychological Study of Primitive Youth for Western Civilisation*—not only signals her position and those that she assigned to her subjects and to presumed readers but also indicates the complexity of the zeitgeist. In the Albany show, the Negro artist might have been likened to the Black laborer in Weaver's study of the expanding American blue-collar workforce, and to the "primitive" of Mead's best seller. That Locke used the trope of development in "Up Till Now," his essay for the Albany Institute's exhibition catalog, is meaningful. There, Locke writes that "the increasing maturity of the Negro artist" is an outcome of being "freed ... from the limiting avoidance of Negro subject-matter and later led him to more objective and effective self-portrayal" during the first half of the 1940s.[18] For Locke, these African American artists, unlike their predecessors in colonial America and subsequent epochs in the United States, had options.

Many of Locke's assertions are taken up in the preface to *The Negro Artist Comes of Age*, in which John Davis Hatch Jr., the Albany Institute's director, praises Locke and his effort. As Locke had, Hatch cites the impact of the Depression-era patronage, namely, the Harmon Foundation and "the Government art projects."[19] Yet Hatch failed to absorb the sweep of Locke's contextualizing account, for he starts off his preface by stating that there had been only "one or two Negro artists whose work had gained them some prominence" prior to the twentieth century. If Edith Halpert had discovered a history of Black artists' activities by reading Locke's writings, Hatch, despite his access to them, simply found historical Black artists' oeuvres inconsequential. For Hatch, it was the contemporary Black artists who had broken through, as he explains:

> We have purposefully called our exhibit "The Negro Artist Comes of Age" as we believe this group is making a *real* contribution

today to our National Art. It is a contribution equal to that of their more popularly recognized contemporaries in music and literature. We believe the group should no longer be judged by special standards as a group, but as individuals among the greater body of creative artists of our country. All of these artists are producing work worthy of inclusion in our larger national art shows; some indeed *have* gained national recognition—yet of forty-one originally selected, only twelve were included in the last issue of *Who's Who in American Art*.[20]

In these statements, Hatch first evokes the contribution model of nation building; the claim is that each ethnic and racial group contributes its unique gift to the multipartite entity that is the nation-state. Hatch's subscription to this pluralist idea—evident throughout the German philosopher Johann Gottfried Herder's writings, which in turn influenced Locke and others— also plays out in the subsequent sentences, in which he turns to a familiar archetype (the Black musician) and endeavors to construct a new one (the Black writer). Hatch's assertion is that Black visual artists were as well known as their counterparts in other fields of expression, for a dozen of the Albany show's exhibitors were included in an important reference book listing American artists of note, and others deserved similar recognition. The obvious paradox is that Hatch, like Locke, made a case for ending the "all-Negro" group exhibition even as his museum produced yet another one of these vehicles.

Still, it seems that Hatch had reached the same conclusions that Downtown Gallery founder Edith Halpert had in 1941: that there were Black artists in the United States and that they were creating display-worthy work, equal to that of the country's racial majority. In a way, it was they—Hatch, Halpert, and other white Americans articulating their desire to mainstream Black artists into an expanding art world—who had come of age during the war years. The twist in this evolutionary road toward inclusion and desegregation in the American art industry was that Black artists were wary of the contradictions of *The Negro Artist Comes of Age*. Indeed, Hatch disclosed in his essay that "many of the artists, it should be fairly noted, were hesitant to exhibit in another all-Negro show, but only one whose work we hoped to include refused on these grounds."[21] While Hatch did not name the *refusé* artist, there were three active contemporaneous artists whose names are conspicuously

absent from the Albany roster of participants: sculptor Nancy Elizabeth Prophet and painter-illustrators Charles H. Alston and Allan Rohan Crite.[22]

Notably, *Ebony* magazine's final issue in 1945 featured a two-page article that promoted the Albany show and the visibility of contemporary Black American artists and exhibitions featuring their work. This unsigned article positioned Hale Woodruff, Rex Goreleigh, Charles White, and Jacob Lawrence as the inheritors of Henry Ossawa Tanner's legacy. Yet, as Locke had asserted in "The Legacy of the Ancestral Arts," an essay published in 1925, the *Ebony* writer argued that none of these artists had produced work equal to that produced in ancient sub-Saharan Africa.[23] In a statement that communicates a collective waiting for something and perhaps impatience about its delayed arrival, the *Ebony* journalist proclaimed that, while the future was promising for Black American artists, "'The Master of the Negro' had yet to appear."[24] Undoubtedly, this pronouncement must have stung those who took part in *The Negro Artist Comes of Age* and also those whose work was not presented.

To our twenty-first-century ears, the "coming-of-age" metaphor certainly infantilizes its centralized subject in the context of assessing art by Black Americans. The clear implication was that these producers had finally reached adulthood and thus had earned the right to be taken seriously by audiences, both Black and non-Black. "Coming of age" placed a burden on the categorized "Negro artist," making anonymity and lack of success a "Negro problem." That the phrase "the Negro artist comes of age" resonates with remarks offered in Locke's eponymous essay for *The New Negro*, his landmark anthology of 1925, is unsurprising. Throughout his intellectual life, Locke returned to key themes and reused piquant terms. In the concluding paragraph of his essay "The New Negro," Locke anticipated a forthcoming shift in the American majority public's perception of the Negro: once he was no longer viewed as "beneficiary and ward," the Negro would be recognized as "a conscious contributor" and "a collaborator and participant in American civilization." Locke ends with restrained hope: "And certainly, if in our lifetime, the Negro should not be able to celebrate his full initiation into American democracy, he can at least, on the warrant of these things, celebrate the attainment of a significant and satisfying phase of group development, and with it a spiritual Coming of Age."[25]

In a way that was not possible in the 1940s, present-day audiences, appraising the phrase "the Negro artist comes of age" more than seventy-five

years after its first articulation, can name the exclusionary practices of national art institutions and galleries led by white Americans. We can lay blame for discrimination, inequity, and racism at their thresholds. If Locke and the organizers of the Albany exhibition counted upon their audiences to accept their mapping of maturation on the bodies of these creatives, the time to flip the script may finally be upon us in 2023. That is, has the US public come of age, reaching a stage where it can no longer *not* know about African American artists?

PICTURING AFRICAN AMERICAN ARTISTS DURING WARTIME

World War II significantly affected all aspects of twentieth-century American society. The war economy eventually lifted the nation out of the worldwide Depression. World War II also became a subject for the culture industry. Museums and galleries shaped a revitalized category of artistic engagement with US military efforts (historical and contemporaneous) in group shows such as *Artists for Victory: An Exhibition of Contemporary American Art* at the Metropolitan Museum of Art in 1942–43.[26] The US military was supported by civilian workers as well as by volunteers and conscripts. Representations of Black servicemen were aspects of World War II's popular iconography. This was a striking phenomenon, in that full participation in World War II was a battle for Black men who wanted to fight America's enemies. The segregation of the US military was among the grievances that were to be articulated at a planned mass protest gathering in Washington, DC, in 1941. Although President Roosevelt staved off that action by issuing an executive order prohibiting discrimination in the war industry, organizers had to continue pressing the government to fully desegregate the armed forces. Nonetheless, the heroism of individuals like Doris (Dorie) Miller and of groups such as the Tuskegee Airmen fueled their iconic status, and they were featured in military recruitment materials, propaganda films, war bond posters, and patriotic cartoons and poetry.

For Howard Romare Bearden, active duty proved to be a different lens through which he could be seen, for his solo exhibition drew attention to his role in the defense of the nation.[27] The title of his 1944 show at the G Place Gallery in Washington, DC—*Ten Hierographic Paintings by Sgt. Romare Bearden*—linked individual creativity to national service. Several photographs were used to publicize the exhibition in the press. One image is a stock

grip-and-grin shot of the artist and G Place Gallery owner Caresse Crosby: she seems to be congratulating him on the occasion of his exhibition's opening. Bearden holds Crosby's right hand in both of his; in her free left hand is a printed flier with the show's title, run dates, and checklist. On the wall behind them is Bearden's *Lovers* (1944), a bold gouache painting that is remarkable for the expressionist rendering of the romantic pair: the heads and hands of the serenading guitarist and the female subject of his desire are disproportionately large and colored with terracotta hues (fig. 12). The sweethearts' skin tones contrast starkly not only with that of the white American Crosby but with that of the light-skinned African American Bearden, a man who could have passed for white. Nonetheless, Bearden's paintings and the G Place Gallery's contextualization of them made audiences aware that he was Black, complicating the reception of this photo. The image is more than a record of a symbolic act, a documented moment of etiquette, and the visual evidence of a friendship and a business relationship.[28] It is a proclamation of racial integration, one loaded with risk, for it might have offended segregationists in the US capital and in other precincts of intolerance.[29]

Commissioned to make art representing a united American nation, realist painter Hughie Lee-Smith nonetheless continued his critique of racism during World War II. Lee-Smith was drafted into the navy in 1943 and assigned to the Great Lakes Naval Center in Illinois, a site for training Black American sailors. There, Lee-Smith, Edsel Cramer, and Isaiah Williams were charged with creating a mural in panel format, *The Negro in the U.S. Navy*.[30] In a newspaper photo recovered by art historian Alona Cooper Wilson, Lee-Smith, Williams, and Cramer stand in front of one of the twelve panels completed for the project (location unknown). Lee-Smith assumes the pedagogue's stance, gesturing at the depicted subject: Black artillery gunmen who work together to load and fire the weapon at an unseen enemy (fig. 13).[31] The artist, whether pointing out a compositional aspect of the painting or explaining the inspiration for the scene, seems to take ownership of the work, which he knew was commissioned to inspire and teach those in the service and the civilian population as well.[32] Yet Lee-Smith, like many in African American communities at the start of World War II, recognized the paradox of serving in the US forces while not enjoying the full rights of American citizenship.[33] His activism, initiated during the interwar years at Cleveland's Neighborhood Settlement Playhouse, continued during World War II, when he organized an exhibition of Black

artists' work for "Problems of the War and the Negro People," a National Negro Congress conference held in Detroit. For Lee-Smith and others, war was no reason to pause the campaign for civil rights.

Still, Black American artists moved in racially mixed cultural circles during World War II, making art and collaborating in the project of picturing integration across class, gender, national, racial, and sexual borders.[34] One understudied case is Carl Van Vechten's photographs of the Stage Door Canteen, a Manhattan theater district club founded in 1942 to serve Allied forces enlisted men and boost public morale. Van Vechten, a portrait photographer of mid-twentieth-century New York cultural workers and a patron of the Harlem Renaissance, was an avid supporter of the Stage Door Canteen and bussed tables there twice a week. Civilians, including "enemy aliens," could volunteer to serve food and entertain at the club, too, making it an interracial and international contact point, according to historian Katherine M. Fluker.[35] Van Vechten was inspired by the Canteen, extolling its cooperative environment in an essay penned in 1943:

> One evidence of the popularity of the place is the eager willingness of service men to help the workers. A great many volunteers do this. One doughboy I know comes to work there four or five times a week.... The place is absolutely democratic in its organization and social behavior, perhaps one of the few democratic institutions in existence anywhere: English soldiers, sailors and RAF men dance beside, mingle and eat with Chinese airmen, Americans from every branch of the service, including Negroes and Indians, Canadians, Australians, South Africans, Dutch and French sailors (how pleasant is it to listen the *bon soirs* which greet them from every side of the room when they enter), occasionally Russians: all are part of the Stage Door Canteen.[36]

Van Vechten's observations not only offer a picture of cross-cultural and international engagement; they also express an undisguised appreciation for self-governing fraternity among men.

African American sculptor James Richmond Barthé was a civilian who volunteered as a server and kitchen worker at the Stage Door Canteen. Van Vechten documented Barthé in this setting on 14 April 1943. Working the front of the house, the bow-tie-, sweater-vest-, and bib-apron-wearing Barthé attends to the table where the Austrian American performer Fritzi

Scheff dines with the gay white American actor Alan Hewitt. Another photo shows the sculptor in the same outfit with busboy Coby Ruskin: both men are on cleanup duty, out of the public view, and Barthé focuses on wiping a tray that he holds in his hand (fig. 14). Barthé was a favored Van Vechten subject. Starting in the 1930s, Van Vechten made numerous Barthé portraits, each presenting him as a handsome member of New York City's African American white-collar class. Van Vechten also pictured others posing with Barthé's work, as well as the artist holding and examining his realist statues and busts, surrounded by finished works and projects in progress in his studio. Van Vechten aimed to make Barthé a celebrity—that is, an individual to whom the public should pay attention because of his (or her or their) special talents, attributes, or both.

In a departure from Van Vechten's usual treatment of Barthé, the Stage Door Canteen photos present him performing ordinary acts, using his hands to contribute to a collective effort. Rather than modeling clay to build up sculpture, Barthé is shown working in the kitchen or bending to offer food and drink to others in the front of the house. There is no question that the stereotype of the cheerful Black servant hangs about these compositions. Yet it is worth noting that Van Vechten similarly photographed himself and other gay male civilians—among them the previously named whites as well as Blacks like author Langston Hughes and educator Harold Jackman—cheerfully attending to Stage Door Canteen diners, too. In doing so, Van Vechten depicted not only the ethno-racial, class, and cultural heterogeneity of the servers but also the mutual benefit of volunteerism, for everyone was doing their bit during wartime.[37] With these representations of men in caregiving roles, Van Vechten challenged the socially and culturally constructed frameworks around jobs usually viewed as feminine and, by extension, often deemed menial and less deserving of acknowledgment.[38]

Barthé was not the only gay African American visual artist in Van Vechten's set at the Stage Door Canteen. Realist painter Charles Sebree was also in this number: he featured in fifteen photos that Van Vechten took at the Stage Door Canteen on 17 February 1943. Drafted into the navy in 1942 and stationed at an all-Black military base in Illinois, Sebree must have been in New York City on approved leave on this date. In six of these mise-en-scènes, Sebree, dressed in seaman's blues, is seen in the company of others: seated fellow servicemen and white waiters who bring wholesome snacks and drinks—coffee, doughnuts, milk, oranges—to these groups. All were

members of Van Vechten's intentional community of gay men and gay-friendly people whom he situated in the war effort. Among the former group was Sebree's close friend Owen Dodson, a Black poet and playwright who left his Howard University faculty post to enlist in the navy. Others in these photos with Sebree were whites: Hiram Sherman, a Broadway actor also in the navy; Allen Porter, a MoMA staffer and army sergeant; the writer Vernon Crane; and Saul Mauriber, a decorator and designer who would become Van Vechten's lover. Not known to be gay or bisexual, but clearly an ally of these racial and sexual minority groups, was Frank Piro, a white plastics designer who was serving in the Coast Guard.[39] In a sequence of images, Sebree is shown in a partner dance with a backward-bending Piro, who was well known in Black and white ballroom circles for his dancing prowess; Sebree and Piro are cheered on by white busboy Phil Denman, a sailor identified as Don Smith, Porter, and Dodson, who mimics the action of playing a harmonica (fig. 15). These photos pushed and crossed the boundaries of the era's proscribed heteronormative behavior, which were constantly policed, especially among servicemen.[40] Their campy bits would be read as the archetypal behavior of homosexual men.[41]

Sebree's presence in Van Vechten's photos of socializing servicemen was a unique documentation of the networks of this artist's life. Interviewed by the journalist Willard Motley for the article "Negro Art in Chicago" in 1940, Sebree was presented as a successful yet troubled creative.[42] In fact, Sebree's work was supported by both Blacks and non-Blacks who were invested in different ways in making the work of African American artists visible during the war years. In his groundbreaking survey text Modern Negro Art (1943), James A. Porter included Sebree in a chapter titled "The New Horizons of Painting," writing that the painter showed "a definite inclination toward the mystical and the ineffable in human life. His work is conceived in a mood of contemplation and recalls the mystical purity of Byzantine enamels or Russian icon painting."[43] Sebree's expressionist painting was exhibited in integrated group shows at the Art Institute of Chicago, the Barnett Aden Gallery, and the G Place Gallery, as well as in all-Negro art surveys at Halpert's Downtown Gallery and Chicago's Tanner Art Galleries, the South Side Community Center, and Hull House. Locke included Sebree in the 1945 traveling group exhibition The Negro Artist Comes of Age and named him one of the thirty-eight artistic talents in the exhibition catalog's introductory essay.[44] It is nonetheless notable that this publication

includes photos of the artists, their work, or both for every artist except Sebree. The absence of his image from *The Negro Artist Comes of Age* stands in contrast to his presence in Van Vechten's Stage Door Canteen photos.

Without question, Van Vechten was an auteur who designed the Stage Door Canteen images carefully: he organized the cast and marked out the space where they stood and sat. Yet this project, like others that he organized for cultural, erotic, political, social, and integrationist ends, depended on the willingness of friends and acquaintances to be actors.[45] They were veritable collaborators, whose bodies, bearing, and performances contributed to the making of the images. They were not mere staffage. All had to buy in to Van Vechten's photographs of homosocial mise-en-scènes staged at the Stage Door Canteen; all knew that the intimacy of same-sex embraces and exchanged looks would be recognized as more than theatrical parody and satire. These photos are complex artifacts of collective activism, advocacy, participation, and visibility. That is, they are evidence of a group undertaking to document the presence of gay men in the military and advocate for their right to serve; they make activist statements of enacted democracy in a cross-cultural and international space; they are investments in gay visibility; they are visual cultural objects that Van Vechten could not produce on his own for they required the participation of others.

The risks for Black gay men in the Stage Door Canteen photos were heightened, for they faced racism and classism as well as homophobia.[46] Yet they all knew that photography was an available medium in the construction of a career. Van Vechten not only photographed Black notables; he made those he photographed better known.[47] Sebree probably hoped for this outcome, and yet the weight of the trade-off is perhaps measured in his varied mien and body language as captured in the photos. In his playful dance with Piro, Sebree grins and challenges his partner to match his moves. The joyful abandon in these moments sits alongside Sebree's self-awareness in other photos. In one shot, he is turned away from busboy Vernon Crane. In another, Sebree seems disengaged from his seated companions Owen Dodson and Allen Porter. In a third, he looks shy and diffident when Porter and Hiram Sherman turn their focus on him. While Van Vechten proclaimed that the Stage Door Canteen brought him to tears for the "sheer happiness that such things can be," Sebree's vulnerability as a marginalized subject facing systemic racism, classism, and homophobia must be measured in the photo documentation of an intentional community.[48]

APPENDIX: LIST OF AFRICAN AMERICAN
PARTICIPANTS IN NEW DEAL ART PROGRAMS
AND/OR HARLEM ARTISTS GUILD

The list below is a work in progress. It has been assembled from a variety of primary and secondary sources, including archival records and published compilations such as bibliographies and oral history records. As an accounting of Black artists who participated in the New Deal art projects, it makes no claim to being definitive or complete. It will certainly be revised and expanded as researchers learn more about this topic. Many names can be cross-checked against multiple sources; others have appeared less frequently, sometimes only once in scattered documents and publications. Like Francis V. O'Connor's research, this list is (regrettably) skewed toward the New York City projects, for which records are most readily available.

I have merged information regarding membership in the Harlem Artists Guild with the participant list. The Henderson Papers contain multiple (undated) HAG membership lists, most of which include addresses. Some seem to be simply internal records, but others were probably assembled expressly for the FAP administration. One list was used to provide contact information for the purpose of distributing applications to members who wanted to submit work for the FAP-sponsored World's Fair art exhibition. Another responds to a WPA inquiry about member artists and their participation in the projects. Earlier membership lists can also be found in the Louise Jefferson Papers.

In 1985, Camille Billops conducted a group interview with artists who had been involved in the HAG and the HCAC. The published transcript in the journal *Artist and Influence* also includes a list of members. There is a great deal of overlap in these sources, but some names on the Henderson lists do not appear in *Artist and Influence* and vice versa. I have combined these sources, with a few noted exceptions.

While HAG membership lists are long, attendance at meetings held during the fall and winter of 1938–39, for which there are minutes, was quite

modest. There were also a handful of individuals who attended meetings but whose names do not appear on any membership lists.

Finally, there are names that appear in the minutes or on various membership lists, but I have not verified that they participated in the projects.

Names in **bold** are project participants who also appear on HAG membership lists. Names in ***bold italics*** appear on HAG lists only; they are not verified as project participants. Names in neither bold nor italics are project participants with no known relationship to the HAG.

Alston, Charles	Carlo, Fred
Alston, Frank	Carter, William
Anderson, Charles	Catlett, Elizabeth
Armstrong, Myra	**Chase, William**
Artis, William	Chesse, Ralph
Atkinson, John	***Christmas, Walter***
Avery, Henry	**Clark, Catavia**
Bailey, Ruby	Clark, Claude
Bannarn, Henry	***Clark, Elizabeth***
Barthé, Richmond[1]	**Coleman, Frederick**
Bearden, Romare	**Colston, Mairl**
Beasley, Olivia	Cooper, William A.
Bennett, Gwendolyn	Cortor, Eldzier
Blackburn, Robert	Crawford, Hubert
Bond, Eugene	**Crichlow, Ernest**
Boyd, David	Crite, Allan R.
Brandford, Edward	Crump, Robert
Brooks, Howard	***Dames, Chester***
Brown, Elmer	Davis, Charles
Brown, Lester	Dawson, Charles
Brown, Samuel	**Day, Selma**
Bruce, Stuart	**Delaney, Beauford**
Buckner, Velma	**Delaney, Joseph**
Bunch, George	Dillard, P.
Burke, Selma	***Dorsey, Jean***
Burroughs, Margaret	***Dorsey, Lillian***
Burton, Leroy	**Douglas, Aaron**

Edmondson, William
Ellison, Walter
Evans, Edgar
Evans, Stafford
Everett, James
Fax, Elton
Fletcher, William
Gaines, Felix B.
Garay, John
Gaylord, Cecil
Gilbert, Emil
Gill, Meshach
Gillien, Theodore
Glenn, Sollace
Goreleigh, Rex
Goss, Bernard
Graves, Goldie
Gray, Paula
Green, Demassqua
Green, Reginald
Grigsby, Eugene
Hardrick, John
Harrington, Ollie
Harris, Arthur
Hayden, Palmer
Hayes, Vertis
Hill, Carl
Hill, Lewis
Holdner, Knute
Holmes, Henry
Holmes, Joseph
Howard, Humbert
Howard, May
Hubbard, Athelina
Hudson, Henry
Hutchinson, David
Ingram, Zell

James, Frederick
Jefferson, Louise
Jennings, Wilmer
Johnson, Dorothy
Johnson, Malvin G.
Johnson, Sargent
Johnson, William H.
Jones, Lawrence
Jones, Mildred
Jones, Robert
Jordan, Rosa
Joseph, Ronald
Kanzaki, Marguerite
Keene, Charles
Kersey, Joseph
Knight (Lawrence),
 Gwendolyn
Laessle, Paul
LaGrone, Oliver
Landau, Victor
Lawrence, Jacob
Lee-Smith, Hughie
Lewis, Norman
Lightfoot (Reyas), Elba
Lindsey, Richard
Loper, Edward
Lord, Francesco
Lutz, John
Martin, Ethel
Mason, John
Mathewson, Claude
Matthews, Lester
McClane, Dorothea
McIver, Susie
Mitchel, B.
Mitchell, Irma
Moore, Lonnie

Motley, Archibald
Murray, George
Murrell, Sara
Nash, Millard
Neal, Frank
Nelson, George
Nugent, Bruce
Perry, Frederick
Peterson, Cynthia
Pierce, James
Pious, Robert
Piper, William
Pollard, Aubrey
Pringle, Bryant
Rabouin, Edna
Reid, Daniel Terry
Reid, Donald
Reid, O. Richard
Richardson, Earle
Riley, Sylvia
Riley, Wilhelmina
Robinson, J. H. D.
Rollins, John
Rollins, Stanley
Ross, David
Sallée, Charles, Jr.
Savage, Augusta
Schardt, Bernard
Scott, William E.
Seabrooke, Georgette
Sebree, Charles
Serrant, Eldon
Shaw, Leora
Shearer, Teddy
Simmons, Cleopatra
Smith, Arina

Smith, Charles
Smith, Florence
Smith, Howard
Smith, Inez
Smith, Marvin
Smith, Morgan
Sorrells, Willie Pope
St. Clair, Evangeline
Steth, Raymond
St. John, Roland
Streat, Thelma
Sutton, Harry
Sweeting, Earl
Tann, Curtis
Taylor, Bernard
Thibeaux, James
Thompson, James
Thrash, Dox
Troy, Adrian
Vaughn, Louis
Vavak, J.
Walker, Earl
Walker, Grayson
Wallace, Dorothy
Warren, Wilbert
Wells, James L.
West, Sarah
White, Charles
Williams, Clarence
Williams, Ezekelia
Williams, Gertrude
Wilson, Ellis
Wilson, John
Woodruff, Hale
Yeargans, James
Yingchousti, Victor

CHAPTER 1

1. Portions of the following discussion were initially published in my article "Expansion and Redirection." Some ideas were also incorporated in Calo, "Significance of the Interwar Decades."

2. Audrey McMahon, "The Trend of the Government in Art," *Parnassus* 8 (January 1936), quoted in Kalfatovic, *New Deal Fine Arts Projects*, lxiii.

3. The Francis V. O'Connor Papers and Holger Cahill Papers are held by the Archives of American Art, Smithsonian Institution. Access to the Cahill Papers was greatly expanded when they were digitized in 2004. O'Connor donated a cache of papers to the National Collection of Fine Arts (now known as the Smithsonian American Art Museum) soon after the completion of his initial research on the New Deal. The NCFA gift aggregated materials used to map the federal projects, with a primary focus on New York. In 2010, O'Connor donated additional supporting documents for this study to the Archives of American Art, including correspondence regarding his requests for funding, outreach to various individuals and institutions for information on project art and artists, and the text of the original 1968 report. The papers also brought together a collection of essays written by project participants in the mid-1930s intended for a WPA/FAP report that was never published. O'Connor rediscovered these essays in 1968 and eventually published them as *Art for the Millions: Essays from the 1930s by Artists and Administrators of the WPA Federal Art Project*.

4. See O'Connor, *Federal Support for the Visual Arts*.

5. "Memo to: All artists, art dealers, art teachers, supervisors and administrators who were employed on New Deal art projects in New York City and New York State between 1933–1943, from Francis V. O'Connor, Director, Federal Support for the Visual Arts: The New Deal and Now, A Research Project," O'Connor Papers, Series 2.1, box 7.

6. This show had been organized by Romare Bearden. O'Connor to Jean B. Hutson, 8 February 1968, ibid., box 8.

7. While the General Services Administration records yielded important information, the questionnaires sent to Black artists during the course of this research were of limited utility owing to the low return rate. See O'Connor Papers, Series 1.2, "WPA/FAP Artists' Files, 1936–1971," and Series 1.3, "GSA Artists' Employment History Records, 1936–1973." There are handwritten notes elsewhere in the files that suggest that O'Connor was engaged at one point in a "ranking process" involving art project participants using a scale of A (famous), B (known), and C (unknown). Jacob Lawrence's name appears as a B that is crossed out and reassigned a C. Ibid., Series 2.1, box 8.

8. *Federal Art Patronage Notes*, September 1974, 1, O'Connor Papers, Series 2.4, box 11.

9. Ibid., 1, 4.

10. On the Glassboro State conference, see Gerald Moore, ed., *Fine Arts and the People: A Report on the Conference on the New Deal Cultural Projects Held at the Hollybush Conference Center of Glassboro State College, October 31, 1975 to November 2, 1975*, supplement to *Federal Art Patronage Notes*, Winter–Spring 1975–76, O'Connor Papers, Series 3.2, box 12.

11. Ibid., 4.

12. O'Connor, untitled remarks, *Federal Art Patronage Notes*, Summer 1983, 3, O'Connor Papers, Series 2.4, box 11.

13. An account of this conference titled "Center Hosts New Deal Conference" was published in the spring 1985 issue of the *Dispatch* (the newsletter of the Center for American Cultural Studies at Columbia

University), 2–5, 21, O'Connor Papers, Series 3.2, box 12. There was also a symposium at Columbia in 1982 called "The New Deal and the ARTS: Lessons for the 1980s." There is a transcript of this conference in ibid., box 13.

14. Quoted in "Center Hosts New Deal Conference," 5.

15. Ibid., 2–3.

16. See especially McDonald, *Federal Relief Administration and the Arts*; McKinzie, *New Deal for Artists*; Park and Markowitz, *New Deal for Art*; and Berman, *Lost Years*. These were followed by resource guides that summarized key details regarding the origins and operations of the projects and in some cases considered historiographic issues. The introduction to Kalfatovic's *New Deal Fine Arts Projects* includes an excellent discussion of the trajectory of New Deal scholarship since O'Connor. See also Bustard, *New Deal for the Arts*. More recently, online sources have been developed to support New Deal scholarship. See, for example, "The Living New Deal," https://livingnewdeal.org/resources.

17. See Rosenzweig, *Government and the Arts*. The Archives of American Art is a major repository of oral histories related to the New Deal art projects.

18. See Rosenzweig and Melosh, "Government and the Arts."

19. Ibid., 604.

20. Ibid. See the transcript of the oral history interview with Charles Alston by Harlan Phillips, 28 September 1965, Archives of American Art, Smithsonian Institution.

21. McKinzie, *New Deal for Artists*. For more recent analysis of the underlying philosophical differences between these projects and their respective administrators, see Hemingway, *Artists on the Left*; and Kennedy, *When Art Worked*.

22. McDonald, *Federal Relief Administration and the Arts*, 410–14.

23. The expression "Negro art" was used during the interwar decades to characterize art made by individuals of African descent. Locke also used the term to describe works made by non-Black artists that dealt with racially inflected subject matter. The Harmon Foundation was a philanthropic organization that promoted the works of African American artists in the late 1920s and early 1930s through a program of exhibitions and awards. On the HF, see Reynolds and Wright, *Against the Odds*. McDonald also devotes a fair amount of space to this situation, explaining the evolution of Black artists as they moved from the HF era to the New Deal.

24. Bustard, *New Deal for the Arts*.

25. See esp. Berman, *Lost Years*.

26. I have relied in this section on a select number of general histories of African American Art, including Fine, *Afro-American Artist*; Lewis, *African American Art and Artists*; Driskell, *Two Centuries of Black American Art*; Bearden and Henderson, *History of African-American Artists*; Powell, *Black Art and Culture*; Patton, *African-American Art*; and Farrington, *African American Art*.

27. There has been a great deal of attention to Dox Thrash and the printmakers associated with the graphics division of the Philadelphia FAP for their development of experimental techniques.

28. See Donaldson, "Generation 306—Harlem, NY."

29. Morgan, *Rethinking Social Realism*.

30. Driskell, *Two Centuries of Black American Art*.

31. Driskell nods here to Romare Bearden's well-known essay "The Negro Artist and Modern Art."

32. Patton, *African-American Art*, chap. 3.

33. The Harry Henderson Papers at Pennsylvania State University contain numerous documents related to the publication of *A History of African-American Artists from 1792 to the Present*. These include correspondence between Bearden and Henderson and early drafts and promotional memos to publishers dating to the mid-1970s. The papers provide a fascinating look at the evolution of this project. Originally under contract with Doubleday, which had published their *Six Black Masters of American Art* in 1972, the book was ultimately brought out by Pantheon Books, an imprint of Random House, in 1993. The first completed draft from 1976 was more than seventeen hundred pages long; by the 1980s it had been cut to 450. Harry Henderson Papers, 1865–2002 (04848), Historical Collections and Labor Archives, Eberly Family Special Collections

Library, Penn State University Libraries, University Park, PA.

34. See Harris, *Federal Art and National Culture*; Saab, *For the Millions*; Langa, *Radical Art*; Grieve, *Federal Art Project*; Sklaroff, *Black Culture and the New Deal*; Helfgott, *Framing the Audience*; and Musher, *Democratic Art*.

35. On the Index of American Design, see especially Clayton et al., *Drawing on America's Past*. Studies of the Index offer few positive insights into African American culture because of the near-exclusive emphasis on Euro-American design traditions. On the CACs as epitomizing Dewey's paradigm of "art as experience," see Cahill, "American Resources in the Arts." This is the text of a talk delivered by Cahill at John Dewey's eightieth birthday celebration in 1939.

36. Harris, introduction to *Federal Art and National Culture*.

37. See especially Hemingway, *Artists on the Left*; Musher, *Democratic Art*; Grieve, *Federal Art Project*; and Gibson, "Managing the People."

38. Erin Cohn also argues for an increased awareness of their impact on subsequent civil rights activism. See Cohn, "Art Fronts."

39. Sklaroff, *Black Culture and the New Deal*, esp. chap. 3.

40. Saab, *For the Millions*, 46–53.

41. Musher, *Democratic Art*, esp. chap. 5.

42. Ibid., 160.

43. Grieve, *Federal Art Project*, esp. introduction and chap. 4.

44. Helfgott views the work of Harris, Grieve, Saab, and Helen Langa as exceptions.

45. Conflict between the HF and artists in the Black community is well documented in literature on the period. For a nuanced account of Alain Locke's relationship to these issues, see Jeffrey C. Stewart's biography *The New Negro*.

CHAPTER 2

1. O'Connor makes clear in his introduction to the collection that while the essays were narrowly focused on New York, the book was to be followed by a second that would create a portrait more national in scope. This second work was issued as *Art for the Millions* in 1973.

2. On the PWAP, see the exhibition catalog by Wagner, *1934: A New Deal for Artists*.

3. It is difficult to arrive at an exact number of African American participants because the data are not consistent. Bearden and Henderson list ten, but a report of the assistant secretary of the Treasury to the Federal Emergency Relief Administration (*Public Work of Art Project: Report of the Assistant Secretary of the Treasury to Federal Emergency Relief Administrator, Dec. 8, 1933–June 30, 1934*) gives the following nineteen names: A. Douglas, P. Hayden, D. Hutchinson, M. G. Johnson, E. Richards [sic; probably Earle Richardson], J. H. D. Robinson (all in the New York metropolitan area); S. Johnson and L. Matthews (California); E. Catlett and H. Hudson (District of Columbia); W. Jennings (Georgia); A. Motley, W. E. Scott, and C. Dawson (Illinois); J. Hardrick (Indiana); E. Fox [sic; probably Elton Fax] (Maryland); A. Crite (Massachusetts); S. Brown (Pennsylvania); and W. A. Cooper (Tennessee). These artists are not listed by race. I have identified their race by cross-checking them against multiple sources on African American art. The Harmon Foundation papers include David Boyd of Missouri, and Bearden and Henderson include Daniel T. Reid of Illinois. A *Chicago Defender* article (2 March 1935) about "race artists" on the PWAP adds Dennis Gross of Baltimore, Clark Hall of DC, and Hale Woodruff.

4. Fiske Kimball to HF, 4 June 1934, Harmon Foundation Papers, Library of Congress, Manuscript Division, box 73.

5. Education and Experience Record, Emergency Relief Bureau Works Division, "Federal Art Project-Questionnaire," O'Connor Papers, Series 1.1, box 1.

6. "Supplement No. 1 to Bulletin #29, W.P.A. Sponsored Federal Project No. 1," 30 September 1935, Cahill Papers, Series 3.1, microfilm reel 5288, frame 342. All citations of reels and frames refer to microfilm.

7. See McMahon, "General View of the WPA."

8. O'Connor, introduction to *Art for the Millions*, 20. O'Connor's inventory suggests that Samuel Brown was to have been represented in the section on the creative projects. Brown's essay "About Myself" is identified in

Appendix B as a missing manuscript that had been included in the original 1939 plan.

9. Thomas Parker, assistant director, FAP, speech delivered at the General Conference of the 35th Annual Meeting of the American Teachers Association, Tuskegee Institute, 29 July 1938, Cahill Papers, Series 3.1, reel 1105, frames 617–27. All quotations in the ensuing discussion come from this document. Known originally as the National Association of Teachers in Colored Schools, the American Teachers Association merged with the National Education Association in 1966.

10. Correspondence between Parker and Alphonse Heningburg of the North Carolina College for Negroes, June and July 1938, Record Group 69, Records of the WPA, National Archives and Records Administration, College Park, MD (hereafter NARA), FAP Office of the National Director, box 13, entry 1021. See also Parker's talks at the American Association of Museums, 4 May 1937, and at the American Library Association, 14 June 1938, Cahill Papers, Series 4.2, reel 5291, frames 218–27 and 270–91, respectively. The North Carolina College for Negroes is now known as North Carolina Central University.

11. Parker was referring to the 1936 MoMA exhibition New Horizons in American Art, which showcased productions from the newly operational FAP. On this exhibition and its implications for African American artists, see Calo, Distinction and Denial.

12. Holger Cahill, "Role of Art in the Community," talk given at the People's Art Center Association in St. Louis, May 1941, Cahill Papers, Series 4.1, reel 5291, frames 42–78 (quotation at frame 56).

13. For an excellent analysis of the multiple promises and accomplishments associated with the CACs, see Musher, Democratic Art, chap. 3.

14. See McKinzie, New Deal for Artists; Grieve, Federal Art Project; and Gibson, "Managing the People."

15. Manual for Federal Sponsored Community Art Centers, August 1937, Cahill Papers, Series 3.1, reel 5288, frames 608–53 (quotation at frames 635–36).

16. See, for example, various documents and reports from 1936–37 on these initiatives in

ibid., reel 1107, frame 420, and reel 5288, frames 404–5, and Series 3.3, reel 1105, frames 1339–40, 1374–82.

17. This is evident in correspondence between FAP officials and in planning documents related to the establishment of specific centers. Early planning focused on the South, but by the end of the decade attention had shifted to the midwestern states and the far West.

18. Thomas Parker to Holger Cahill, 3 November 1935, NARA, General Records, 1935–1940, "Field Trip Material," box 4, entry 1021.

19. Parker, "Field Trip Report," 14 February 1936, ibid.

20. See especially McKinzie, New Deal for Artists; Musher, Democratic Art; and Saab, For the Millions.

21. Jones, "New Orleans WPA/FAP."

22. Hayes, "Negro Artist Today."

23. Bennett, "Harlem Community Art Center."

24. Sutton, "High Noon in Art."

25. WPA, "Art Project Opens Negro Extension Galleries," press release, 31 December 1937, O'Connor Papers, Series 1.1, box 1.

26. See "Federal Art Project Has Opened Race Extension Galleries over Dixie," Atlanta Daily World, 9 January 1938, 8; "116,000 Attend U.S. Extension Art Galleries," Baltimore Afro-American, 15 January 1938, 22; and "115,000 View WPA Art Exhibit in South," Pittsburgh Courier, 15 January 1938, 11. In April 1938 the Chicago Defender reported, erroneously, that the recently opened art center at LeMoyne College in Memphis, established for the Black community with local support, was the first and only one of its kind. "First Federal Art Center in South Opens at Le Moyne," Chicago Defender (national ed.), 23 April 1938, 5.

27. "The Raleigh Art Center," n.d., Cahill Papers, Series 3.7, reel 1107, frame 161; "Proposed Negro Extension Division at Raleigh Art Center," 2 April 1936, ibid., frame 239; 1st Yearbook of Raleigh Art Center 1936, ibid., frame 270.

28. See O'Connor, Art for the Millions, "Appendix D: List of Community Art Centers," 306–7; Kalfatovic, New Deal Fine Arts Projects, "Appendix D: WPA/FAP Community Art

Centers," 441–45; Foushee, "North Carolina's Community Art Centers."

29. Daniel Defenbacher to Edith Halpert, 14 September 1936, and Cahill to Defenbacher, 18 September 1936, both in NARA, Central Files: State 1935–1944 North Carolina, box 2190, file 651.315.

30. Cahill to Gene Erwin, 4 October 1938, and Parker to Erwin, 20 October 1938, ibid.

31. See, for example, "Art Center Enjoys a Gala Opening at Bennett as 200 Attend Affair," *Topeka Capitol Plaindealer*, 11 October 1936. See also "New Art Show Opened Today," *Greensboro (NC) Record*, 26 September 1936.

32. "Prepare Studio for Bennett Art Exhibit," *Greensboro (NC) Daily News*, 22 October 1936.

33. David D. Jones to Ben E. Looney, 29 December 1936, NARA, Central Files: State 1935–1944 North Carolina, box 2190, file 651.315.

34. Looney to Erwin, 29 January 1937, ibid.

35. Ben E. Looney, "High Artistic Standards Revealed in WPA Exhibit," *Greensboro (NC) Record*, 26 August 1936.

36. Erwin to Looney, 29 January 1937; Erwin to David D. Jones, 31 January 1937; Erwin to Defenbacher, 1 February 1937, all in NARA, Central Files: State 1935–1944 North Carolina, box 2190, file 651.315.

37. Defenbacher to Charley Tidd Cole, 29 September 1937, NARA, Correspondence with State and Regional Offices, 1935–1940, box 38, entry 1023. This was probably the Negro Agricultural and Technical College of North Carolina, now North Carolina Agricultural and Technical State University.

38. "Whiteman Has Assumed Post," *Greensboro (NC) Record*, 16 October 1937.

39. "Plan Addition to Art Staff," ibid., 13 September 1938.

40. "Negro Art Exhibit Attracts Attention," *Greensboro (NC) Daily News*, 16 October 1938; and Fritz Raley Simmons, "Expressions and Impressions: Art," ibid., 23 October 1938.

41. Robert Armstrong Andrews to Erwin, 19 October 1938, NARA, Central Files: State 1935–1944 North Carolina, box 2190, file 651.315. This so-called informant is not identified by name. It may have been William A. Cooper, an artist and preacher who was involved in race relations and arts education in North Carolina

before moving to St. Louis, where he helped facilitate the establishment of the People's Art Center.

42. Erwin to Robert Armstrong Andrews, 24 October 1938, ibid.

43. Cahill to Erwin, 4 October 1838; Erwin to Parker, 21 December 1938, ibid. Scattered references in the literature suggest that Goreleigh and Lewis also taught at the Negro Agricultural and Technical College of North Carolina (later renamed North Carolina A&T State University), perhaps in another Greensboro extension program, and that Goreleigh taught at Palmer Memorial Institute in Sedalia. See Russo, "Federal Art Project Reconsidered."

44. I compiled information on the development of FAP art centers in Florida from several kinds of sources, which included both published lists of CACs in the secondary literature and archival documents. Discrepancies abound, in part because certain places are designated as extensions in some lists and as CACs in others. Kalfatovic adds two extensions that are also listed in *For the Millions* but not confirmed by other sources: the Milton Art Center (Pensacola) and Coral Gables Art Gallery (Miami). An internal document from 1939 meant to confirm the number of centers in Florida refers to the Miami Beach Federal Art Gallery as an extension gallery run out of Miami, but this does not appear on all lists. Parker to Eve A. Fuller, 14 March 1939 (page appended that lists Florida centers), NARA, FAP Office of the National Director, Correspondence with State and Regional Offices, 1935–1940, box 41, entry 1023.

45. Ibid., box 31, entry 1023.

46. The Liberty Square housing project opened in 1937; Lemon City was an older Black neighborhood in Miami. Fuller to Parker, 28 September 1936, ibid., box 31, entry 1023; "Florida Galleries of the Federal Art Project Works Progress Administration" (information on the opening time line of Florida art centers suggests a probable date of ca. October 1936), O'Connor Papers, Series 1.4, box 6; "Personnel List—Professional Technical Status," 23 June 1939, NARA, FAP Office of the National Director, Correspondence with State and Regional Offices, 1935–1940, box 41, entry 1023; Harry H. Sutton Jr., "High Noon in Art,"

original MS, O'Connor Papers, Series 1.4, box 7; and "Report on History of FAP in Florida," 1942, Cahill Papers, Series 3.4, roll 5289, frames 659–707.

47. "Little Bits From Here and There," *Chicago Metropolitan News*, 14 November 1936, 13.

48. "Florida Galleries of the Federal Art Project Works Progress Administration," ca. October 1936, O'Connor Papers, Series 1.4, box 6.

49. "Work by Negro Artists in Other States Under the WPA Federal Project," n.d. Reference to the two-year period of operation in Jacksonville suggests that this report was shared in the summer of 1938. Alain Locke Papers, Howard University, Moorland-Spingarn Research Center, Washington, DC, box 119.

50. "Narrative Report," FAP, Florida, 1–15 January 1936, Cahill Papers, Series 3.1, reel ND 15, frames 822–53; "Report: Personnel of Federal Art Project in the State of Florida, as of Sept. 9, 1936," NARA, FAP Office of the National Director, Correspondence with State and Regional Offices, 1935–1940, box 18, entry 1023. See also Sutton's biography in O'Connor, *Art for the Millions*, 293.

51. "Report on History of FAP in Florida," 1942, Cahill Papers, Series 3.4, reel 5289, frame 674.

52. "Narrative Report," FAP, Florida, December 1937, NARA, FAP Office of the National Director, Correspondence with State and Regional Offices, 1935–1940, box 31, entry 1023.

53. "Florida Galleries of the Federal Art Project Works Progress Administration," ca. October 1936, O'Connor Papers, Series 1.4, box 6.

54. Parker to Fuller, 28 October 1936, NARA, FAP Office of the National Director, Correspondence with State and Regional Offices, 1935–1940, box 18, entry 1023.

55. Parker to Fuller, 31 October, 14 November, and 1 December 1936, ibid.

56. Sutton, "High Noon in Art," 216.

57. This facility, located on West Ashley Street, is sometimes referred to in FAP documents as the Eartha White Settlement House. Clara White died in 1920, and her daughter named the mission in her memory. Art classes

were already offered at the mission before the gallery formally opened in June 1936. Eartha White's charitable work and advocacy had a profound impact on the Jacksonville community. She also ran a printing operation on the premises, called the Mission Publishing Company, which issued a newsletter called the *Friend* (see the first issue, from June 1933). Eartha M. M. White Collection, University of North Florida, Thomas G. Carpenter Library Special Collections and Archives, https:// digitalcommons.unf.edu/eartha_materials /10/. See also https://www.clarawhitemission .org and the Viola Muse archives in the Jacksonville Historical Society at http://www .jaxhistory.org/portfolio-items/documenting -the-african-american-community-viola-b -muse-and-the-federal-writers-project-in -jacksonville.

58. Regarding the opening exhibition, Sutton mentions specifically Gumren of Pensacola, Richardson of Jacksonville and Tallahassee, Williams of Daytona Beach, Tate of Orlando, Dominis of St. Petersburg, and Williams of West Palm Beach. Sutton, "High Noon in Art," original MS, O'Connor Papers, Series 1.4, box 7. The original manuscript for this essay is considerably longer than the published version.

59. Ibid., 12–13. When Sutton was invited to contribute an essay to *Art for the Millions*, Emanuel Benson, a consultant on the project, offered to provide him, via Fuller, relevant information on other Negro extensions operating under the auspices of the FAP. Although the data are not consistent from one letter to the next as to the number and location of these programs, Benson was clearly underscoring what he then understood to be a significant number of initiatives for the Black community. He hoped that with this material Sutton might be able to write a general statement on what had been accomplished by Negroes generally in these centers across the country as well as on what was being done specifically in Jacksonville. Emanuel Benson to Fuller, 28 April 1939; Parker to Fuller, 27 May 1939; Benson to Fuller, 19 June 1939, all in NARA, FAP Office of the National Director, Correspondence with State and Regional Offices, 1935–1940, box 41, entry 1023.

60. Sutton, "High Noon in Art," original MS, 14–15.

61. Ibid.

62. Parker to Fuller, 4 April 1938; Sutton to Parker, 11 April, 1938; Parker to Fuller, 18 April 1939; Fuller to Russell Parr, 17 June 1938; Parr to Sutton, 25 June 1938, all in NARA, FAP Office of the National Director, Correspondence with State and Regional Offices, 1935–1940, box 41, entry 1023.

63. "Art Work by Race Children Wins Praise at Gallery," *Atlanta Daily World*, 28 August 1939, 1.

64. The titles and locations of Sutton's lectures included "The New Day in Negro Art," Bethune-Cookman College, Daytona Beach, 17 January 1937; "The Negro in the Field of Painting and Sculpture," location unknown, 28 January 1937; "Opportunities for the Negro in American Art," Davis Street School (Jacksonville), 2 November 1937 (in celebration of American Art Week); "The Highlights in Negro Art," Davis Street School, 9 February 1938 (on the occasion of National Negro History Week); and "The Opportunities of the Negro in Art," Davis Street School, 14 February 1938, all in Cahill Papers, Series 4.2, reel 5291, frames 205–7, 208–12, 258–60, 261–65, 266–69, respectively.

65. "A Pictorial Review of Activities Conducted Under Auspices of the Clara White Mission," n.d., unpaginated, Eartha M. M. White Collection, https://digitalcommons .unf.edu/cgi/viewcontent.cgi?article=1000& context=eartha_books.

66. "The Clara White Mission Needs $25,000 to Match Gift of the Same Amount," *Chicago Defender* (national ed.), 26 June 1937, 16.

67. "Eartha M. M. White Museum Committee Objectives," n.d., Eartha M. M. White Collection, box K1, folder 644.

68. The photographs of White doing the inventory and of the coquina cottage are in the Clara White Mission, where the Eartha M. M. White Historical Museum is housed. I am grateful to Meg White and Ju'Coby Pittman of the mission for invaluable information and insights obtained during my 2018 visit. The other additional relevant documents and photographs can be found in the White Collection,

box K1, folders 640 and 641. See also "75th Diamond Birthday Observance of Useful Life of Mary Magdalene White, 'Doctor of Humanities,'" 1951, University of North Florida Digital Commons, digitalcommons.unf.edu/eartha _materials/24.

69. Cahill to Fuller, 1 and 7 March 1938, NARA, FAP Office of the National Director, Correspondence with State and Regional Offices, 1935–1940, box 41, entry 1023.

70. "Memorandum Regarding Florida," Defenbacher to Parker, 3 August, 1938, ibid.

71. Parker to Fuller, 14 November 1936, ibid., box 18, entry 1023.

72. For an excellent analysis of the LeMoyne Federal Art Center and the accomplishments of Vertis Hayes as teacher and director, see Jenkins, "Vertis Hayes and the LeMoyne Federal Art Center."

73. "Many Present at Reopening of Art Center; Project Now Housed Rent-Free in West 116th Street," *New York Amsterdam Star-News*, 20 December 1941, 7.

74. Thomas Parker, "Report on Greensboro, North Carolina," 16 May 1937, NARA, FAP Office of the National Director, General Records, 1935–1940, box 12, entry 1021. See also Parker, "Progress Report of the WPA Federal Art Project from May 26 to Date," 10 June 1937, Cahill Papers, Series 3.3, reel 1105, frames 1402–4.

75. Daniel S. Defenbacher, oral history interview by Mary McChesney, 16 April 1965, Archives of American Art, Smithsonian Institution.

76. O'Connor, introduction to *Art for the Millions*, 20.

77. See Saab's study *For the Millions*.

CHAPTER 3

1. There is excellent information on the origins of the Artists' Union and its strategic and logistical alliances, as well as extensive analysis of its relationship to progressive politics and cultural initiatives such as the government art projects. See especially Monroe, "Artists Union of New York" (PhD diss.) and "Artists Union of New York" (article); McCoy, "Rise and Fall of the American Artists' Congress"; Tyler,

"Artists Respond to the Great Depression";
Monroe and Hills, "Artists as Militant Trade
Union Workers"; and Hemingway, *Artists on
the Left.*

2. See McMahon, "WPA/FAP and the
Organized Artist" and "General View of the
WPA."

3. See Rothschild, "American Artists'
Congress" and "Artists Organizations of the
Depression."

4. La More, "Artists' Union," 238.

5. See Heiberg, "Minnesota Artists' Union."
The MAU eventually became an affiliate of the
New York AU-CIO alliance.

6. Wolff, "Chicago and the Artists' Union,"
241.

7. Davis, "Why an Artists' Congress?"

8. Documents related to the HAG's
activities can be found in a range of archival
repositories with holdings on African Amer-
ican artists and the New Deal art programs,
including the Archives of American Art and
the Schomburg Center for Research in Black
Culture. There are useful accounts of its
history and activities in specialized studies
of African American artists and the 1930s. Its
interventions in the cultural politics of the era
are also noted by scholars interested in specific
incidents, such as the controversy over the
Harlem Hospital mural project. See especially
Donaldson, "Generation 306—Harlem, NY";
"Harlem Artists Guild and Harlem Commu-
nity Art Center"; Carlton-Smith, "New Deal
for Women"; Greene and Linden, "Charles
Alston's Harlem Hospital Murals"; Langa, *Rad-
ical Art*; Calo, *Distinction and Denial*; and Hills,
Painting Harlem Modern. Understanding of
the internal dynamics of the HAG was greatly
enriched by the publication of Bearden and
Henderson's *History of African-American Artists*
in 1993. Drawing on previously unpublished
documents, now in the Henderson Papers, the
authors identify the many frustrations plaguing
the organization, both ideological and prac-
tical. These documents date primarily from
mid-1938 to early 1939, what can be thought of
as the second phase of the organization's his-
tory. They include not only transcripts of the
minutes but also a preamble and constitution
in draft form, handwritten notes and planning
documents, annual reports, press releases

about upcoming exhibitions, and membership
lists with addresses. The following discussion
relies heavily on these sources.

9. See especially Tyler, "Artists Respond to
the Great Depression."

10. Cohn, "Art Fronts."

11. Elba Lightfoot, interview by Camille
Billops, in "Harlem Artists Guild and Harlem
Community Art Center," 40.

12. On conditions in Harlem, see Green-
berg, *"Or Does It Explode?"*

13. "Report of the First Meeting of Executive
Committee for Negro Art Exhibition," 18 Feb-
ruary 1935, Henderson Papers, box 50.

14. Harlem Art Committee, foreword to
An Exhibition of Negro Art, 17–30 March 1935,
Harmon Foundation Papers, box 2.

15. Claude McKay, "Harlem Artists' Guild,"
4, Schomburg Center for Research in Black
Culture, Manuscripts, Archives and Rare
Books Division, New York, NY (hereafter
SCRBC), Public Library Digital Collec-
tions, 1936–1941, http://digitalcollections
.nypl.org/items/907f19a0-75de-0133-07c8
-00505686a51c. The essay is undated, but its
content suggests that it was written in 1936.

16. Preamble to the constitution of the
HAG, handwritten, n.d., Henderson Papers,
box 50. Given the absence of references to an
art center, it is likely that this second preamble
was written after the opening of the HCAC
in December 1937, or at least after it had been
formally approved. Reprinted in Bearden and
Henderson, *History of African-American Artists,*
239.

17. See especially Greene and Linden,
"Charles Alston's Harlem Hospital Murals."

18. HAG membership list; invitation to a
"House-warming" at the "Little Art Colony,"
on 22 December 1935; HAG stationery, all
in scrapbook in the Louise Jefferson Papers,
Amistad Research Center, New Orleans, LA.
An identical piece of HAG stationery can be
found in the Harry Henderson Papers. The
Jefferson Papers contain several versions of this
letterhead with slight variations. Although the
logo itself is unsigned, it is possible that Jeffer-
son, who was an illustrator, was responsible
for the design. I am grateful to Lisa Moore for
bringing these documents to my attention and
for her insights into their origins.

19. See documents related to the HAG in Henderson Papers, box 50. Many of the addresses on the lists in the Louise Jefferson Papers differ from those in the Henderson Papers, which were probably assembled several years later, perhaps under Bennett's leadership.

20. McMahon to Cahill, 21 July 1937, O'Connor Papers, Series 1.1, box 1.

21. "Harlem Artists Guild: A Statement," Art Front, July–August 1936, 4–5.

22. "Race Discrimination in WPA Dead, Ridder Tells Festival Crowd," and "Granger Raps Ridder Speech," unidentified clippings, 1936, Augusta Savage Papers, SCRBC, Sc MG 731.

23. Bennett, "Harlem Artists Guild."

24. Stewart, New Negro, chap. 37.

25. Baigell and Williams, introduction to Artists Against War and Fascism. Aaron Douglas spoke at the first American Artists' Congress and Gwendolyn Bennett spoke at subsequent events.

26. On the NNC, see Mark Naison, Communists in Harlem During the Depression; Gellman, Death Blow to Jim Crow; and Dolinar, Black Cultural Front.

27. Cultural panels convened at national conferences in 1936, 1937, 1940, and 1946. Among the regular artist participants were Aaron and Alta Douglas, Charles White, Elizabeth Catlett, Augusta Savage, Gwendolyn Bennett, and Alain Locke. What Dolinar calls the "Black cultural front" operated under several names during its existence: the Committee for Democratic Culture, the Cultural Division of the NNC, and the Committee for the Negro in the Arts. See also Naison, Communists in Harlem During the Depression; Gellman, Death Blow to Jim Crow.

28. Gellman argues that the NNC's work contributed to a significant cultural shift in Chicago and ultimately led to what has become known as the city's Black cultural renaissance. Death Blow to Jim Crow, 59–60.

29. Stewart, New Negro, 744.

30. Naison, Communists in Harlem During the Depression, chap. 8.

31. Walter Speck (National Executive Committee of American Artists' Congress) to Phillip Evergood (Artists Union), 10 January 1938; Gwendolyn Bennett to Speck, 15 and

28 January 1938; Speck to Bennett, 15 February 1938; Bennett to Laverta Harvey, 21 February 1938, all in the Henderson Papers, box 50.

32. Minutes of the Harlem Artists Guild, 27 September 1938, ibid. The Henderson Papers include copies of HAG meeting minutes held on 20 and 27 September, 4, 11, and 18 October, 15, 22, and 29 November, and 6 and 13 December 1938. There are summaries of the 20 December and 3 January 1939 meetings. Handwritten notes in a steno pad summarize a meeting held 10 January 1939. Most of these minutes list attendees and capture the substance of the discussions. During this period, Gwendolyn Bennett, who had been president in 1937–38, acted as recording secretary. Leadership passed from Ernest Crichlow to Ronald Joseph midfall. The minutes are at least partly derived from steno notes taken by T. Brunder, who emphasized that she was taking notes for practice and that they should not be regarded as verbatim accounts.

33. Minutes of the Harlem Artists Guild, 27 September, and 4, 11, and 18 October 1938, ibid.

34. Minutes of the Harlem Artists Guild, 6 December 1938, ibid.

35. The Southern Negro Youth Congress, founded in Richmond, Virginia, a year after the first meeting of the NNC, similarly embraced the support of Black culture as an activist strategy and was instrumental in promoting cultural events for the benefit of Black communities in the South. With support from funds raised by the Negro People's Art Committee, the organization established the Negro Community Theater in Richmond.

36. Minutes of the Harlem Artists Guild, 13 December 1938, Henderson Papers, box 50.

37. Bearden and Henderson, History of African-American Artists, 238–40.

38. Minutes of the Harlem Artists Guild, 29 November and 13 December 1938, Henderson Papers, box 50.

39. Bennett to Joe Leboit, 9 August 1938, ibid.

40. I was unable to locate in the Henderson Papers an official copy of the long-awaited report on this joint meeting. Minutes of the Harlem Artists Guild, 20 September, 4 October, and 29 November 1938; résumé of the minutes of 3 January 1939, ibid.

41. Steno pad with handwritten minutes for Harlem Artists Guild meeting of 10 January [1939], ibid.

42. Gwendolyn Bennett, annual report of HAG executive committee to the HAG for the period July 1937–July 1938, 12 July 1938, ibid. Bearden and Henderson rely heavily on this report to account for various activities of the HAG and to capture a sense of the tensions within it. They confirm that, as in many social organizations, a handful of dedicated members took on the bulk of responsibility to achieve a wide range of goals, some of which required large commitments of time with meager resources. Bearden and Henderson, *History of African-American Artists*, 238–40.

43. Preamble to the constitution of the HAG, handwritten, n.d., Henderson Papers, box 50. Bearden and Henderson reproduce the preamble, overlaid with an image of the organization's official logo, in *History of African-American Artists*, 239.

44. Minutes of the Harlem Artists Guild, 13 December 1938, Henderson Papers, box 50.

45. Minutes of the Harlem Artists Guild, 20 September 1938, ibid.

46. Minutes of the Harlem Artists Guild, 18 October 1938, ibid. Proposed guidelines for the composition of a HAG jury specified that it should consist of one sculptor, two painters, two watercolorists, two printmakers, and one member at large, for a total of eight. It appears that the jury elected was a group of seven: Burke and Bannarn (sculptors), Pious and Perry (painters), Joseph and Coleman (printmakers), and Glenn (at large).

47. Minutes of the Harlem Artists Guild, 20 September 1938, ibid. The Artists Coordination Committee was an advocacy group made up of artists' societies that exchanged information of interest to their affiliates, including matters of discrimination and unfair employment practices. The member organizations were the AAC, An American Group, Inc., the American Society of Painters, Sculptors and Engravers, the HAG, the National Association of Women Painters and Sculptors, the National Association of Mural Painters, the New York Society of Women Artists, the Sculptors Guild, Inc., and United American Artists. They were very active in planning for the World's Fair and lobbied for a greater role for artists in securing appropriate representation in the art exhibits. See Gellert, "Artists' Coordination Committee."

48. Minutes of the Harlem Artists Guild, 22 November 1938, Henderson Papers, box 50. Sculptor Richmond Barthé, it was noted, was on the jury but he was not a HAG member. Sargent Johnson was on the sculpture jury in California.

49. Minutes of the Harlem Artists Guild, 29 November 1938, ibid.

50. "Fair to Display All Types of Art; Every Artist in Nation Is Invited: To Assure Fair Play," *New York Times*, 15 August 1938, 10.

51. Minutes of the Harlem Artists Guild, 13 December 1938, Henderson Papers, box 50.

52. "Race Hit Hard by WPA Layoffs in New York," *Atlanta Daily World*, 17 January 1939, 1.

53. David Ward Howe, "Congress Plans to Cut WPA Appropriation; How Will This Affect Arts Community?," *Chicago Defender*, 1 July 1939, 14.

54. The reorganization plan of April 1939 created the Federal Works Agency, which absorbed the WPA. The name changed from Works Progress Administration to Work Projects Administration.

55. See Greene and Linden, "Charles Alston's Harlem Hospital Murals."

56. Announcement for "Negro Culture Faces World of Tomorrow: A Harlem Community Cultural Conference," 6–7 May 1939, Locke Papers, box 171. Participants included the HAG, United American Artists, the Negro Actors Guild, the Public Use of Arts Committee, the League of American Writers, the NNC, the New Theatre League, the Theatre Arts Committee, the Federal Arts Council, the Consumers' and Craftsmen's Guild, Inc., the NAACP, the New York Urban League, and the Association for the Study of Negro Life and History.

57. Ibid. (boldface in the original.)

58. The Federal Theatre Project was a casualty of the WPA's reorganization. During the last years of the Depression, many American artists and artists' groups lobbied consistently—and unsuccessfully—for the creation of a permanent national arts bureau.

59. "Charge Bias on Federal Arts Project," *Baltimore Afro-American*, 3 June 1939, 10.

60. "Cultural Conference to Sponsor Meeting," *New York Amsterdam News*, 3 June 1939, 6.

61. "Protest WPA Cuts on Art Project Here; Mass Meeting Held by the Harlem Cultural Confab at Theatre," *New York Amsterdam News*, 24 June 1939, 19.

62. "Push Campaign on Art Firings; Harlem Cultural Conference Seeking All Data," *New York Amsterdam News*, 5 August 1939, 5.

63. "White Models Forbidden to Pose for Negro WPA Artists," *Pittsburgh Courier*, 26 August 1939, 4.

64. Parker to McMahon, 26 June 1939, and McMahon to Parker, 11 July and 9 August 1939, O'Connor Papers, Series 1.1, box 1. I have not been able to locate the report itself.

65. Stewart, *New Negro*, 778–79.

66. Alain Locke to Mary B. Brady, 8 May 1939, Harmon Foundation Papers, box 1.

67. Locke hoped to displace the traveling exhibition program of the Circuit Case Extension Cooperative established by the Carnegie Corporation, led at the time by Davis Hatch. See Helfgott, *Framing the Audience*, 99–101, on Hatch and the Case Extension project.

CHAPTER 4

1. *An Exhibition of Negro Art*, 17–30 March 1935, Harmon Foundation Papers, box 2.

2. "Artistic Harlem Goes on Display," *New York Amsterdam News*, 20 June 1936, Schomburg clipping file, SCRBC.

3. "Art in Harlem," *Art Front*, July–August 1936, 12.

4. *Exhibition of Negro Cultural Work*, n.d., NARA, Reports, Press Releases, Catalogs, Bibliographies, Other Records, FAP in New York City, 1935–1942, box 63, entry 1030. This show brought together work produced under the sponsorship of Federal One, which included the art, music, writers, and theater projects and the historical records survey. A number of non-Black artists were included in this show, presumably because they made works with African American themes and subjects.

5. See Calo, *Distinction and Denial*, for an extensive discussion of Negro art shows before and during the New Deal.

6. Morsell, "Exhibition Program of the WPA/FAP."

7. See especially Helfgott, *Framing the Audience*.

8. See Landgren, "New York City Municipal Art Galleries."

9. According to Landgren, the design of the exhibition program was based on the nonjuried model pioneered by the MacDowell Club in the early twentieth century. Ibid., 272–74.

10. A number of scholars have noted the overlap between planning for the HCAC and the Municipal Art Gallery program. In her study of Jacob Lawrence, *Painting Harlem Modern* (288n143), Patricia Hills points out that not a single African American artist exhibited at the Manhattan space in its first year (1936).

11. McDonald, *Federal Relief Administration and the Arts*, 413–14.

12. Steno pad with handwritten minutes for Harlem Artists Guild meeting of 10 January [1939], Henderson Papers, box 50.

13. Cahill quoted in Govan, "After the Renaissance," 229.

14. Minutes of the Harlem Artists Guild, 11 October 1938, Henderson Papers, box 50.

15. Minutes of the Harlem Artists Guild, 18 October 1938, ibid. Point 12 is probably a reference to the commission Augusta Savage received to create a sculpture for the World's Fair. In subsequent meetings, Glenn reported on local businesses that had agreed to place HAG work on permanent exhibition. He had also approached the subway authority about displaying HAG artworks in select stations. Minutes of the Harlem Artists Guild, 15 November and 6 December 1938, ibid.

16. WPA-FAP, "Harlem Community Art Center Celebrates First Anniversary," press release, 20 December 1938, O'Connor Papers, Series 1.1, box 1. A conference was held on 7 November at the HCAC in conjunction with the *Art and Psychopathology* show; it featured several speakers, including members of the FAP's teaching staff and Bellevue staff. See outreach letters from the WPA-FAP dated

19 October and 1 November 1938, ibid. The show was also exhibited at the Commodore Hotel in New York, hosted by the American Orthopsychiatric Association, 23–24 February 1939. See *Art and Psychopathology*, brochure, NARA, Reports of FAP from New York State, New York City, and New Jersey, box 65, entry 1031.

17. Bennett, "Harlem Community Art Center," 214.

18. Harris, *Federal Art and National Culture*, 80–84; Musher, *Democratic Art*, 161–63; and Saab, *For the Millions*, 70–72.

19. See Musher, *Democratic Art*, 163.

20. *Art and Psychopathology*, brochure, NARA, box 65, entry 1031.

21. Some patients are identified by race within these respective categories.

22. Saab, *For the Millions*, 71.

23. See Calo, *Distinction and Denial*, on the terms of critical discourse used to describe African American art.

24. Savage introduced participating artists, many of whom were involved with the HAG, to the crowd at the opening. They included Meta Warrick Fuller, Richmond Barthé, Robert Pious, Rex Goreleigh, Morgan Smith, Gwen Knight, Ronald Joseph, George Murray, Sarah Murrell, Norman Lewis, Edgar Evans, Earl Sweeting, Elba Lightfoot, Sollace J. Glenn, Ellis Wilson, Beauford Delaney, Lawrence Jones, Georgette Seabrooke, Marvin Smith, William Farrow, John Atkinson, Francisco P. Lord, Frederick Perry, W. F. Davis, Lois M. Jones, Grace Mott Johnson, Selma Burke, Ernest Crichlow, and James L. Wells. See news clippings from *New York Age*, 27 May 1939, and *Washington DC Tribune*, 17 June 1939, Augusta Savage Papers.

25. Stewart, *New Negro*, 173–77.

26. For an extensive discussion of Locke and cultural nationalism, see Calo, *Distinction and Denial*.

27. Stewart, *New Negro*, 778.

28. This was true even though the Harmon Foundation's Mary Brady agreed to cooperate with the Golden Gate Expo in bringing the works of Black artists to the attention of the organizers. Brady expressed dismay that there would not be a dedicated Negro art exhibition at the New York World's Fair, which had the practical effect of denying Black artists recognition. Brady to Henry Hudson, 21 March 1938, Harmon Foundation Papers, box 76.

29. Locke, "American Negro Exposition's Showing of the Works of Negro Artists," a one-page essay in the brochure for *The Art of the American Negro: 1851 to 1940*, ibid., box 105.

30. Ibid.

31. M. Akua McDaniel likens this painting to a sixteenth-century artist's self-portrait and describes its pictorial qualities as mannerist. See McDaniel's catalog entry on Frederick C. Flemister in Powell, *To Conserve a Legacy*, 196. On the Chicago exhibition, see also Helgeson, "'Who Are You America But Me?'"

32. For an extensive analysis of the content of *The Negro in Art* and the circumstances of its publication, see Stewart, *New Negro*, chaps. 40 and 41.

33. Alain Locke, "Memorandum of a Publication Project: A Portfolio of Negro Art with Critical Notes on the Work of Negro Artists and the Negro Theme in American Art," 11 November 1938, Locke Papers, box 118. This memo was sent to Frederick Keppel, president of the Carnegie Corporation, from whom Locke was seeking funding for the project. The Locke Papers contain several versions of this proposal in varying degrees of completion.

34. Locke to Keppel, 20 December 1938, ibid.

35. Locke, *Negro in Art*, 3.

36. Stewart, *New Negro*, 802.

37. Locke, *Negro in Art*, 10.

38. Archibald MacLeish to Cahill, 16 November 1940, NARA, WPA Central Files, 1935–1944, box 458, entry 11.

39. US Library of Congress, "Creative Art of the American Negro," press release, 18 December 1940, Locke Papers, box 183.

40. Ibid., 1.

41. Rose Chatfield-Taylor, "Negro Artists Prove Skill in DC Display," *Washington Post*, 5 January 1941; "Negro Art in America," *Roanoke World-News*, 18 December 1940, Howard University Gallery of Art, clipping files.

42. Butler's article "Ground Breaking in New Deal Washington" includes an extensive analysis of these projects—their context, content, and implications as examples of racial activism during the New Deal. Frederick Douglass was the first Black American named as Washington,

DC, recorder of deeds. The African American physician William J. Thompkins held the position at the time of the commissions. The mural project was intended in part to reflect the historical relationship of this government office to African Americans. But Butler argues that the program itself was meant to highlight Black contributions to history at a time when the issue of integrating the military had become pressing in the context of World War II.

43. "Competition for the Mural Decoration of the Recorder of Deeds Building Washington, DC," Record Group 121, Case Files Concerning the Embellishment of Federal Buildings, 1934–43, NARA, Recorder of Deeds Building, Correspondence A-C (hereafter RG 121), box 127, entry 133. The announcement is undated but seems to have been widely distributed at the end of 1942, with a submission deadline of March 1943.

44. According to Butler, the composition of the jury changed several times. The jurors as stated in the announcement were Henry Varnum Poor (mural painter), Captain Henry Billings (mural painter), Kindred McLeary (mural painter), E. Simms Campbell (painter), James V. Herring (Howard University Art Department), William J. Thompkins (recorder of deeds) and Edward B. Rowan (Treasury Department's Section of Fine Arts). Butler, "Ground Breaking in New Deal Washington," 295–96.

45. Ibid., 293.

46. There are two mailing lists in the NARA Recorder of Deeds files. One seems to be of artists based in New York City. The other is titled "Negro Mural Painters" and includes artists from across the country. The former probably came from Halpert and the latter from James Herring of Howard University, who agreed in November 1942 to serve on the jury. Only three artists appear on both lists: Charles Alston and Joseph and Beauford Delaney. Edith Halpert to Edward Rowan, 13 and 23 January 1942; Rowan to Halpert, 17 January 1942; William Thompkins to Rowan, 10 December 1942, all in RG 121, box 127, entry 133.

47. According to Cornelius Smith, the Fort Huachuca mural was for a recreation center located off the base in the Fry district. The

mural, titled *Peace with Victory*, was installed behind the bar. See Smith, *Fort Huachuca*, 305.

48. Edward Rowan to William Edouard Scott, 5 and 14 April 1943; Scott to Rowan, 11 April 1943; Rowan to Hale Woodruff, 3 May 1943, all in RG 121, box 127, entry 133. For a detailed description of paintings and resolutions based on these exchanges, see Butler, "Ground Breaking in New Deal Washington"; and Taylor and Warkel, *Shared Heritage*.

49. Edmund Gaither, who viewed this project as inferior to Scott's mural, noted that Scott sensed the weakness of the work and tried to strengthen it with innovative lighting. See Gaither's catalog essay "The Mural Tradition," in Taylor and Warkel, *Shared Heritage*, 124–46.

50. There are multiple documents regarding this commission in RG 121, box 127, entry 133. See especially the Selma Burke file.

51. Rowan to Burke, 23 March 1944, ibid.

52. Rowan to Burke, 19 April 1944, ibid.

53. Oronzio Maldarelli to Rowan, 17 July 1944; Rowan to Maldarelli, 18 July 1944, ibid.

54. Ralph Stackpole to Rowan, 19 November 1944; Rowan to Stackpole, 26 December 1944, ibid.

55. Rowan to Burke, 29 December 1944; Burke to Rowan, 11 January 1945, ibid.

56. Herring to Marshall Shepard, 6 March 1945; Eleanor Roosevelt's secretary to Rowan, 17 March 1945; Rowan to Burke, 3 May 1945, ibid.

57. Exchange of letters between Holger Cahill and Charles H. Sawyer, director of the Worcester Art Museum, October 1941, NARA, WPA Central Files, 1935–1944, box 459, entry 11.

58. Some artists whose works were seen regularly in Harlem did not receive much attention from Locke; both Sollace Glenn and Frederick Perry were active members of the HAG and were included in many Negro art shows, but Locke did not seem much interested in them.

59. Charles Sebree was also in the *New Horizons* show.

60. Locke, *Negro Art: Past and Present*, 82.

61. Charles Alston, oral history interview by Harlan Phillips, 28 September 1965, Archives of American Art, Smithsonian Institution.

62. Scholars have noted that these ambitious goals were greatly undermined by the

coincidence of the Downtown Gallery exhibition opening with the bombing of Pearl Harbor. Although this changed the priorities for some who had shown enthusiasm for the overall project, Halpert maintained her commitment to sponsor the show and ultimately added Jacob Lawrence to the gallery's roster of artists. See Stewart, *New Negro*; and Hills, *Painting Harlem Modern*. On Halpert, see Rebecca Shaykin, *Edith Halpert, the Downtown Gallery*.

CHAPTER 5

1. "Creations of Forty-One WPA Artists Illustrated in 'The Negro in Art,'" press release, n.d., Locke Papers, box 119.

2. Locke, *Negro in Art*, 3.

3. Porter, "Art Reaches the People," 376.

4. Porter, "Four Problems." See also Coleman, "James A. Porter's Four Problems."

5. Alain Locke, foreword to *Exhibition of Paintings by Negro Artists of America, Atlanta University*, 1942, unpaginated pamphlet, Locke Papers, box 114.

6. I am grateful to Jacqueline Francis for this observation and many other insights into the 1940s.

7. For a more nuanced discussion of the ideological fault lines that led to the eventual collapse of Federal One, the umbrella under which the FAP operated, see Hemingway, *Artists on the Left*.

8. Helfgott, *Framing the Audience*, esp. introduction and conclusion. On the World's Fair, see also Harris, *Federal Art and National Culture*, chap. 6; Saab, *For the Millions*, chap. 4.

9. Helfgott, *Framing the Audience*, chap. 6.

10. Saab, *For the Millions*, 173–75.

11. See especially Powell, *Black Art and Culture*.

12. On Dondero, see Hauptman, "Suppression of Art"; and Jane de Hart Mathews, "Art and Politics."

13. Morgan, *Rethinking Social Realism*, 26–27, 34–35.

14. See Gaither's catalog essay "Toward a Truer History of American Art." See also Powell, *To Conserve a Legacy*; Coleman, "Black Colleges and the Development of an African American Visual Tradition."

15. On the early exhibition program at Howard University, see Calo, *Distinction and Denial*, 183–87.

16. James Herring, foreword to *Contemporary American Art*, the exhibition catalog of a show held 1–30 April 1940 at the Howard University Gallery of Art, unpaginated, Harmon Foundation Papers, box 105. The catalog acknowledges the assistance of the College Art Association, American Association of Museums, American Federation of Arts, Metropolitan Museum of Art, Museum of Modern Art, National Collection of Fine Arts, Carnegie Corporation, Harmon Foundation, Phillips Memorial Gallery, Library of Congress, WPA-FAP, PWAP, and the Treasury Department's Section of Fine Arts, as well as a handful of individuals, among them Eleanor Roosevelt.

17. Charles Seymour Jr., introduction to *The Negro in the American Scene: Exhibition of Paintings of Negro Subjects by White American Artists*, unpaginated, Moorland-Spingarn Research Center, Howard University, Washington, DC. The show was held 9 March–12 April 1942.

18. "Largest Race Subject Art Exhibition Opens," *Howard University Hilltop*, 10 March 1942; Leila Mechlin, "Art Notes," *Washington Star*, 29 March 1942, both in Howard University Gallery of Art, Washington, DC, clipping files.

19. "Art in the University, the Teachers College, and the Secondary School," regional conference of the College Art Association in celebration of the seventy-fifth anniversary of the founding of Howard University, 9–10 March 1942, Howard University Gallery of Art, Washington, DC, records. There is some irony here in that Locke, who taught philosophy at Howard, had spent years investigating this topic and twice published collections of what he called "Negro art," which included many examples of Black subjects by non-Black artists. Locke's definition of Negro art, articulated in the 1920s, had always included works about Black people in addition to works by Black artists. There was considerable overlap between the artists featured in Locke's publications and those represented in this show. Locke's problematic relationship with the Howard Art Department has been well documented.

20. The literature on the South Side Community Art Center is vast. For a general introduction, see Burroughs, "Chicago's South Side Community Art Center." See also Williams, "(Re)Culturing the City"; and http://www.sscartcenter.org.

21. The Fort Huachuca show was titled *Exhibition of the Work of 37 Negro Artists* and was held 16–22 May 1943 at the Mountain View Officers' Club, a historic structure that originally served as a club for African American soldiers stationed at the fort. I am grateful to Betsy Fahlman for sharing her research on Fort Huachuca with me, including a copy of the 1943 exhibition catalog. See also Fahlman, *New Deal Art in Arizona*. For additional information on the FAP exhibition and other aspects of Fort Huachuca's history, see Smith, Enscore, and Hunter, *Analysis of the Mountain View Officers' Club*; Smith, *Fort Huachuca*; and Cahill Papers, Series 3.1, "WPA—General Subjects."

22. "Progress Report of the People's Art Service Center," 26 June 1942, People's Art Center of St. Louis (SC18:70), St. Louis Public Library, St. Louis, MO (hereafter SLPL). During the war, the PAC also provided after-school child care for working mothers. See undated typescript on the history of the PAC, Mabel B. Curtis Files Regarding the People's Art Center, 1941–1968, Missouri History Museum Archives, St. Louis, MO (hereafter Mabel B. Curtis Files), Series II, box 1, folder 2.

23. I relied on several sources for information on the early history of the PAC. See especially Towey, "Design for Democracy"; Henry S. Williams, "A History of the People's Art Center, 1942–1955," typescript, SLPL; Elizabeth Green, "The People's Art Center: How and When It Was Started," typescript, 22 May 1947, Mabel B. Curtis Files, Series II, box 1, folder 2. Henry Williams was president of the People's Art Center Association from 1946 to 1949 and draws heavily on reports from its annual meetings to create his narrative history. Many of these reports can be found in the PAC records at the SLPL.

24. Vera Flinn, art supervisor for the suburban University City school district, initially proposed a CAC for Negroes in October 1940 on the basis of her concern that neither Black artists nor Black children were benefiting from

the Missouri FAP. See Towey, "Design for Democracy"; and Williams, "History of the People's Art Center."

25. "Design for Democracy, People's Art Center, 1942–1946," unpaginated pamphlet, SLPL.

26. See Williams, "History of the People's Art Center."

27. Fannie Cook quoted in "Design for Democracy, People's Art Center, 1942–1946," unpaginated pamphlet, SLPL.

28. Balch, "Democracy at Work."

29. "People's Art Center Dedication Program," 25 November 1946, SLPL. On Karamu House, see Fearnley, "Writing the History of Karamu House." See also https://karamuhouse.org.

30. Williams, "History of the People's Art Center."

31. "People's Art Center, 10th Anniversary, 1942–1952," unpaginated report, SLPL.

32. "The 12th Annual Meeting of the People's Art Center Association," unpaginated report, 24 February 1955, SLPL.

33. On the Spirit of St. Louis Fund and other sources of support for the arts in St. Louis, see Newton and Hatley, *Persuade and Provide*.

34. "Evaluation of the People's Art Center—1961," report, Mabel B. Curtis Files, Series II, box 1, folder 5.

35. "Memorandum on a Committee to Study Conditions and Needed Changes at People's Art Center" (Judy Stix to Ben Roth, handwritten at top of page), 10 November 1961, People's Art Center Records (S0612), State Historical Society of Missouri, St. Louis, MO (hereafter SHSM). This collection contains numerous documents related to the conflicts within the PAC Association board.

36. Louis J. Schaefer to Julius Klyman, 4 September 1962, regarding the "Report of the Evaluation Committee on the People's Art Center," SHSM.

37. "People's Art Center Loses Fund Support," *St. Louis Globe-Democrat*, 14 March 1963; "Art Center Head Quits in Dispute over Policy," ibid., 10 January 1963; "People's Art Center Head Says 2 Directors Forced Her to Resign," unidentified, undated clipping, Mabel B. Curtis Files, Series V, subseries B, box 3, folder 28.

38. "Troubles at the People's Art Center Linked to Integration Policy," *St. Louis Post-Dispatch*, 21 April 1963, clipping, SHSM.

39. George McCue, "New Life for the People's Art Center," *St. Louis Post-Dispatch*, 5 May 1963, clipping, Mabel B. Curtis Files, Series V, subseries B, box 3, folder 28.

40. Mabel B. Curtis to George McCue, 10 May 1963, ibid., folder 33.

41. Undated and unsigned typescript, ibid., folder 24; handwritten and undated folio, ibid., folder 23. Curtis probably wrote both documents.

42. Undated and unsigned typescript, ibid., folder 24. See also Mabel B. Curtis to George McCue, 10 May 1963, folder 33.

43. David Millstone, president, PACA Board of Directors, to PAC Friends and Members, 9 January 1964, ibid., Series VIII, box 5, folder 18.

44. Mason Cloyd, acting chairman of PACA Board of Directors, to Mrs. Hardy, 14 January 1965; "Meeting Discusses Reviving Art Center," *St. Louis Post-Dispatch*, 20 January 1965, both in ibid.

45. Frank Peters, "From Business to Bohemia," *St. Louis Post-Dispatch*, 23 January 1966, clipping, ibid.

46. Mason Cloyd, "As to People's Art Center," letter to the editor, *St. Louis Post-Dispatch*, 29 January 1966, clipping in ibid.

47. See Newton and Hatley, *Persuade and Provide*, 36.

48. For a detailed account of the Whitney protest, see Wallace, "Exhibiting Authenticity."

49. Ibid., 10–14.

EPILOGUE

1. Locke, foreword to *Contemporary Negro Art*, unpaginated.

2. Indeed, Locke lent a work from his collection—James Richmond Barthé's plaster sculpture *West Indian Girl* (1929)—to the Baltimore exhibition. Locke and Barthé, from their first acquaintance in 1928 until Locke's death in 1954, were intertwined in a complicated relationship. See Stewart, *New Negro*, 593–94, 852–53.

3. Locke, "Advance on the Art Front," 134.

4. Locke writes, "Imagine confronting a Polish artist with the alternative of a national or an international showing: if he had as few as two pictures the answer would be 'one in each.'" Ibid., 132. See also Locke's "Who and What Is 'Negro'?," in which he characterizes "Negro art" as an "artificial separatist criterion" (37).

5. Chinese American painter Yun Gee (Zhu Yuanzhi) participated in the Boston Museum of Modern Art's *Paintings by Fifty Oncoming Americans* in 1941. The painter Yasuo Kuniyoshi, born in Japan, and the Japanese American sculptor Isamu Noguchi were in the Whitney Museum of American Art's *1945 Annual Exhibition of Contemporary American Sculpture, Watercolors, and Drawings*. Octavio Medellín, a Mexican American of Otomi Indian heritage, was featured in the MoMA's *Americans 1942: 18 Artists from 9 States*.

6. Among those who garnered such sustained attention were Romare Bearden, Claude Clark, William H. Johnson, Jacob Lawrence, Hughie Lee-Smith, Edward L. Loper, and Horace Pippin. Lawrence, by far, was the most exhibited African American artist of the decade.

7. African American artists in the US services during World War II include Charles H. Alston, William A. Artis, Henry W. Bannarn, Howard Romare Bearden, John T. Biggers, Edsel Cramer, Frederick Flemister, Reginald Gammon, Bernard Goss, Lawrence L. Jones, Jacob Lawrence, Hughie Lee-Smith, Junius Redwood, Charles Sebree, George Spencer, Frank Steward, Charles White, Isaiah Williams, and Ellis Wilson.

8. Barat and English, "Blackness at MoMA," 30–31. Although Barat and English imply that Lowenfeld held more nuanced opinions of his Black Hampton students, his writings about creativity among Black people indicate the limitations of his racialized thinking. In his essay "New Negro Art in America," Lowenfeld proclaimed that "New Negro Art is not the art of visually minded people who feel as spectators rather than being involved. New Negro Art in its pureness must necessarily be extremely haptic" (21). Design historian Peter Smith, the author of several studies of Lowenfeld that aim to situate him as an integrationist, nonetheless

concedes, "Writing in the 1940s, Lowenfeld's thinking was not free of stereotypes about Afro-Americans and their visual expression." Smith, "Lowenfeld Teaching Art," 34.

9. MoMA, "Work of Negro Artists Exhibited at Museum of Modern Art," press release, 30 September 1943, 1, available as a PDF at https://assets.moma.org/documents/moma_press-release_325414.pdf.

10. Ibid., 1–2.

11. The preoccupation with the student artists' majors and curricular path is also on display in "Hampton Students Exhibit Art," *Crisis: A Record of the Darker Races* 50 (November 1943): 346–47.

12. See the final page of the PDF cited in n. 9.

13. Barat and English write that Dorothy Miller, curator of *Americans 1942*, considered including Charles White in this show but ultimately did not "for reasons now lost." "Blackness at MoMA," 37.

14. Medellín was born in San Luis Potosí, Mexico, and moved to San Antonio, Texas, as a teenager. Yet in the press release for *Americans 1942*, he was said to be from Denton, Texas, the location of North Texas State College, where he taught art. The catalog made Boston the nationalizing location for Bloom, who was born in the Russian Empire (now Latvia); Chicago for Breinin, also born in Russia; Detroit for Cashwan, born in Ukraine; Santa Barbara, California, for Lebrun, born in Italy; and Los Angeles for Merrild, born in Denmark. See MoMA, "Large Exhibition of Painting and Sculpture by Young American Artists from All Sections of the Country Opens at Museum of Modern Art," press release, n.d. (ca. early January 1942), PDF available at https://assets.moma.org/documents/moma_press-release_325292.pdf.

15. "Current Exhibition," *Art News*, 15–30 November 1943, 22.

16. On Biggers, see "Gastonia Native One of the South's Most Promising Artists," *Future Outlook*, 6 November 1943, 6. *Dying Soldier* is reproduced in "On Exhibit in New York," *Jackson (Mississippi) Advocate*, 30 October 1943, 4, and in "Hampton Students Exhibit Art," *Crisis: A Record of the Darker Races* 50 (November 1943): 346–47. Of Biggers, the *Crisis* writer stated, "In *Dying Soldier*, John T. Biggers of

Gastonia, NC, formerly a student of plumbing, depicts in oils his striking conception of a mortally wounded Negro fighter in World War II. Twelve works by Mr. Biggers are in the present exhibition" (347).

17. Mead's book was an influential best seller for decades. In it, she contrasted American sociocultural values—read as proper but repressed—with those of the Samoan Islands, whose people she saw as sexually uninhibited and untainted by modernity.

18. Locke, "Up Till Now," vii.

19. An art historian and collector, Hatch (1907–1996) was the director of the New England region (Region 1) of the Public Works of Art Project (PWAP) in 1933–34. In his preface to *The Negro Artist Comes of Age*, he hails the government program: "The Government art projects, beginning a little over ten years ago, and which proved a great boon to younger American artists, were especially helpful to the Negro group, not only in subsidizing painters and sculptors, but in offering opportunities to study in Government sponsored art centers. With this impetus, and from natural developments, the number of professional Negro painters and sculptors has mushroomed in the past decade" (i).

20. Ibid.

21. Ibid., ii.

22. Sculptor Meta Vaux Warrick Fuller and painter William E. Scott also did not participate in the Albany show. Locke did not regard these living artists as "moderns," nor did he consider their realist works modernist. Instead, he relegated them to a historical era whose notables included the Barbizon school- and impressionist-influenced painter William A. Harper, the academic sculptor May Howard Jackson, and the realist-turned-symbolist painter Henry Ossawa Tanner.

23. "Even before the Egyptian Pharaohs, black sculptors of darkest Africa created some of the classic pieces of art of all time. They outshone many Greek and Roman creations. They left a legacy in Congo jungles which today's modern artists have not been able to live up to." "Art Gamblers Haunt Negro Shows to Stock Up Big Names," *Ebony*, 1 December 1945, 49. "The Legacy of the Ancestral Arts" was published in Locke's *New Negro*, 254–67.

24. "Art Gamblers Haunt Negro Shows," 49. As the article title indicates, art made by Black Americans was viewed as a commodity, a thing that could be bought and sold, and something that some purchasers predicted would increase in value. Such an assessment of art's worth as an investment seems to be as important as the prestige of being recognized for skill in the visual arts.

25. Alain Locke, "The New Negro," in Locke, New Negro, 16.

26. Other wartime shows included *American Artists' Record of War and Defense* (National Gallery of Art, 1942); *Battles and Symbols of the U.S.A.: 18th and 19th Century Paintings and Sculpture by Outstanding American Folk Artists* and *Paintings, Sculpture, Drawings by Leading American Artists* (both at Downtown Gallery, 1942); *The Merchant Seaman's Exhibition: Art and the People* (Hull House, Chicago, 1944); and *Oils, Prints, Drawings by Seaman Hughie Lee-Smith* (South Side Community Art Center, Chicago, 1945).

27. Art historians Bridget R. Cooks and John Ott have identified the propaganda aims of photos of Jacob Lawrence in uniform at the exhibition *Paintings by Jacob Lawrence: "Migration of the Negro" and Works Made in US Coast Guard* at the MoMA in October 1943. See Cooks, *Exhibiting Blackness*, 37–44; Ott, "Battlestation MoMA."

28. Bearden biographer Mary Schmidt Campbell states that in the context of the sudden death of his indomitable mother—the activist and journalist Bessye J. Bearden—in 1943, the artist "found that having an older woman [Crosby] take such a serious interest in him so soon after his mother's death salutary." *American Odyssey*, 135, 363n60.

29. Campbell links Bearden's *Passion of Christ* painting series (1945), "and particularly the persecuted figure of Christ," to "his own personal circumstances as a soldier in a segregated army." Ibid., 137. While President Franklin Delano Roosevelt worked to desegregate the federal government during his three terms in office (1933–45), Washington, DC, remained a segregated city through midcentury.

30. Alona Cooper Wilson and Leslie King-Hammond have researched this mural project and the African American press's coverage of it. See Wilson, "Formation of an African-American Artist," 123–40, and King-Hammond, *Hughie Lee-Smith*, 12. In 1947, the navy donated the murals to the South Side Community Art Center; at present, their location is unknown.

31. Wilson identifies the photo as *Untitled (Dorie Miller)*, the Archives of American Art file label for this image. Wilson, "Formation of an African-American Artist," 324, fig. 2.6.

32. In a retrospective account of his time as a "combat artist," Lee-Smith said that the naval recruits at the Great Lakes Naval Center learned seamen's skills and basic literacy. See "Archive Footage: Combat Artists of WWII—Blood, Ink, and Oil," Charlie Dean Archives," video available at YouTube (29:58), 30 July 2013, https://youtu.be/mEeOgodaDjI.

33. Wilson, "Formation of an African-American Artist," 48–89, 90–112, 115–19. The National Negro Congress (1935–46), at the time of its inception, took an antiwar stance.

34. The intersecting interracial, international, gay, and heterosexual circles in which gay African American artists traveled during World War II have been discussed in Bauer, "On the Transgressiveness of Ambiguity"; Vendryes, *Richmond Barthé: A Life*; and Leeming, *Amazing Grace*.

35. Fluker, "Creating a Canteen Worth Fighting For," 3.

36. Van Vechten, "Ode to the Stage Door Canteen," 230.

37. "Hostesses and busboys are an equally heterogeneous lot," Van Vechten wrote. "It is quite possible that the Canteen has done as much (or more) for the workers as (or than) it has done for the service men. The place has brought people together who never knew each other before and given their lives a new social direction. It is a pleasure for each member of his shift to greet other members of his shift once a week; indeed, a new kind of spirit has developed which might be utilized profitably in another field in the post-war era." Ibid.

38. Interpreting the creation of gendered meanings of work, sociologist Elaine J. Hall has studied table service in US restaurants. While Hall's case studies are from the late twentieth century, her observations about the status of

men and women in the restaurant industry are applicable to earlier contexts. See "Waitering/ Waitressing."

39. Fit and skilled, Piro was nicknamed "Killer Joe" because he tired out his dance partners. He was recruited to dance with the Stage Door Canteen's female hostesses; Van Vechten also photographed him in the company of popular female actors Shirley Booth and Selena Royle. See Goldman, *I Want to Be Ready*, 44–45; Goldstein, *Helluva Town*, 141.

40. Fluker reports that "servicemen at the canteen would sometimes dance with other servicemen" and that the Canteen's hostesses were authorized to dissuade them from doing so by ridiculing, mocking, and interrupting the dancers. See "Rules for Junior Hostesses Committee," in Rules of the Stage Door Canteen, 8, Delmer Papers, box 14, folder 11; and "Laugh It Off," 20 April 1944, Emeline Roche Collection, box 1, folder 15, both quoted in Fluker, "Creating a Canteen Worth Fighting For," 41.

41. In her groundbreaking 1964 essay "Notes on Camp," Susan Sontag lists fifty-eight elements of the gay male style and sensibility. She argues that they manifest as "a private code, a badge of identity even, among small urban cliques" (514).

42. In the profile, Motley wrote, "I summed up Sebree in my own mind, as a much-confused and disillusioned young man who hasn't as yet come of mature stature; a young man who is unstable, not tied down tightly enough to any one overwhelming, self-sacrificing desire; a young man who doesn't know his own mind. Sebree has done marvelously well so far. Whether he can get up off the floor and fight back rests with him alone. "Negro Art in Chicago," 29–30. Although Motley was only a few years older than Sebree, he struck a generational distance from the artist.

43. Porter, *Modern Negro Art*, 122.

44. Locke, "Up Till Now," v.

45. Historian Leon Coleman asserts that, "for Van Vechten, party-giving was, at least in part, a social means to a racial end." *Van Vechten and the Harlem Renaissance*, 98–99. Art historian James Smalls situates Van Vechten's erotic images within underground and marginalized American cultures, arguing that they countered prevalent midcentury conservativism in the nation. See his *Homoerotic Photography of Carl Van Vechten*.

46. In their book-length studies of Van Vechten, James Smalls and Emily Bernard conclude that he failed to account for the difference between his experience as a white American and that of his Black confreres. See Smalls, *Homoerotic Photography of Carl Van Vechten*; and Bernard, *Remember Me to Harlem*.

47. Contemporary novelist Darryl Pinckney observes that "Van Vechten was an avid collector of several things, famous artists among them maybe." See his introduction to *"O, Write My Name,"* 12.

48. The last sentence of Van Vechten's "Ode to the Stage Door Canteen" reads: "Is it any wonder that almost every one who sees the Stage Door Canteen for the first time bursts into tears from sheer happiness that such things can be?"

APPENDIX

1. Barthé is listed as a HAG member in the transcript of the group interview conducted by Camille Billops published in *Artist and Influence* 5 (1987): 35–47, and on a list in the Jefferson Papers. But his name does not appear on any of Henderson's lists, and an exchange in the minutes regarding juries states specifically that he was not a member.

ARCHIVES

Archives of American Art, Smithsonian Institution, Washington, DC
Holger Cahill Papers
Francis V. O'Connor Papers
Howard University, Moorland-Spingarn Research Center, Washington, DC
Alain Locke Papers
Library of Congress, Manuscript Division, Washington, DC
Harmon Foundation Papers
Missouri History Museum Archives, St. Louis, MO
Mabel B. Curtis Files Regarding the People's Art Center, 1941–1968
National Archives and Records Administration, College Park, MD
Record Group 69, Records of the WPA, FAP
Record Group 121, Case Files Concerning the Embellishment of Federal Buildings, 1934–43
Pennsylvania State University, Eberly Family Special Collections Library, University Park, PA
Harry Henderson Papers
St. Louis Public Library, St. Louis, MO
People's Art Center of St. Louis
Schomburg Center for Research in Black Culture, Manuscripts, Archives and Rare Books Division, New York Public Library, New York, NY
Augusta Savage Papers
State Historical Society of Missouri, St. Louis, MO
People's Art Center Records
Tulane University, Amistad Research Center, New Orleans, LA
Louise Jefferson Papers
University of North Florida, Thomas G. Carpenter Library Special Collections and Archives, Jacksonville, FL
Eartha M. M. White Collection

PUBLISHED SOURCES

Baigell, Matthew, and Julia Williams, eds. *Artists Against War and Fascism: Papers of the First American Artists' Congress.* New Brunswick: Rutgers University Press, 1986.
Balch, Jack. "Democracy at Work: The People's Art Service Center in St. Louis." *Magazine of Art* 36 (February 1943): 66–68.
Barat, Charlotte, and Darby English. "Blackness at MoMA: A Legacy of Deficit." In *Among Others: Blackness at MoMA,* edited by Darby English and Charlotte Barat, 14–99. New York: Museum of Modern Art. Exhibition catalog.
Bauer, J. Edgar. "On the Transgressiveness of Ambiguity: Richard Bruce Nugent and the Flow of Sexuality and Race." *Journal of Homosexuality* 62, no. 8 (2016): 1021–57.
Bearden, Romare. "The Negro Artist and Modern Art." *Opportunity: A Journal of Negro Life* 12 (December 1934): 371–72.
Bearden, Romare, and Harry Henderson. *A History of African-American Artists from 1792 to the Present.* New York: Pantheon Books, 1993.
Bennett, Gwendolyn. "The Harlem Artists Guild." *Art Front,* April 1937, 20.
———. "The Harlem Community Art Center." In O'Connor, *Art for the Millions,* 213–15.
Berman, Greta. *The Lost Years: Mural Painting in New York City Under the WPA Federal Art Project, 1935–1943.* New York: Garland, 1978.
Bernard, Emily, ed. *Remember Me to Harlem: The Letters of Langston Hughes and Carl Van Vechten, 1925–1964.* New York: Knopf, 2001.
Burroughs, Margaret Goss. "Chicago's South Side Community Art Center:

. A Personal Recollection." In White, *Art in Action*, 131–44.

Bustard, Bruce. *A New Deal for the Arts*. Washington, DC: National Archives and Records Administration, 1997.

Butler, Sara A. "Ground Breaking in New Deal Washington, DC: Art, Patronage, and Race at the Recorder of Deeds Building." *Winterthur Portfolio* 45 (Winter 2011): 277–320.

Butts, J. J. *Dark Mirror: African Americans and the Federal Writers' Project*. Columbus: Ohio State University Press, 2021.

Cahill, Holger. "American Resources in the Arts." In O'Connor, *Art for the Millions*, 33–44.

Calo, Mary Ann. *Distinction and Denial: Race, Nation, and the Critical Construction of the African American Artist, 1920–40*. Ann Arbor: University of Michigan Press, 2007.

———. "Expansion and Redirection: African Americans and the New Deal Federal Art Projects." *Archives of American Art Journal* 55 (Fall 2016): 80–89.

———. "The Significance of the Interwar Decades to Scholarship on African American Art." In *The Routledge Companion to African American Art History*, edited by Eddie Chambers, 16–26. New York: Routledge, 2020.

Campbell, Mary Schmidt. *An American Odyssey: The Life and Work of Romare Bearden*. New York: Oxford University Press, 2018.

Carlton-Smith, Kim. "A New Deal for Women: Women Artists and the Federal Art Project, 1935–1939." PhD diss., Rutgers University, 1990.

Clayton, Virginia Tuttle, Elizabeth Stillinger, Erika Doss, and Deborah Chotner. *Drawing on America's Past: Folk Art, Modernism, and the Index of American Design*. Washington, DC: National Gallery of Art; Chapel Hill: University of North Carolina Press, 2002. Exhibition catalog.

Cohn, Erin P. "Art Fronts: Visual Culture and Race Politics in the Mid-Twentieth-Century United States." PhD diss., University of Pennsylvania, 2010.

https://repository.upenn.edu/edissertations/156/.

Coleman, Floyd. "Black Colleges and the Development of an African American Visual Tradition." *International Review of African American Art* 11, no. 3 (1994): 31–38.

———. "James A. Porter's Four Problems and the Development of African American Art Historiography." In Howard University Gallery of Art, *James A. Porter*, 49–55.

Coleman, Leon. *Carl Van Vechten and the Harlem Renaissance: A Critical Assessment*. New York: Garland, 1998.

Cooks, Bridget R. *Exhibiting Blackness: African Americans and the American Art Museum*. Amherst: University of Massachusetts Press, 2011.

Davis, Stuart. "Why an Artists' Congress?" In Baigell and Williams, *Artists Against War and Fascism*, 65–70.

Dolinar, Brian. *The Black Cultural Front: Black Writers and Artists of the Depression Generation*. Jackson: University Press of Mississippi, 2012.

Donaldson, Jeff. "Generation 306—Harlem, NY." PhD diss., Northwestern University, 1974.

Driskell, David C. *Two Centuries of Black American Art*. Los Angeles: Los Angeles County Museum of Art; New York: Knopf, 1976. Exhibition catalog.

Fahlman, Betsy. *New Deal Art in Arizona*. Tucson: University of Arizona Press, 2009.

Farrington, Lisa. *African American Art: A Visual and Cultural History*. New York: Oxford University Press, 2017.

Fearnley, Andrew. "Writing the History of Karamu House: Philanthropy, Welfare, and Race in Wartime Cleveland." *Ohio History* 115 (2008): 80–100.

Fine, Elsa Honig. *The Afro-American Artist: A Search for Identity*. 1973. New York: Holt, Rinehart and Winston, 1982.

Fluker, Katherine M. "Creating a Canteen Worth Fighting For: Morale Service and the Stage Door Canteen in World War II." Master's thesis, Ohio University, 2011. https://etd.ohiolink.edu.

Foushee, Ola Maie. "North Carolina's Community Art Centers." In White, *Art in Action*, 158–66.

Fraden, Rena. *Blueprints for a Black Federal Theatre, 1935–1939*. Cambridge: Cambridge University Press, 1994.

Gaither, Edmund Barry. "Toward a Truer History of American Art: The Contributions of Black Colleges and Universities." In *Revisiting American Art: Works from the Collections of Historically Black Colleges and Universities*, 5–18. Katonah, NY: Katonah Museum of Art, 1997. Exhibition catalog.

Gellert, Hugo. "The Artists' Coordination Committee." In O'Connor, *Art for the Millions*, 255–57.

Gellman, Erik S. *Death Blow to Jim Crow: The National Negro Congress and the Rise of Militant Civil Rights*. Chapel Hill: University of North Carolina Press, 2012.

Gibson, Lisanne. "Managing the People: Art Programs in the American Depression." *Journal of Arts Management, Law and Society* 31 (Winter 2000): 279–91.

Goldman, Danielle. *I Want to Be Ready: Improvised Dance as a Practice of Freedom*. Ann Arbor: University of Michigan Press, 2010.

Goldstein, Richard. *Helluva Town: The Story of New York During World War II*. New York: Free Press, 2010.

Govan, Sandra. "After the Renaissance: Gwendolyn Bennett and the WPA Years." *MAWA Reviews: Quarterly Publication of the Middle Atlantic Writers Association* 3 (December 1988): 227–31.

Greenberg, Cheryl Lynn. *"Or Does It Explode?" Black Harlem in the Great Depression*. New York: Oxford University Press, 1991.

Greenberg, Clement. "Avant-Garde and Kitsch." In *Art and Culture: Critical Essays*, 3–21. Boston: Beacon Press, 1961.

Greene, Larry A., and Diana Linden. "Charles Alston's Harlem Hospital Murals: Cultural Politics in Depression Era Harlem." *Prospects* 26 (2001): 391–421.

Grieve, Victoria. *The Federal Art Project and the Creation of Middlebrow Culture*. Urbana: University of Illinois Press, 2009.

Hall, Elaine J. "Waitering/Waitressing: Engendering the Work of Table Servers." *Gender and Society* 7, no. 3 (1993): 329–46.

"Harlem Artists Guild and Harlem Community Art Center." *Artist and Influence* 5 (1987): 35–47.

Harris, Jonathan. *Federal Art and National Culture: The Politics of Identity in New Deal America*. New York: Cambridge University Press, 1995.

Hatch, John Davis, Jr. Preface to *The Negro Artist Comes of Age: A National Survey of Contemporary American Artists*, i–ii. Albany: Albany Institute of History and Art, 1945. Exhibition catalog.

Hauptman, William. "The Suppression of Art in the McCarthy Decade." *Artforum* 12 (October 1973): 48–52.

Hayes, Vertis. "The Negro Artist Today." In O'Connor, *Art for the Millions*, 210–12.

Heiberg, Einar. "The Minnesota Artists' Union." In O'Connor, *Art for the Millions*, 243–47.

Helfgott, Isadora Anderson. *Framing the Audience: Art and the Politics of Culture in the United States, 1929–1945*. Philadelphia: Temple University Press, 2015.

Helgeson, Jeffrey. "'Who Are You America But Me?' The American Negro Exposition, 1940." In Hine and McCluskey, *Black Chicago Renaissance*, 126–46.

Hemingway, Andrew. *Artists on the Left: American Artists and the Communist Movement, 1926–1956*. New Haven: Yale University Press, 2002.

Hills, Patricia. *Painting Harlem Modern: The Art of Jacob Lawrence*. Berkeley: University of California Press, 2010.

Hine, Darlene Clark, and John McCluskey Jr. *The Black Chicago Renaissance*. Champaign: University of Illinois Press, 2012.

Howard University Gallery of Art. *James A. Porter, Artist and Art Historian: The Memory of the Legacy*. Washington, DC: Howard University Gallery of Art, 1992.

Jenkins, Earnestine. "Muralist Vertis Hayes and the LeMoyne Federal Art Center:

A Legacy of African American Fine Arts in Memphis, Tennessee, 1930s–1950s." *Tennessee Historical Quarterly* (Summer 2014): 132–59.

Jones, Lawrence A. "The New Orleans WPA/FAP." In O'Connor, *Art for the Millions*, 198–99.

Kalfatovic, Martin R. *The New Deal Fine Arts Projects: A Bibliography, 1933–1992.* Metuchen: Scarecrow Press, 1994.

Kennedy, Roger G. *When Art Worked: The New Deal, Art, and Democracy.* New York: Rizzoli, 2009.

King-Hammond, Leslie. *Black Printmakers and the WPA.* New York: Lehman College Art Gallery, 1989. Exhibition catalog.

———. *Hughie Lee-Smith.* David C. Driskell Series of African-American Art 8. San Francisco: Pomegranate, 2010.

La More, Chet. "The Artists' Union." In O'Connor, *Art for the Millions*, 237–38.

Landgren, Marchal E. "A Memoir of the New York City Municipal Art Galleries, 1936–1939." In O'Connor, *New Deal Art Projects*, 269–301.

Langa, Helen. *Radical Art: Printmaking and the Left in 1930s New York.* Berkeley: University of California Press, 2004.

Leeming, David. *Amazing Grace: A Life of Beauford Delaney.* New York: Oxford University Press, 1998.

Lewis, Samella. *African American Art and Artists.* 1978. Berkeley: University of California Press, 1990.

Locke, Alain. "Advance on the Art Front." *Opportunity: A Journal of Negro Life* 17 (May 1939): 132–36.

———. Foreword to *Contemporary Negro Art*, unpaginated. Baltimore: Baltimore Museum of Art, 1939. Exhibition catalog.

———. *Negro Art: Past and Present.* Washington, DC: Associates in Negro Folk Education, 1936.

———. *The Negro in Art: A Pictorial Record of the Negro Artist and the Negro Theme in Art.* Washington, DC: Associates in Negro Folk Education, 1940.

———, ed. *The New Negro.* 1925. New York: Atheneum, 1992.

———. "Up Till Now." In *The Negro Artist Comes of Age: A National Survey of Contemporary American Artists*, iii–viii. Albany: Albany Institute of History and Art, 1945. Exhibition catalog.

———. "Who and What Is 'Negro'? (Part I)." *Opportunity: A Journal of Negro Life* 20 (February 1942): 36–41.

Lowenfeld, Viktor. "New Negro Art in America." *Design* 46, no. 1 (1944): 20–29.

Mathews, Jane de Hart. "Art and Politics in Cold War America." *American Historical Review* 81 (October 1976): 762–87.

McCoy, Garnett. "The Rise and Fall of the American Artists' Congress." *Prospects* 13 (1988): 325–40.

McDonald, William F. *Federal Relief Administration and the Arts.* Columbus: Ohio State University Press, 1969.

McKinzie, Richard D. *The New Deal for Artists.* Princeton: Princeton University Press, 1973.

McMahon, Audrey. "A General View of the WPA Federal Art Project in New York City and State." In O'Connor, *New Deal Art Projects*, 51–76.

———. "The WPA/FAP and the Organized Artist." In O'Connor, *Art for the Millions*, 259–60.

Monroe, Gerald M. "The Artists Union of New York." *Art Journal* 32 (Autumn 1972): 17–20.

———. "The Artists Union of New York." PhD diss., New York University, 1949.

Monroe, Gerald M., and Patricia Hills. "Artists as Militant Trade Union Workers During the Great Depression." *Archives of American Art Journal* 49 (Spring 2010): 42–53.

Morgan, Stacy I. *Rethinking Social Realism: African American Art and Literature, 1930–1953.* Athens: University of Georgia Press, 2004.

Morsell, Mary. "The Exhibition Program of the WPA/FAP." In O'Connor, *Art for the Millions*, 229–31.

Motley, Willard. "Negro Art in Chicago." *Opportunity: A Journal of Negro Life* 18 (January 1940): 19–22, 28–31.

Musher, Sharon Ann. *Democratic Art: The New Deal's Influence on American Culture.*

Chicago: University of Chicago Press, 2015.

Naison, Mark. *Communists in Harlem During the Depression.* Urbana: University of Illinois Press, 1983.

Newton, Michael, and Scott Hatley. *Persuade and Provide: The Story of the Arts and Educational Council in St. Louis.* St. Louis: Associated Council of the Arts, 1970.

O'Connor, Francis V., ed. *Art for the Millions: Essays from the 1930s by Artists and Administrators of the WPA Federal Art Project.* Greenwich, CT: New York Graphic Society, 1973.

———. *Federal Support for the Visual Arts: The New Deal and Now.* Greenwich, CT: New York Graphic Society, 1969.

———, ed. *The New Deal Art Projects: An Anthology of Memoirs.* Washington, DC: Smithsonian Institution Press, 1972.

Ott, John. "Battlestation MoMA: Jacob Lawrence and the Desegregation of the Armed Forces and the Art World." *American Art* 29, no. 3 (2015): 58–89.

Park, Marlene, and Gerald E. Markowitz. *New Deal for Art: The Government Art Projects of the 1930s with Examples from New York City and State.* Hamilton, NY: Gallery Association of New York State, 1977.

Patton, Sharon F. *African-American Art.* Oxford: Oxford University Press, 1998.

Pinckney, Darryl. Introduction to *"O, Write My Name": American Portraits, Harlem Heroes—Portraits by Carl Van Vechten,* edited by Leslie George Katz and Peter Kayafas, 7–19. New York: Eakins Press, 2015.

Porter, James A. "Art Reaches the People." *Opportunity: A Journal of Negro Life* 17 (December 1939): 375–76.

———. "Four Problems in the History of Negro Art." *Journal of Negro History* 27 (1942): 9–36.

———. *Modern Negro Art.* Washington, DC: Howard University Press, 1943.

Powell, Richard J. *Black Art and Culture in the 20th Century.* New York: Thames and Hudson, 1997.

———, ed. *To Conserve a Legacy: American Art from Historically Black Colleges and Universities.* Andover, MA: Addison Gallery of American Art; New York: Studio Museum in Harlem, 1999. Exhibition catalog.

Reynolds, Gary A., and Beryl J. Wright, eds. *Against the Odds: African-American Artists and the Harmon Foundation.* Newark, NJ: Newark Museum, 1989. Exhibition catalog.

Rosenzweig, Roy, ed. *Government and the Arts in Thirties America: A Guide to Oral Histories and Other Materials.* Fairfax: George Mason University Press, 1986.

Rosenzweig, Roy, and Barbara Melosh. "Government and the Arts: Voices from the New Deal Era." *Journal of American History* 77 (September 1990): 596–608.

Rothschild, Lincoln. "The American Artists' Congress." In O'Connor, *Art for the Millions,* 250–52.

———. "Artists Organizations of the Depression Decade." In O'Connor, *New Deal Art Projects,* 198–221.

Russo, Jillian. "The Works Progress Administration Federal Art Project Reconsidered." *Visual Resources* 34 (2018): 13–32.

Saab, A. Joan. *For the Millions: American Art and Culture Between the Wars.* Philadelphia: University of Pennsylvania Press, 2004.

Shaykin, Rebecca. *Edith Halpert, the Downtown Gallery, and the Rise of American Art.* New Haven: Yale University Press, 2019.

Sklaroff, Lauren Rebecca. *Black Culture and the New Deal: The Quest for Civil Rights in the Roosevelt Era.* Chapel Hill: University of North Carolina Press, 2009.

Smalls, James. *The Homoerotic Photography of Carl Van Vechten: Public Face, Private Thoughts.* Philadelphia: Temple University Press, 2006.

Smith, Adam D., Susan I. Enscore, and Samuel L. Hunter. *Analysis of the Mountain View Officers' Club, Fort Huachuca, Arizona.* Fort Huachuca Cultural Resources Report FH-12-5. US Army Corps of Engineers,

Engineer Research and Development Center, September 2012. https://usace.contentdm.oclc.org/digital/collection/p266001coll1/id/3657/.

Smith, Cornelius C., Jr. *Fort Huachuca: The Story of a Frontier Post.* Washington, DC: US Army, 1981. https://archive.org/stream/forthuachucathesoowash/forthuachucathesoowash_djvu.txt.

Smith, Peter. "Lowenfeld Teaching Art: A European Theory and American Experience at Hampton." *Studies in Art Education* 29, no. 1 (1987): 30–36.

Sontag, Susan. "Notes on Camp." *Partisan Review* 30, no. 4 (1964): 515–30.

Stewart, Jeffrey C. *The New Negro: The Life of Alain Locke.* New York: Oxford University Press, 2018.

Stewart, Ruth Ann. *New York/Chicago: WPA and the Black Artist.* New York: Studio Museum in Harlem, 1977.

Sutton, Harry H., Jr. "High Noon in Art." In O'Connor, *Art for the Millions,* 216–17.

Taylor, William E., and Harriet G. Warkel. *A Shared Heritage: Art by Four African Americans.* Indianapolis: Indianapolis Museum of Art, 1996. Exhibition catalog.

Towey, Martin G. "Design for Democracy: The People's Art Center in St. Louis." In White, *Art in Action,* 79–97.

Tyler, Francine. "Artists Respond to the Great Depression and the Threat of Fascism: The New York Artists' Union and Its Magazine 'Art Front' (1934–1937)." PhD diss., New York University, 1991.

Van Vechten, Carl. "An Ode to the Stage Door Canteen." *Theater Arts* 27 (April 1943): 229–31.

Vendryes, Margaret Rose. *Richmond Barthé: A Life.* Jackson: University Press of Mississippi, 2008.

Wagner, Ann Prentice. *1934: A New Deal for Artists.* Washington, DC: Smithsonian American Art Museum, 2009. Exhibition catalog.

Wallace, Caroline V. "Exhibiting Authenticity: The Black Emergency Cultural Coalition's Protests of the Whitney Museum of American Art, 1968–71." *Art Journal* 74 (Summer 2015): 5–23.

Weaver, Robert C. "The Negro Comes of Age in Industry." *Atlantic Monthly,* September 1943, 54–59.

White, John Franklin, ed. *Art in Action: American Art Centers and the New Deal.* Metuchen: Scarecrow Press, 1987.

Williams, Germaine Shaw. "(Re)Culturing the City: Race, Urban Development, and Arts Policy in Chicago, 1935–1987." PhD diss., Carnegie Mellon University, 2015.

Williams, Reba, and Dave Williams. *Alone in a Crowd: Prints of the 1930s and 1940s by African-American Artists, from the Collection of Reba and Dave Williams.* Washington, DC: American Federation of the Arts, 1993.

Wilson, Alona Cooper. "The Formation of an African-American Artist, Hughie Lee-Smith, from 1925 to 1968." PhD diss., Boston University, 2016.

Wolff, Robert Jay. "Chicago and the Artists' Union." In O'Connor, *Art for the Millions,* 239–42.

Note: Photographs are indicated by the figure
number (for example, fig.1). Endnotes are
referenced with "n" followed by the endnote
number.